the best of Nature Photography

IMAGES AND TECHNIQUES
FROM THE PROS

Jenni Bidner and *Meleda Wegner*

AMHERST MEDIA, INC. ■ BUFFALO, NY

PHOTO CREDITS

Copyright © 2003 by Jenni Bidner and Meleda Wegner. All rights reserved.

Published by:
Amherst Media, Inc.
P.O. Box 586
Buffalo, N.Y. 14226
Fax: 716-874-4508
www.AmherstMedia.com

Publisher: Craig Alesse
Senior Editor/Production Manager: Michelle Perkins
Assistant Editor: Barbara A. Lynch-Johnt

ISBN: 1-58428-084-0
Library of Congress Control Number: 2002103385
Printed in Korea.
10 9 8 7 6 5 4 3 2 1

TABLE OF CONTENTS

Photo by Mundy Hackett

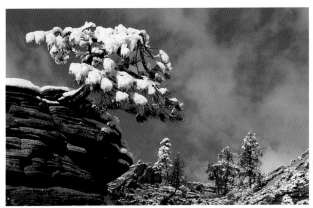

Photo by Russ Burden

CLAUDIA ADAMS

Claudia Adams has visited 53 countries documenting an ever-changing world with her camera. Looking back, she remembers that watching a baby giraffe's first hours of life were four of the most exciting hours of her entire life. She encountered the mother and calf in Kenya with her two Masai guides. The youngster was not an albino as she first thought; it was a newborn whose spots had not yet matured. Claudia burned through 15 rolls of Velvia that morning with her Canon EOS 1n stabilized in a 5-pound bag of rice!

Claudia's images have appeared in *Audubon, Nature Conservancy, National Geographic Traveler,* and many other publications. Some of her 50,000 images can be viewed at www.claudiaadams.com and at www.NaturePhotosOnline.com. She can be reached by e-mail at Claudia@tir.com.

THIS PAGE (CLOCKWISE FROM TOP LEFT): A coiled green tree python was photographed in the controlled environment of a studio; white-tailed deer mother and fawn; captive baby Canada Lynx; and three-hour-old Masai giraffe.
FACING PAGE (RED MAPLE IN PINE): A frosty morning treasure.

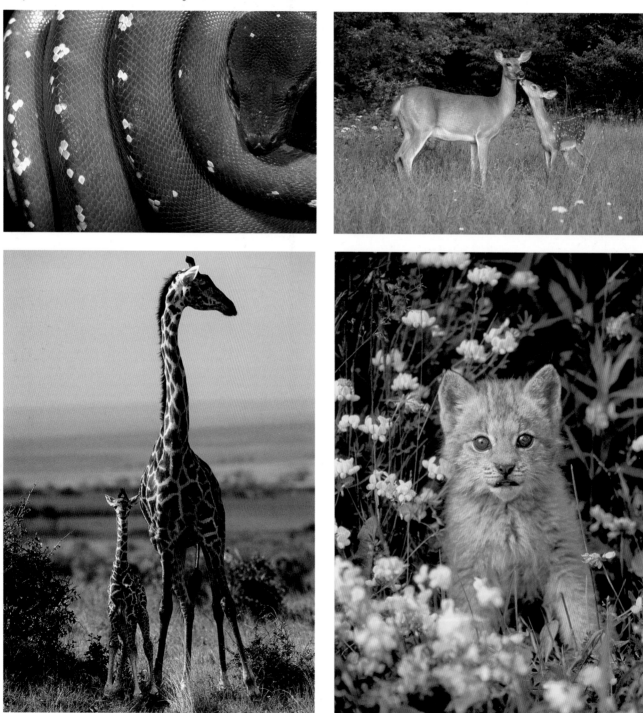

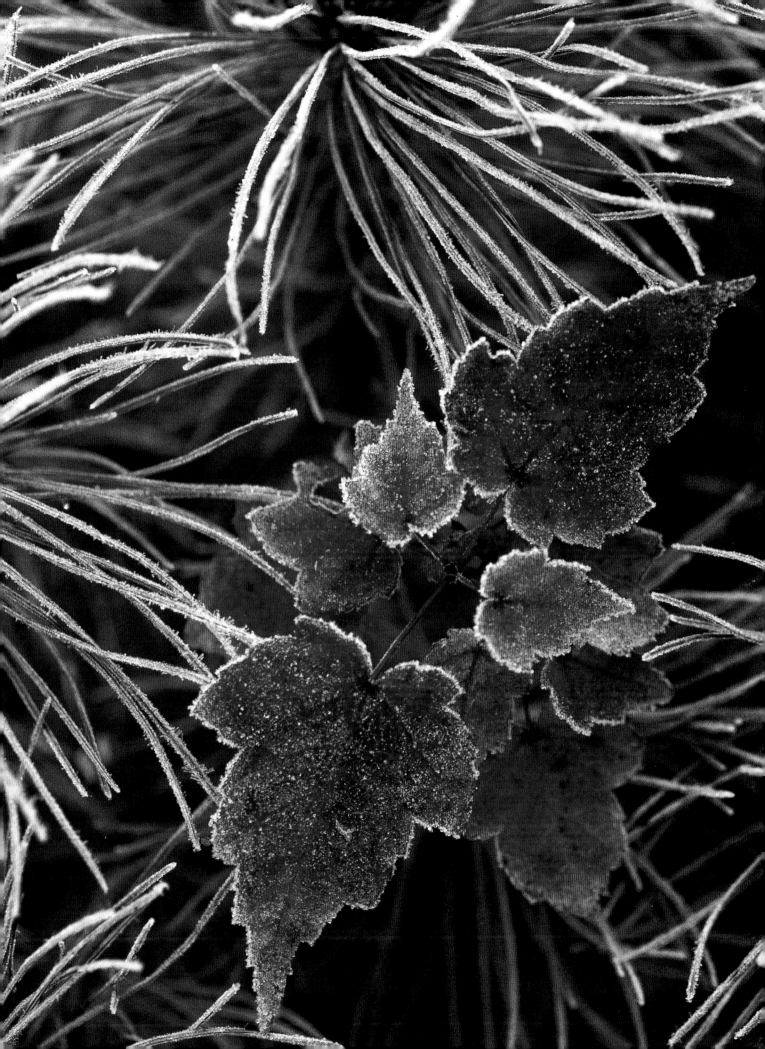

Eleanore Avery lives in Dallas, Texas, but does most of her photographic shooting out of the United States. She is a travel photographer, who specializes in wildlife and landscapes, and enjoys doing digital manipulations of her flower images.

As she began to travel extensively in 1985 her interest in photography grew, sparked by her desire to capture the new sights on film. At the time, she was using a point & shoot camera, but when she took the step up to an SLR camera, she was hooked on the creative possibilities.

Soon she purchased a computer and began experimenting with Adobe® Photoshop®. She entered photo competitions early in her career, and became a finalist in a *National Geographic* annual contest. Like many photographers we have interviewed, this early success inspired her to work even harder at her craft.

Africa has become her preferred shooting location because it offers the photographer everything—wildlife, scenery, sunsets, and people. She finds the best time to visit East Africa is during the Southern hemisphere's winter, June through September. She also tries to spend February there whenever she can to chronicle the East African summer. "The sun is much, much stronger in February, but the greens are gorgeous," she explains.

In southern African countries, the summer foliage is so intense that it makes viewing difficult, and the temperature can become very hot and uncomfortable. Therefore, winter is preferred.

Eleanore recalls an exciting moment while shooting a cheetah on location in a Namibian animal reserve known as Okonjima. This is a temporary holding area for cheetahs and leopards rescued from farmer's traps. At Okonjima the animals roam within a vast amount of fenced-in acreage until they can be relocated elsewhere in the country.

As Eleanore recounts, the cheetah (seen below) "jumped up on the hood of our vehicle after dinner to have a look around. This was the type of vehicle common on safaris with the windshield lowered, so I had a clear shot. But since I was sitting in the front seat, I was too close to shoot with the 170–500mm lens I had on my Minolta Maxxum 9 SLR camera. I don't think any-

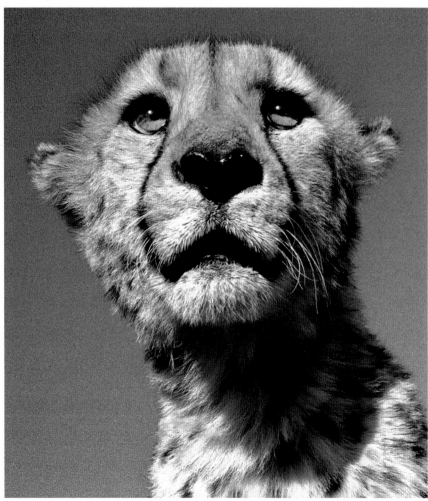

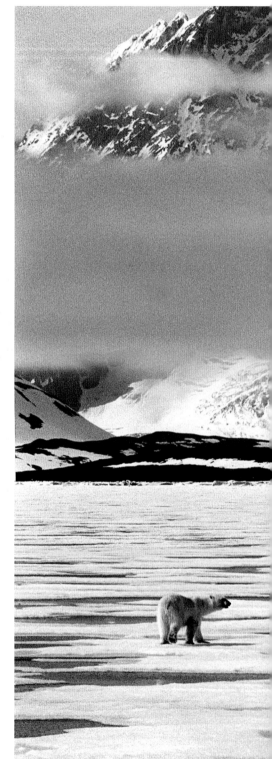

one has ever switched lenses so quickly! It was a unique opportunity to shoot with a wider angle lens from below this beautiful cat. I actually had to scrunch down in my seat to shoot up. The cloudless blue sky made for a great, nondistracting background.

"This was a magical moment in which I burned film as fast as I could from every focal length on the 28–300mm lens, until this wild cheetah decided it was time to run off into the bush."

BELOW (SVALBARD, NORWAY):
Avery photographed polar bears from the deck of a ship.
FACING PAGE (CHEETAH PORTRAIT):
Photographed on the hood of her jeep in a park in Namibia.

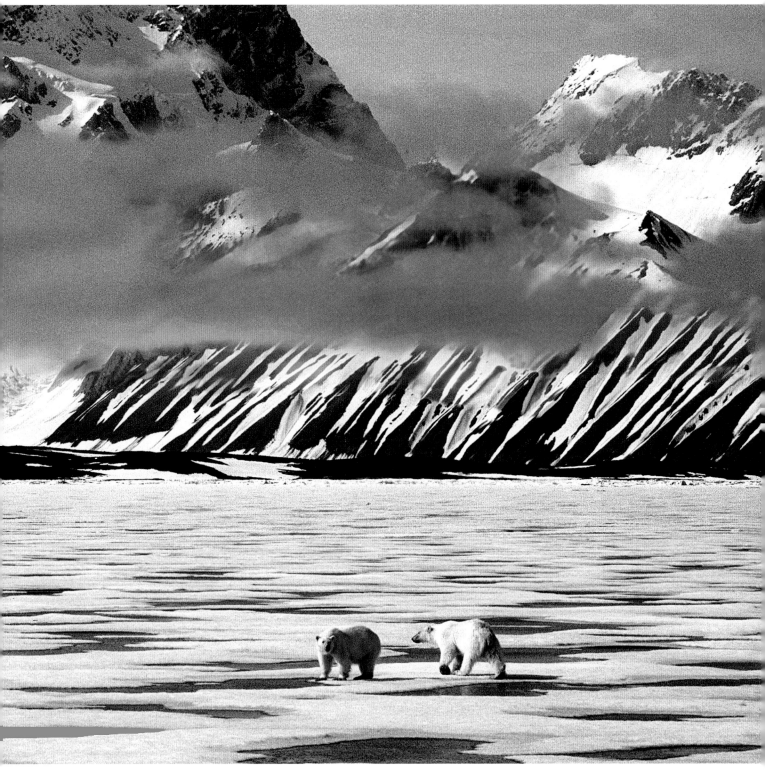

This is just one example of when Eleanore's trusted Tamron 28–300mm lens saved the day. "This is a fabulous lens to carry around the world. It is small, compact and the zoom range coverage is great for most situations," explains Eleanore. "I have a back condition that greatly limits the amount of equipment I can carry, so this is ideal for me."

To help her navigate the airports with her various pieces of equipment she uses a rolling microfiber computer carrying case that is filled with camera equipment. She always travels with her flash attachments, soft box, filters and other helpful lighting gear she considers essential.

Traveling light allows Eleanore to visit many remote areas. While searching for polar bears she traveled to Svalbard, Norway. This is an extraordinarily pristine region in the arctic circle, about 400 miles north of Norway. It is a popular area for scientists to study polar bears in their natural habitat.

In Svalbard, Eleanore boarded a small ship to reach the temporary frozen ice pack where polar bears often hunt seals. There she saw a group of four polar bears in the far distance. She settled in for a long wait, hoping the bears would become curious and move closer.

Approaching them herself was not an option, as she was well aware that she could provoke either manifestation of the "flight or fight" response. After fourteen hours, she was rewarded for her diligence, when two young bears started walking toward the ship.

"One bear actually came up and put his paws on the side of the ship! The two siblings were about a year and a half old, and very curious. They kept accidentally posing perfectly as they stood to get a better look at me," reports Eleanore.

In fact, they were so close that she could not use her long zoom Sigma 170–500mm lens to get a full body shot. Again, her 28–300mm lens saved the day, and she was able to capture this image of the standing juvenile polar bear (right) as it peered at her shipmates. Seeing polar bears in Svalbard is not unusual, but seeing them this close is a rare treat.

Shooting in the Arctic during the midnight sun (24 hours of daylight), Eleanore decided to bring mostly 400 ISO Fuji print film. "It turned out to be a very wise choice," she explains. "In addition to the changing and

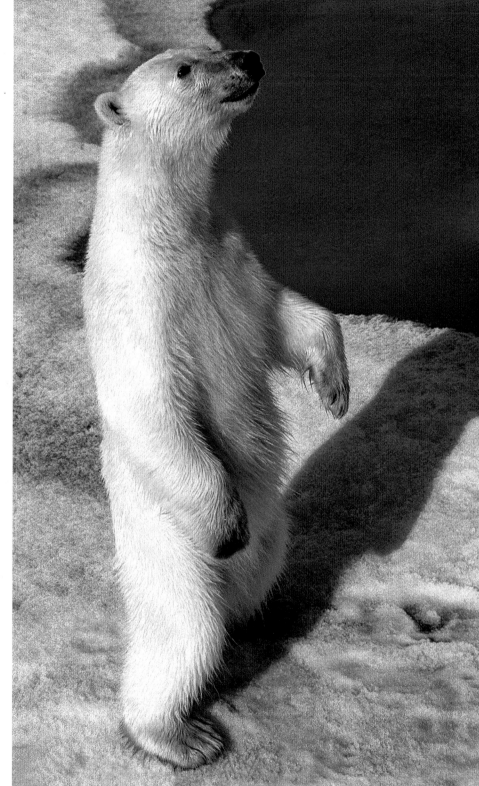

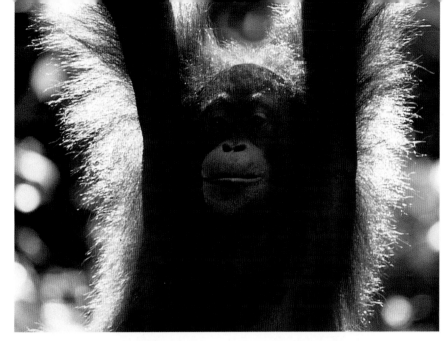

uncertain light, the best shooting location was aboard ship. A slower film speed would likely have blurred the images because of the ship's motion and the vibrations from the engines."

"When shooting wildlife, you have to always be ready for anything," says Eleanore. "Hours can pass with nothing much to shoot, then suddenly a scene will unfold in front of you that makes you forget everything except the excitement of the moment."

Eleanore Avery can be reached by telephone at 214-350-2240, by e-mail at eleanorea@aol.com or through her web site at www.skylightartists.com.

TOP RIGHT (ORANGUTAN):
A young, wild orangutan visits a feeding station at the rescue and release Sepilok Sanctuary in Sabah, Malaysia.
RIGHT (TREE IN NAMIBIA):
A tree stump in the Dead Vlei salt flats of Soussevlei National Park, Namibia.
BELOW (THE SERENGETI):
Cattle egrets accompany zebras and wildebeests during their migration in February in the Ndutu area of the southern Serengeti, Tanzania.
FACING PAGE (YOUNG POLAR BEAR):
An adolescent polar bear strains to see onto the deck of the ship in Svalbard, Norway.

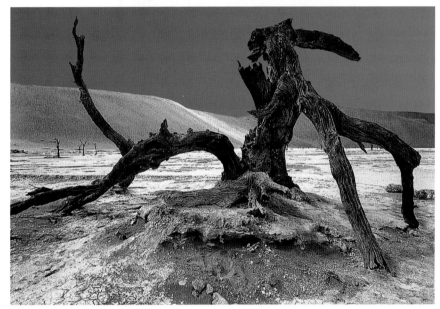

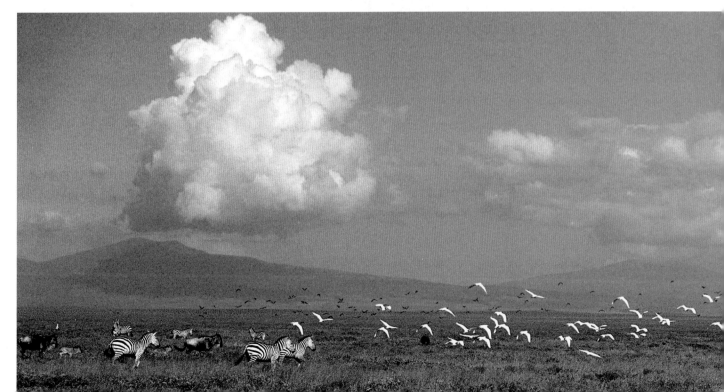

Erwin and Peggy Bauer are one of the best known husband and wife shooting teams in the business. Erwin began his photographic career by shooting images to complement articles he had written for the Ohio Conservation Bulletin. Peggy began shooting shortly after marrying Erwin. Between them they have over 75 years of photographic experience, and have photographed in the most remote corners of the world.

Of all the exotic locations they've visited, Erwin reveals, "Alaska is my favorite—especially during the fall when creatures are in the mating mood, and the vegetation is at its most colorful." Another advantage to shooting in Alaska during autumn is that early snowfall can dramatically transform the landscape from one day to the next. This, of course, gives the photographer opportunities to reshoot images and produce different effects over the same terrain.

One of the Bauers' favorite shooting stories occurred when cruising the Shelikof Strait, paralleling the coast of Katmai National Park in Alaska. "We saw two bears that we thought were fighting. The height of the breeding season had passed and we expected to find single bears chasing migrating salmon or digging for clams. But it soon became evident that this was a courting pair performing an amazing dance." The bears (seen in the photo on the next spread), whom the Bauers refer to as Fred and Ginger, did not pay the least bit of attention to the approaching photographers, but continued their interaction. When it stopped ten minutes later (perhaps the unheard music had ceased), they turned in opposite directions and wandered off, never looking over their shoulders at the delighted photographers who stood in what was now knee-deep water from the incoming tide.

Differing from her husband, Peggy's favorite location is East Africa. She notes that "There is just so much there to be seen and photographed: chases, birth, feeding, parenting, migrations, bathing, etc. The opportunities are endless. Plus, most of the animals are accustomed to tourist vehicles so they behave in an unaffected way.

"Our fear, however, is that the encroaching population with livestock and agriculture constantly eats away at the wild areas, shrinking the land these animals need to survive and prosper," she adds.

BELOW (GUANACO IN CHILI):
A lone Guanaco stands before the spectacular mountain backdrop of Torres del Paine National Park in southern Chile. The Guanaco is one of the few types of wildlife in the area that is unfamiliar to North Americans.
FACING PAGE (CAPTIVE KOALA):
This endearing marsupial was photographed in captivity where it has no worries of loss of habitat or lack of its favorite food, eucalyptus leaves.

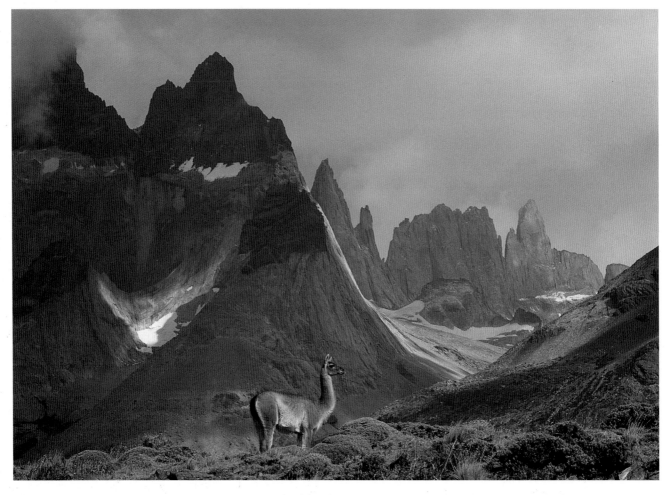

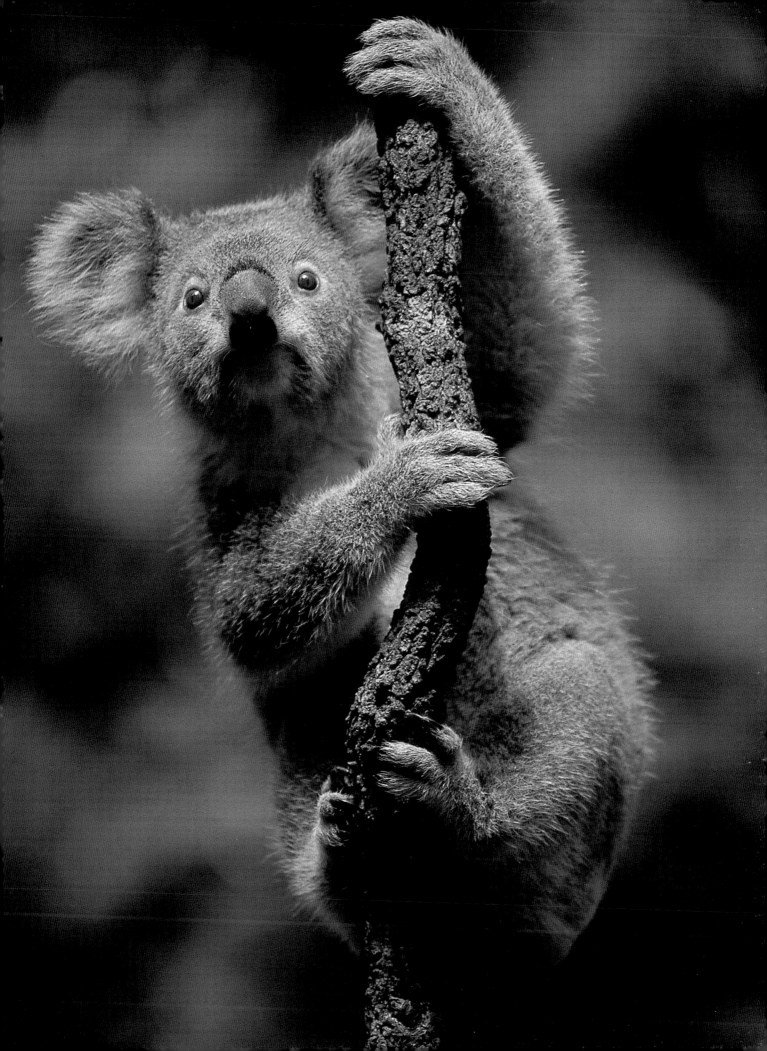

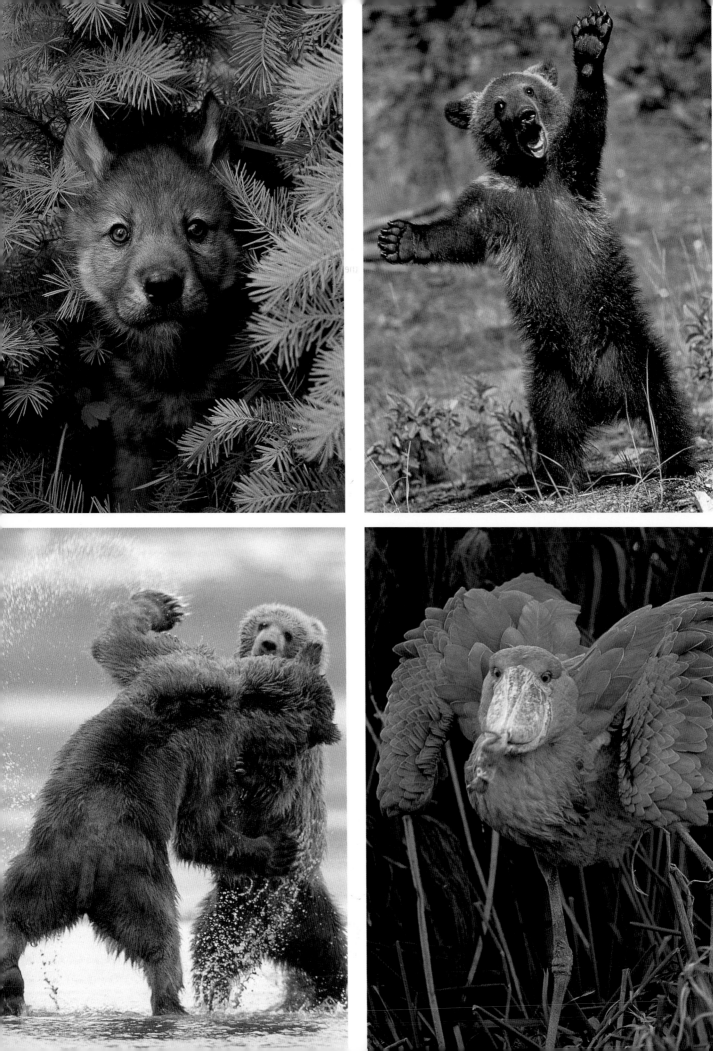

Peggy observes that most visitors to Africa go in search of the large well-known animals and they're not disappointed. But others concentrate on the vast bird life that blankets the savannas, the trees and the watering places. The variety of shapes, sizes and colors is mind-boggling. One of the rarest of the birds is the whale-headed stork (facing page). This is a huge gray-blue bird with a monstrous bill, thoughtfully equipped with a hook on the end that helps it down one small aquatic creature after the other.

This is not to say that the Bauers only photograph rare and endangered species. One of their most memorable bird photographs is of a grouse (shown below). Erwin and Peggy have long been fascinated by the springtime courtship rituals of the grouse. "The drumming ritual of the ruffed grouse is one of the finest we've ever seen," explains Erwin. "The male bird cups its wings and beats them against its chest, producing a deep beating tone that begins slowly, then increases in speed and volume to a crescendo that would make a philharmonic drummer proud. Then it gradually slows and becomes softer until it disappears altogether. It's an amazing combination of grace and fury."

When they heard this distinctive sound in Grand Teton National Park, Wyoming, they followed it to an open space, and set up a small blind and photographed for several days.

Erwin and Peggy are among the most widely published photographers in the world. They have received the North American Nature Photographers Association's 2000 Lifetime Achievement Award and have a stock file that rivals most agencies.

They have produced 44 books and have hundreds of magazine covers to their credit. Their most recent books are *Denali* and *Glacier Bay*, published by Sasquatch Books. *The Alaska Highway* and *Bears of Alaska* will be released soon. Currently the Bauers are working on *Great Cats of the World*, which will be published by Voyageur Press.

You can see more of Erwin and Peggy Bauer's work on the Internet at www.agpix.com/epbauer. Or contact them via e-mail at epbauer@olypen.com, or by phone at 360-683-1300 or fax at 360-681-2117.

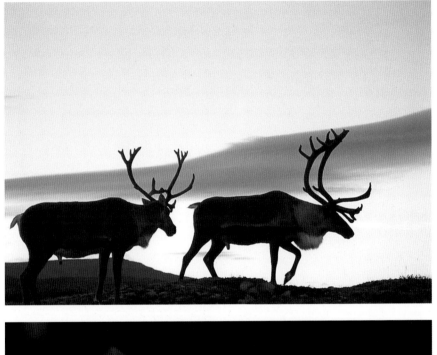

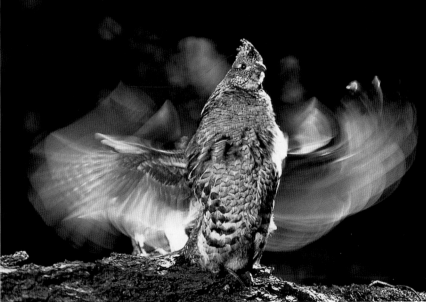

TOP (CARIBOU BULLS):
Two bull caribou move through the fog in late autumn in Denali National Park and Preserve, Alaska.

BOTTOM (RUFFED GROUSE):
The ruffed grouse performs its "drumming" springtime courtship ritual. The image was shot from behind a small blind in Grand Teton National Park, Wyoming. The image was created using a combination of flash and a long exposure (to capture the blurring wings).

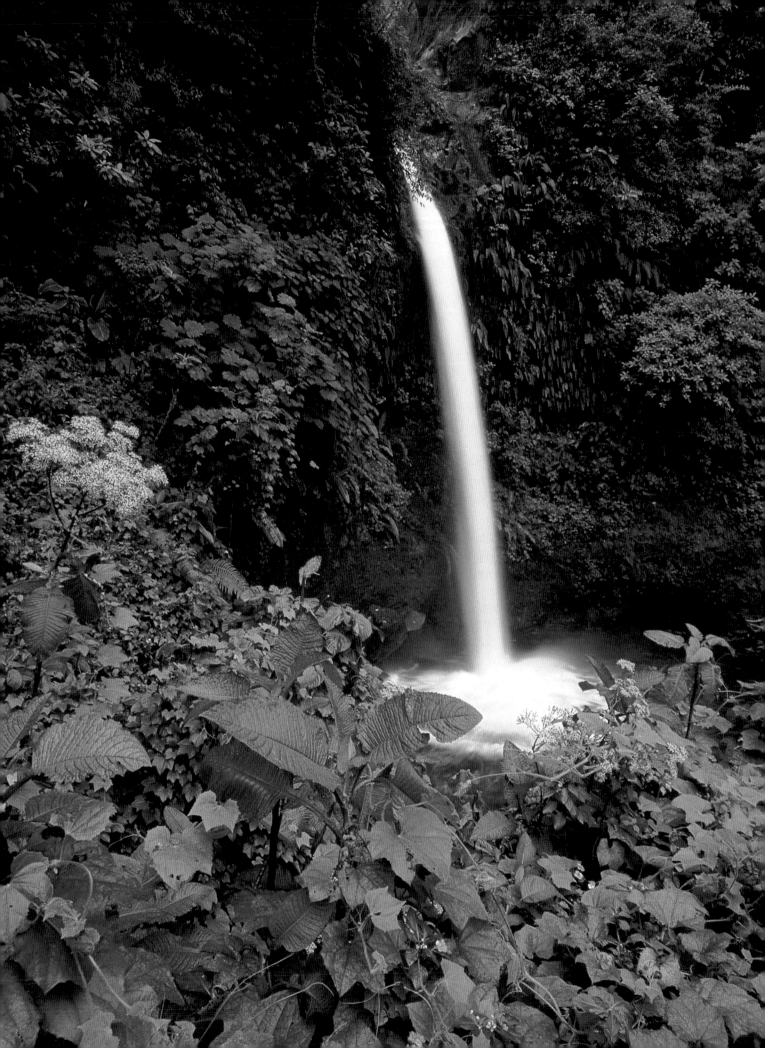

Tom Boyden started his professional career as a zoologist and botanist conducting research in Central America and the Pacific Northwest. "Eventually I felt my focus on the natural world and opportunities to travel were too restricted in science, so I decided to become a nature photographer."

Tom has been a professional photographer for more than twenty years. His artistic eye and scientific background allow him to serve an expansive clientele. Advertisers, attracted by the aesthetics of his images, have used his photos in numerous advertising campaigns. Editors, looking for "biological and scientific accuracy," find that Tom's work conveys essential concepts in biology. Overall, his unique credentials give his photographs broad appeal.

When on assignment Tom finds that his scientific training helps him "hit the ground running." He always conducts thorough research before leaving, and he has an action

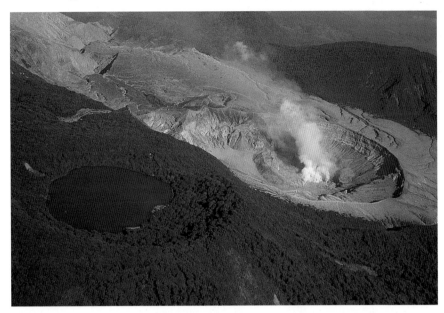

LEFT (VOLCANO):
This image of Poas Volcano, Costa Rica was surprisingly taken from a commercial airliner through three-layered Plexiglas windows!

BELOW (BUTTERFLY):
A gulf fritillary butterfly was photographed on the flower, using a 100mm macro lens and fill-flash.

FACING PAGE (WATERFALL):
La Paz waterfall in Costa Rica, photographed at $1/30$-second to blur the water.

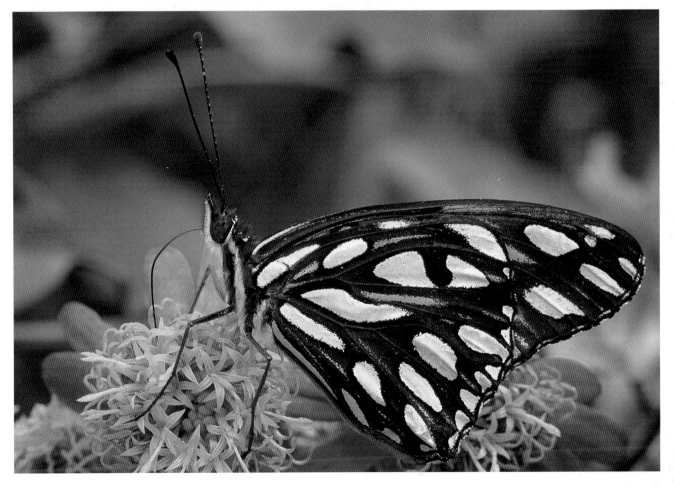

plan upon arrival. This disciplined approach helps him identify in advance what equipment will be required for the assignment or expedition, and it ensures that he optimizes his time in the field.

Although Tom is a knowledgeable naturalist in his own right, he sometimes enlists the assistance of local guides. Tom learned the value of hiring a competent guide during a trip to Central America. He wanted to photograph some of the exotic Costa Rican snakes and thought that he knew enough about their habitat to "go it alone." On the first day of the trip Tom didn't see a single snake. "The next day," as Tom tells it, he "went out with a local herpetologist, and the snakes were everywhere! I just hadn't known where to look."

In addition to helping Tom quickly locate unfamiliar animal species, local guides can be a great resource as photo assistants and for learning the nuances of local customs, culture and language.

Although Tom usually shoots in the wild, there are occasions when he will photograph captive animals. Many endangered species, and some particularly elusive species, have

TOP LEFT (MOUNTAIN & CLOUDS):
A mountain peak in North Cascades National Park.
CENTER LEFT (RAINFOREST):
Early morning fog in a rainforest in Trinidad's Arima Valley.
BOTTOM LEFT (EGRET):
A great egret on Mrazek Pond in the Everglades National Park. Boyden spot-metered off the bird and opened up two stops because of the backlighting.
FACING PAGE UPPER LEFT (FROG):
A red-eyed tree frog outside a nature lodge in Costa Rica. Photographed with a 100mm macro lens and fill-flash.
FACING PAGE UPPER RIGHT (MONARCHS):
A gathering of Monarch Butterflies in a reserve in central Mexico. Boyden used two flashes (one on-camera and one off-camera).
FACING PAGE BOTTOM (JAGUAR):
A captive jaguar in a Central American zoo. Zoos provide an excellent opportunity to take portraits of this elusive species without endangering the animal.

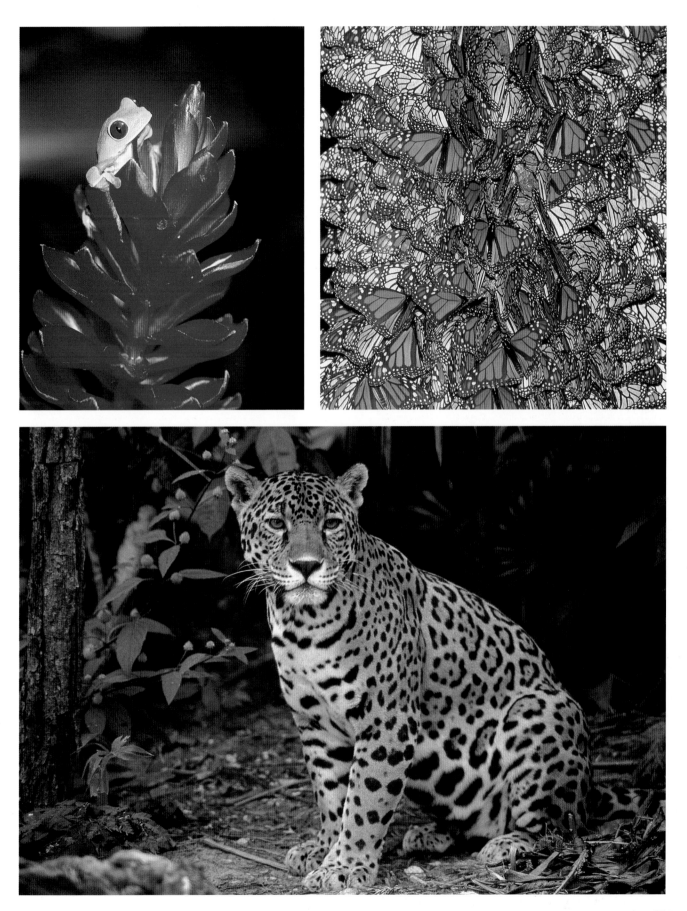

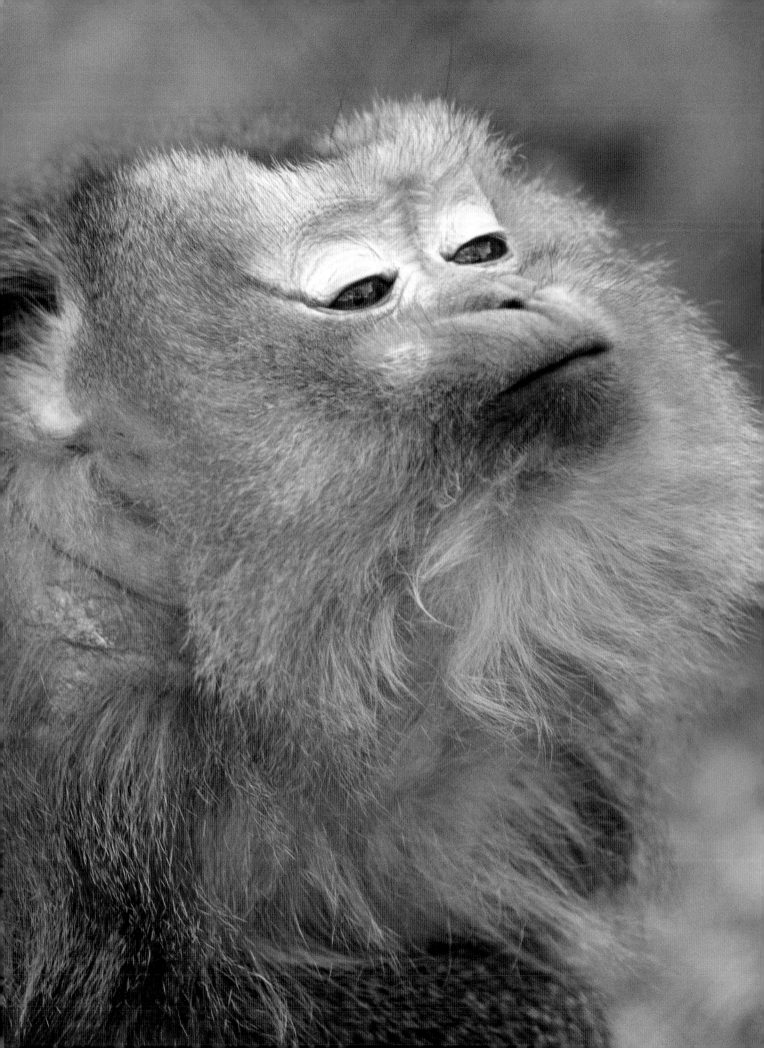

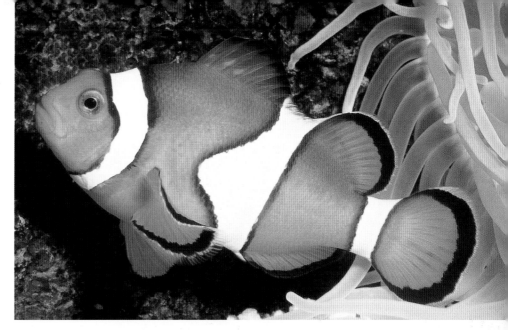

never been photographed outside of captivity. When Tom takes assignments that require him to photograph captured animals, he attempts to make the image look as natural as possible. On such shoots he usually uses a telephoto lens and a wide aperture setting to blur out distracting elements in the background. The results are impressive. Often the photograph's caption provides the only indication that the image was not shot in a natural habitat.

When not on assignment, Tom teaches photography classes and workshops. He enjoys the stimulation of the classroom, and finds that "it's usually a great learning experience for everyone including the teacher." He reminds his students that photography requires both hard work and a judicious use of one's time. "If you spend a week slogging around in the rain without getting any saleable images, then you just had a cold, wet and miserable work week without pay." Fortunately for Tom this doesn't happen very often.

Tom has more than 100,000 transparencies on file. He is represented by several different agencies including AG Editions, Inc., Getty Images, Dembinsky Photo Associates, Lonely Planet Images and Delmont, Herbig & Associates. You can view his images at www.agpix.com/tomboyden. Tom is available for assignments in his Seattle-area base or worldwide. He can be reached by e-mail at tomboyden@mindspring.com.

NEAR RIGHT (HERON):
Boyden found this heron on a beach in Florida standing near a fisherman at sunset. It soon became evident why—as he tossed the bird his catch.
UPPER RIGHT (CLOWN FISH):
A clown fish and anemone shot in an aquarium with a 100mm lens, rubber lens hood (pressed against the glass to eliminate reflections), flash and 81B warming filter (to counter the green cast of the glass).
FACING PAGE (MONKEY):
A pig-tailed macaque in a Canadian zoo. Boyden was mesmerized by the monkey's array of interesting expressions.

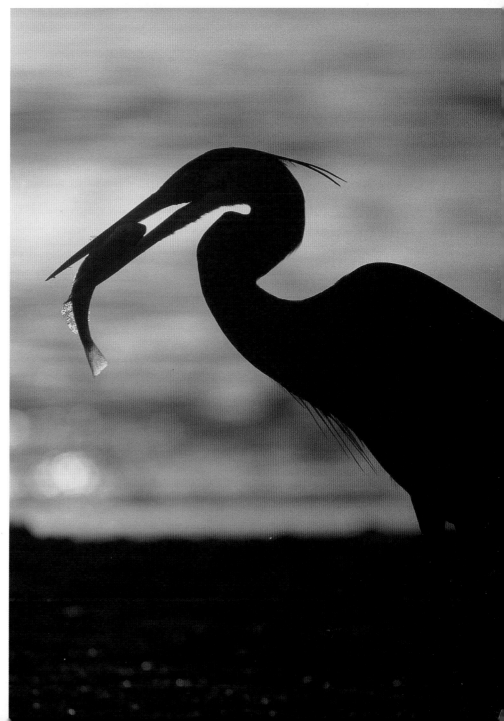

Steve Brimm explains why Lake Superior and its environs is his preferred shooting location. "The lake is a dynamic subject as it continues to move and change in a matter of minutes right before your lens. Also, the four seasons add another layer of texture to this wonderful lake." Steve has braved the elements, and in so doing, has collected as many memories as he has photographs.

Listening to Steve recount his adventures reminds us of looking through a wonderful kaleidoscope. He speaks of having been roped to the side of a cliff, and accidentally dropping thousands of dollars worth of camera equipment into the water; watching for hours as loons feed their chicks; seeing a rainbow fill a blackened sky; having a hermit thrush sing him to sleep; watching coyotes trot across the ice at sunset; seeing the northern lights dance across the sky over the lake; and a surprise meeting with a Grizzly—and the revelation that his mommy was not far off! It is safe to say that for Steve Brimm there is no "typical day at the office."

Steve's love for the outdoors and his belief that we have a responsibility to foster the health of the land and all living creatures provides an emotional quality to his work. He understands that technical mastery alone will not guarantee powerful images. Rather it is the combination of technical skills and a passionate vision that will produce exceptional photographs.

He acknowledges that sophisticated equipment features like fast autofocus and motordrives help to capture more usable wildlife images, yet he cautions those who put too much stock in their equipment. Steve is quick to point out that one of his best-selling prints was shot with a thirty-year-old manual

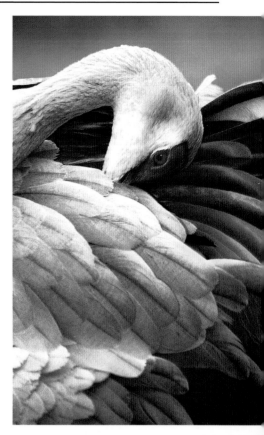

RIGHT (PREENING CRANE):
Brimm photographed this crane at a rehabilitation center. He braced the camera and used the self-timer to achieve a sharp $\frac{1}{15}$-second exposure in low light.
BELOW (LAKE SUPERIOR):
Lichen-covered rocks in front of an island on Lake Superior. Shot from a sea kayak.

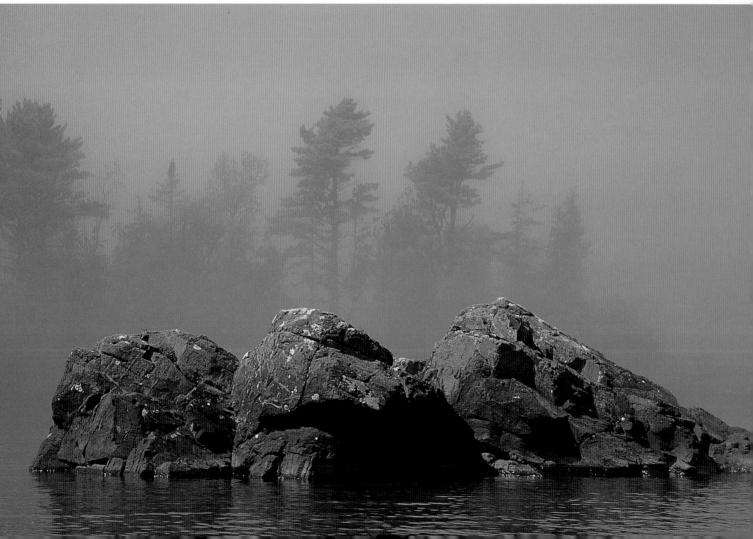

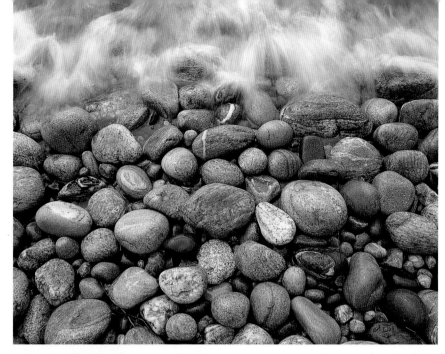

camera, an after-market zoom lens and slide film off of a supermarket shelf.

Steve's most important piece of equipment may in fact be his compass. "Yes, I would be lost without it—literally" he tells us. Not only does he use it to help him navigate back home after a shoot, but he also relies on it to anticipate the likely angles of sunlight. Knowing what he is looking for allows Steve to time his shots for optimal lighting.

While kayaking in Lake Superior near the Basalt reefs (pictured on the facing page), Steve positioned himself to take advantage of an anticipated angle of sunlight. Steve watched and waited to see if the fog would roll out enough to let the sun hit the lichen-covered rocks. When the moment came, he used a lens with a 100mm focal length. This effectively compressed the scene, creating the illusion that the reef was just offshore. Since a Kayak doesn't provide a stable platform, Steve had to use a fast shutter speed to prevent blurring.

Steve prefers to use his tripod whenever possible and hand-holds his camera only when necessary. The tripod helps him create photographs that otherwise would not be possible. An example of this is the image of the wave washing over stones on the shore of Lake Superior, seen on this page. To achieve this dynamic effect, Steve shot the frame at the slow shutter speed of $^1/_8$ second. Had he not used a tripod, Steve would not have been able to hold the rocks in focus. It is the very contrast between the sharpness of the rocks and the motion of the water that makes this a compelling image.

To see more of Steve's beautiful nature photography visit www.brimmages.com.

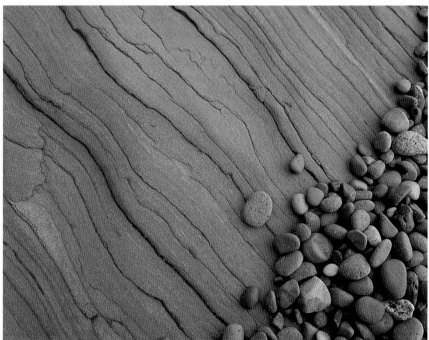

TOP RIGHT (AGATE BEACH):
Wave washing over beach stones on the shore of Lake Superior. Brimm used a slow $^1/_8$-second shutter speed to blur the water.
CENTER RIGHT (SANDSTONE):
Layers of sandstone and beach pebbles were shot in the warm light of sunset on the edge of Lake Superior with a wide angle lens.
BOTTOM RIGHT (FEATHER):
Smooth, wet beach stones and a solitary gull feather on the shores of Lake Superior became an elegant found still life.

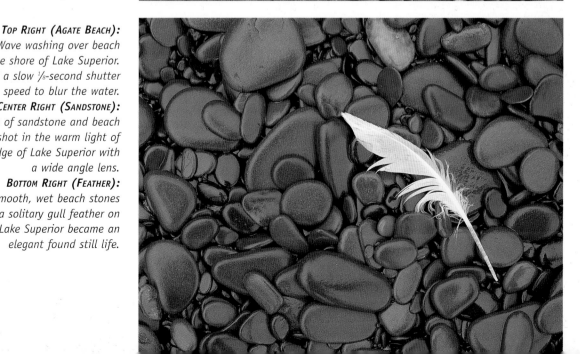

Larry Brownstein used to regard photography as a "strange hobby." Larry wondered why people would want to be so loaded down with equipment during their travels.

His perspective changed after spending six months traveling in Asia with a friend who was a photographer. Larry started the adventure without a camera, thinking that he could just get copies of his friend's pictures at the end of the trip. When Larry noticed how much fun his friend was having taking pictures, he decided to buy a camera of his own in Hong Kong. Before Larry knew it, he was quickly running lots of film through his camera, thus beginning his brilliant photo career. Larry characterizes his career path as "slow and steady." As with most photographers, his business has developed incrementally, like building a house brick by brick. Larry notes that in addition to talent it takes time and hard work to succeed. His recommendation to budding photographers is to "find a subject that excites you and you will enjoy what you are doing and be far more likely to obtain good results."

Nature photography definitely excites Larry, because he never knows what obstacles await him in the wild. Obtaining a good shot often takes patience and perseverance. On one outing, Larry waited three days for the dreary overcast skies to clear from Yosemite Valley. He hardly took a picture. He decided to leave the next day if there was no change in the weather. Fortunately, a storm deposited a fresh blanket of snow in the valley. Early the next morning the clouds began to break up. Larry put on his snow chains, drove into the valley and took pictures all day long.

This wonderful day of photography culminated with an amazing sunset reflected off of

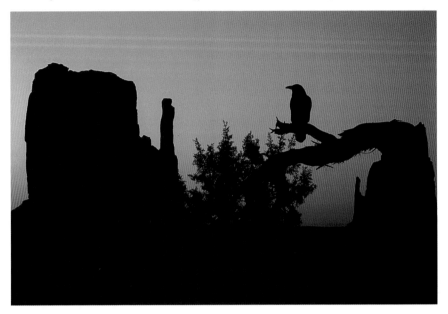

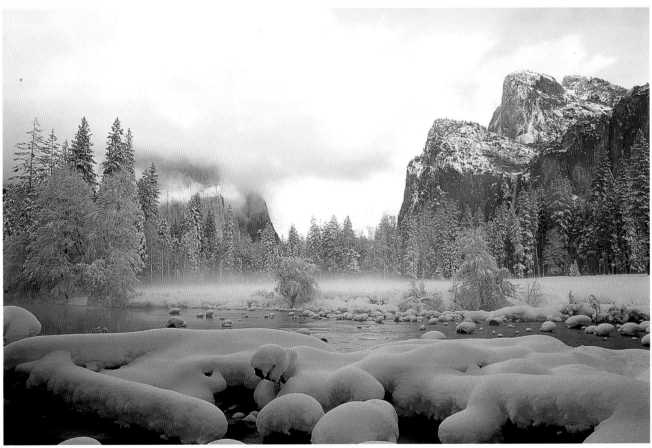

El Capitan (facing page). This vantage point shows the fresh snow and the Merced River in the foreground.

Larry loves "shooting at extremes" using his wide angle Nikkor 20mm lens or his 300mm telephoto lens. The Yosemite shot is a great example of how the superwide 20mm can be used in landscape photography to capture a strong foreground and background.

He also endeavors to incorporate a sense of design to his photographs. Both in the image of the aloe flowers and the ferns in the Hoh Rainforest, his use of pattern as a compositional device is readily apparent.

Electrical storms also present interesting depth of field opportunities as well as a certain degree of peril. Although Larry rarely feels scared when taking photos, he has a healthy respect for lightning. The electrical storm in Monument Valley pictured at bottom right was shot at a great distance. He opened the lens for several long 10–20 second exposures, until lightning finally struck the right subject during one of these long exposures.

Larry sells stock photos and prints on his web site: www.larrybrownstein.com. You can contact him by phone at 800-240-1669, or via e-mail at larry@larrybrownstein.com.

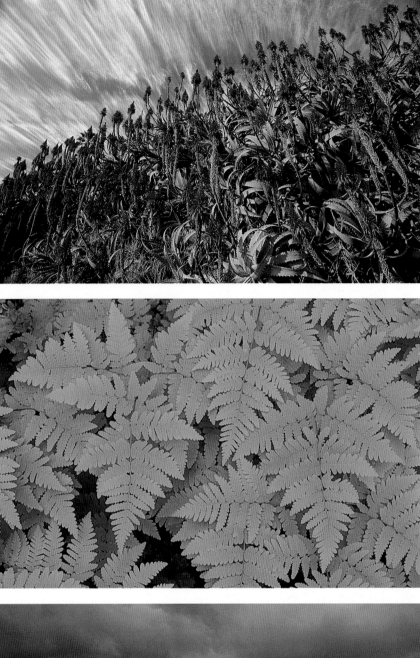

TOP RIGHT (DECEMBER ALOES):
Brownstein keeps track of the flower bloom schedules, and always visits Laguna Beach, CA, in December to shoot the aloes.
MIDDLE RIGHT (OLYMPIC NATIONAL PARK):
The Hoh Rainforest is so full of lush vegetation that it can be hard to pick out one subject. Brownstein used a wide-angle lens to emphasize the pattern of ferns.
BOTTOM RIGHT (MONUMENT VALLEY):
The trick to great lightning photos is to set up the shot, and then hope lightning strikes during a series of long exposures.
FACING PAGE TOP (MONUMENT VALLEY):
When Brownstein saw this crow he immediately realized it could become an important compositional element to this morning silhouette.
FACING PAGE BOTTOM (YOSEMITE NATIONAL PARK):
Three days of bad lighting were followed by a snowy sunset with El Capitan and the Merced River.

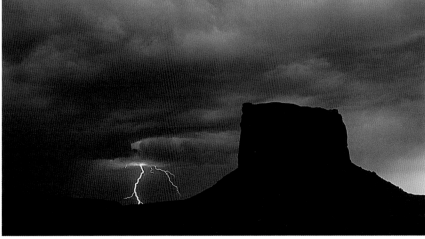

Ray Bulson's passion for photography began fifteen years ago when he received a Nikon FM camera as a gift. Ray, who began his career concentrating on landscapes, has expanded his work to include wildlife and macro subjects.

Ray stresses that "Creating photographs away from the usual vantage point will render unique landscapes."

Lake Louise, pictured on this page, is one of the most photographed and recognizable lakes in the world, yet when Ray turns his lens on this familiar site he transforms it into something altogether new. Ray achieved this by including the large rock in the foreground. Ray felt that by lighting this rock with fill

flash, the viewer's eye would be led into and through the picture, almost giving it a three-dimensional look. He took his time using combinations of exposures with fill flash settings, and graduated filters to produce this desired effect.

Not far from Lake Louise is Jasper National Park, where Ray hoped to capture the alpine glow off of Mt. Athabasca. While he waited for the setting sun, several Rocky Mountain bighorn sheep came into view. Here was an unexpected opportunity. Ray left his spot and crawled on his belly for a couple hundred feet to get as close as possible.

Ray advises, "When something unplanned happens, go shoot it, because that may be

your shot." In this case the spectacular photo on page 25 was Ray's "shot of the day". The image conveys the strength and beauty of the sheep in their grandiose natural habitat.

View Ray Bulson's work on his web site www.wilderness-visions.com or contact his business, Wilderness Visions, Inc. at rb@wilderness-visions.com, or 2 Earls Court, Newark, DE 19702, or call 302-292-0485.

LEFT (HOH RAINFOREST):
This image of Olympic National Park was one of Ray Bulson's first medium format pictures. He's been hooked ever since!
BELOW (LAKE LOUISE, BANFF):
A 2-stop graduated neutral density filter (to darken the sky) and fill-flash on the rock brought this image to life.
FACING PAGE TOP (BIGHORN SHEEP):
Wilcox Pass in Jasper National Park, Alberta Canada.
FACING PAGE BOTTOM (BOILING SPRINGS):
Sunrise in the Pennsylvania forest.

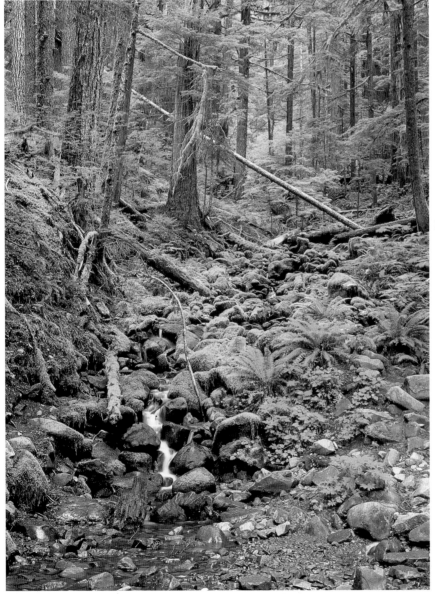

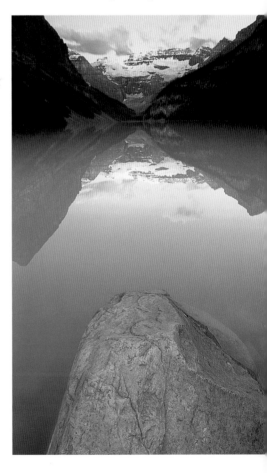

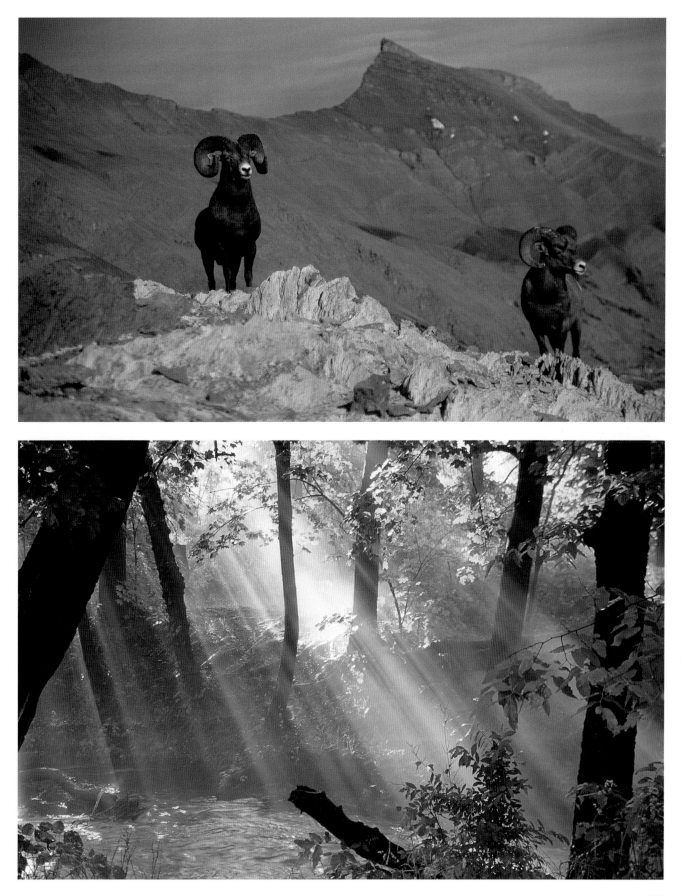

RUSS BURDEN

Russ Burden was a schoolteacher and weekend photographer for 27 years. He merged his two loves into one when he decided to begin a business offering photo tours for nature photography students. In Russ's words, "I put down the chalk and picked up the camera full-time." Russ has a passion for sharing his knowledge. "There's nothing like being in the great outdoors, creating wonderful images, and instructing people on the fine points of photography."

Russ uses "before-and-after" images to demonstrate various photographic techniques. He begins with an "auto-everything" picture. Here the camera makes all the decisions for the photographer. The "after" photo showcases some of the possibilities available to the photographer who has mastered the use of manual settings. Russ calls this the "creatively controlled solution." His before-and-after tutorials often appear in *Petersen's Photographic* and other magazines. The "before" and "after" images help students instantly understand how a narrow aperture setting compares with a wider setting and what the implications are for the

RIGHT (BEAR CUB):
A captive bear cub takes a break during a "modeling session" to scratch her back.
BELOW AND FACING PAGE
(BLACK SWALLOWTAIL BUTTERFLY):
Russ Burden hatches his own butterflies indoors. When they hatch, he has about an hour to photograph them before they "become flighted" and go on their way. In this time, he is able to change backgrounds (painted cardboard) and the flowers on which he places them, for studio-style portraits.

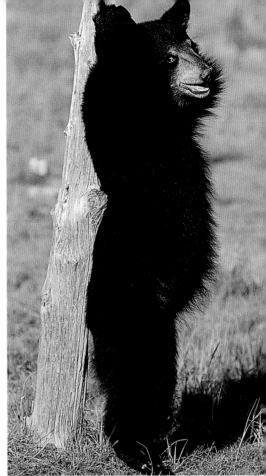

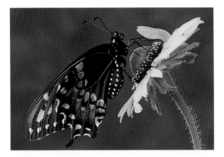

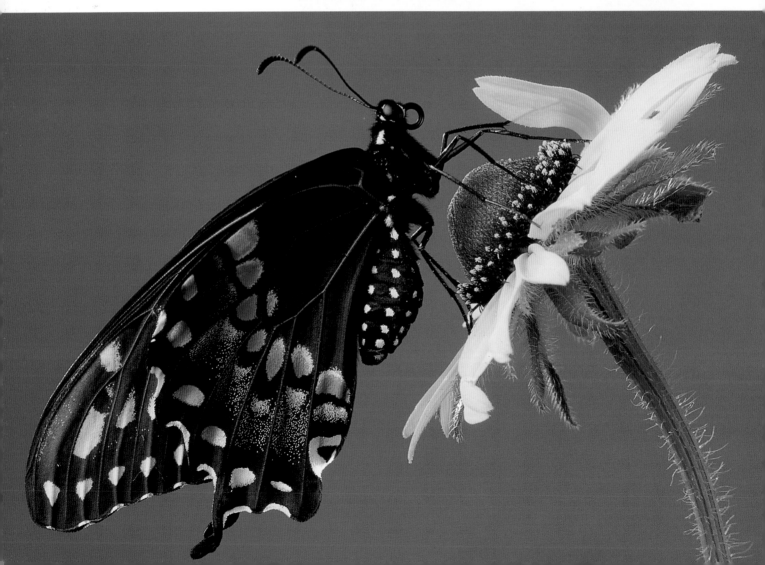

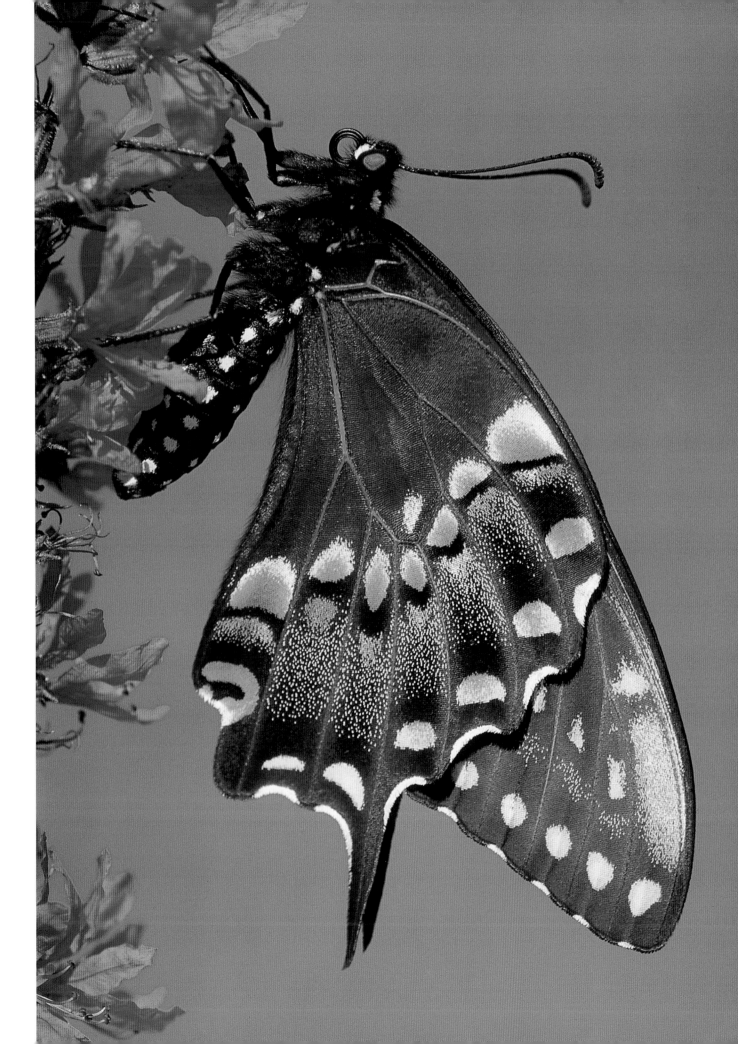

depth-of-field. Likewise, Russ compares shutter speeds, flash configurations, and many other aspects.

As a teacher, Russ advises: "Shoot a lot and take a lot of notes! The more you know about what you did and how to either repeat what is successful or eliminate the errors, the faster you'll see major advancements in your photography." He tells his students to master one camera, one lens and one type of film. He encourages them to know how the three interact under all conditions. Once this interaction is understood, then it's time to add another lens to the equation and begin the process of mastering that.

This incremental approach has no end. Russ himself admits that he is always learning. "Owning the most gadgets and fanciest equipment doesn't guarantee the best images," says Russ, "you must know how to control all the variables."

After mastering one's equipment, Russ suggests that students learn about the physics of light. The word "photo," of course, is derived from the Greek word for "light." A photographer will create compelling images to the extent that she understands light. Russ tells us that he would "rather photograph an ordinary subject in great light than an incredible subject in ordinary light."

The notion of "great light," however, depends upon the subject. Russ has found that animal photographs are rich and textured when front-lit, yet front-lit scenic photographs often lack dimension. "Knowing when a photograph will work well with front light, back light, side light, top light or overcast light is a key concept to master."

Returning to the same spot to shoot in different light situations is a great way to practice and learn. Different times of the year result in completely different renderings of the same location. The ever-changing angles of the sun offer endless possibilities for the patient photographer. Knowing what time of year to photograph a specific location is a skill that often takes years to develop.

Experimenting with subtle compositional change fascinates Russ. The butterfly study on pages 26 and 27 provides a good example. If you look closely, you will notice that Russ used the same butterfly in each of the

BELOW (GRAND TETONS):
Burden used a graduated neutral density filter to darken the sky and Grand Teton Mountains in comparison to the lake for a better overall exposure.
FACING PAGE BOTTOM
(BEFORE AND AFTER OF OWL):
Like his butterflies on pages 26 and 27, Burden can make background variations of this long-eared owl by returning to a raptor rehabilitation center at different times, days and even seasons.

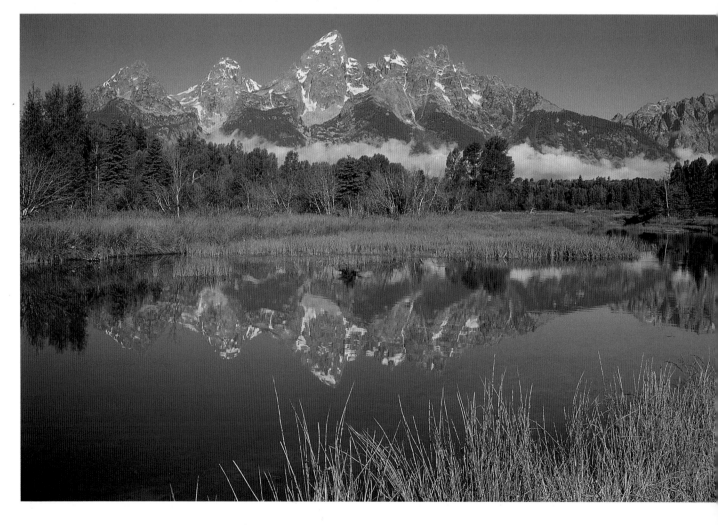

photographs. Finding a cooperative black swallowtail butterfly to pose on several different flowers was no easy feat. To do so Russ cultivated his own colony of butterflies. He began by planting dill in his garden. This herb is quite popular with egg-bearing insects. Russ inspected his dill each day. He found a hatch of young caterpillars and brought them indoors to prevent them from becoming robin fodder. He raised the caterpillars and watched as each began spinning a chrysalis. After three weeks, butterflies emerged. Russ selected one and began photographing his subject. He had only one hour in which to shoot, the amount of time it takes for butterflies to become "flighted." Russ lit

BELOW (FLOWER COMPARISONS):
Always the instructor, Burden likes to do before and after photographs to demonstrate how a certain photo technique can radically alter an image. In this case selective focus is examined, with the left image shot at f/22 and the right image at f/5.6.

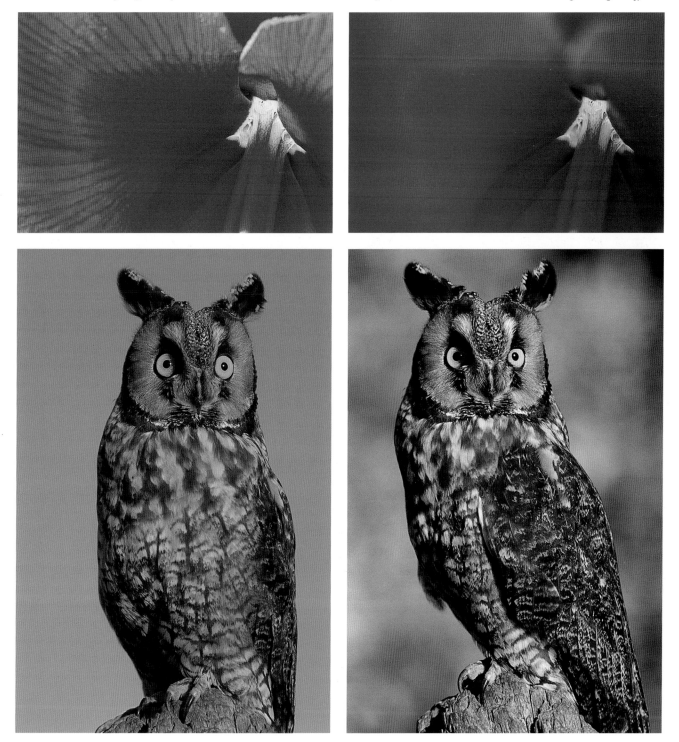

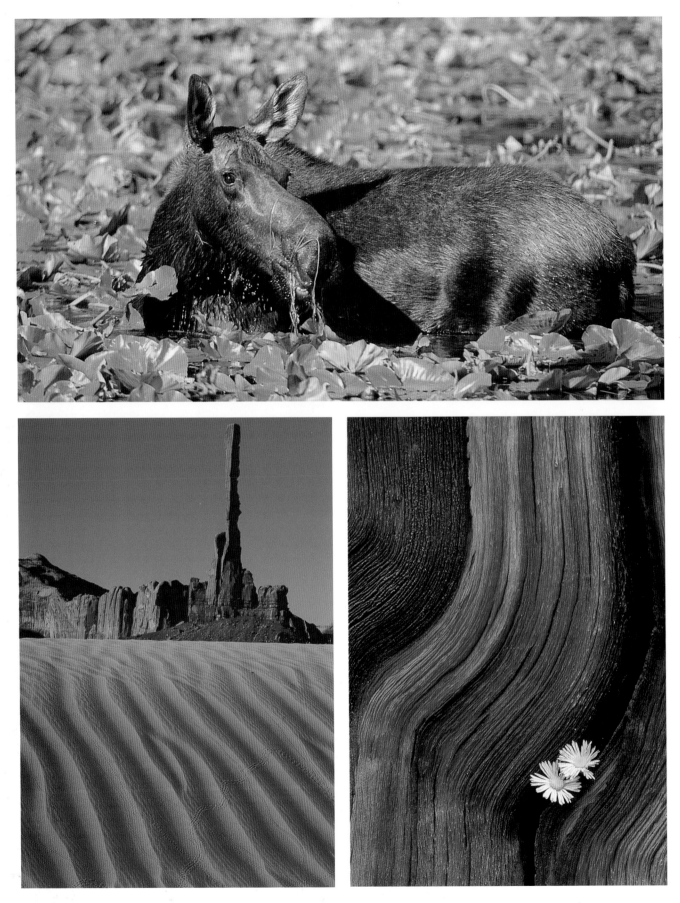

the butterfly with a Vivitar 283 flash mounted in a softbox and used a Nikon 8008, a 75–300mm Nikkor lens and a 5T close-up filter. For the backgrounds he used sheets of painted cardboard. As if on cue, after one hour, Russ's butterfly flew away.

Whether photographing butterflies in his backyard or a sweeping landscape in the Grand Tetons, Russ relies on relatively simple equipment. He always carries three filters: a polarizer, an enhancer, and a graduated neutral density filter. Russ uses these filters individually or sometimes in combination. The polarizer helps saturate colors and increases the intensity of the sky. This is particularly true when the subject is at a 90° angle to the sun. Polarizers also eliminate unwanted reflections. When shooting fall foliage, sunsets, and red-rock country, Russ prefers the enhancer. As the name suggests, this filter increases color vibrancy. The graduated neutral density filter harmonizes the tonal range of reflections and tames the contrast of sunrises and sunsets. For Russ, the proper use of a filter "can mean the difference between an ordinary image and an extraordinary one."

Russ Burden runs photo tours that are custom-tailored for large and small groups. Contact him at Russ Burden Photo Tours, 2323 East Chesapeake Lane, Highlands Ranch, CO 80126. He can be reached at 303-791-9997 or rburden@ecentral.com.

TOP RIGHT (ZION NATIONAL PARK):
A momentary break in the clouds on a stormy day in the red-rock country of the U.S. Southwest.
CENTER RIGHT (HAWK):
A red tailed hawk after it caught a prairie dog on a falconer's hunt.
BOTTOM RIGHT (ROSE):
A rose in the neighbor's garden photographed in the rain.
FACING PAGE TOP (MOOSE):
Moose resting in Grand Teton National Park.
FACING PAGE BOTTOM LEFT
(MONUMENT VALLEY):
Burden leads photo tours to Monument Valley, where there is never a shortage of subjects.
FACING PAGE BOTTOM RIGHT
(BARK STILL-LIFE):
The bark on a bristle cone pine tree on Mount Evans in Colorado. The black area was caused by a lightning strike. To get the deep saturation in the color of the wood, Burden sprayed the bark with water.

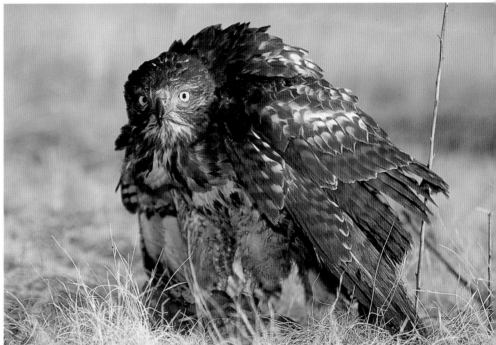

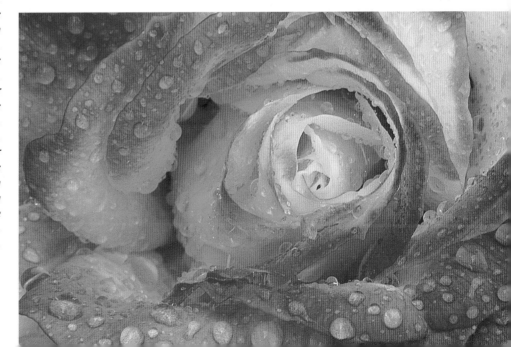

CHERYL CROSTON

It's no wonder why Cheryl Croston, a Seattle-based photographer, is drawn to the outdoors. "I was born amidst the picturesque Redwood forest," she explains. "My father, a retired heavy-weight boxer, worked in the logging industry so it seemed we were always moving from one small backwoods town to another following the work. The days of my childhood were filled with the outdoors and any creepy, crawly thing we could find under a rock or in a rotting log!"

Her childhood interest in insects continues in adult life. Cheryl's remarkable butterfly images convey a sense of delicate grace. Although her photographic pursuits are not limited to the world of butterflies, she makes several trips a year to the butterfly parks at the Seattle Science Center and at the Seattle Woodland Park Zoo. Both institutions provide excellent opportunities to observe and photograph butterflies in natural habitats.

During these outings Cheryl arrives before the crowds. She finds that the cooler, early morning hours tend to make the butterflies more docile and thus more cooperative. This allows her sufficient time to compose and expose her images.

Before entering a tropical butterfly exhibit Cheryl always puts her camera in a Ziploc® bag. As she explains, "This will cause the condensation to form on the bag and not your camera. After the camera and air are the same temperature, you can remove the camera and start shooting."

Cheryl has been busy creating a butterfly habitat of her own in her backyard. She has planted asters, cosmos, marigolds, dianthus, lavender and butterfly bush in her garden. All of these plants are known to attract butterflies. Cheryl's work supports Robert Frost's notion that butterflies "are flowers that fly and all but sing!" The idea that the butterfly is an extension of the flower's beauty is one of Cheryl's dominant themes.

Cheryl Croston's exquisite handmade photography cards can be found in specialty stores in the Northwest states, or ordered via her website at www.therainbowrealm.com. Cheryl can also be reached via e-mail at Photogra4@aol.com.

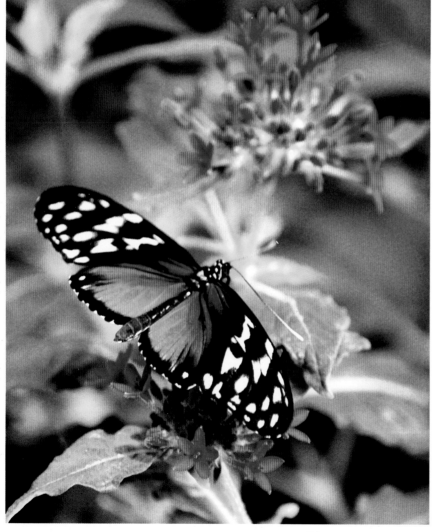

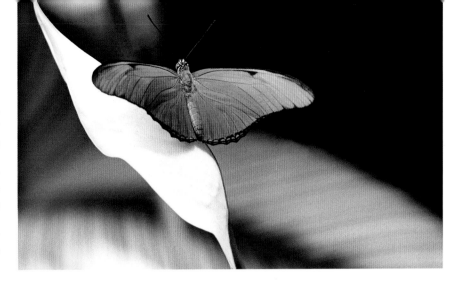

RIGHT ("JULIA" BUTTERFLY):
When photographing in "butterfly parks"
Cheryl Croston looks for landing spots
that are as elegant as the subject.
BELOW (GIANT SWALLOWTAIL):
Croston always keeps a camera
nearby when she gardens, in case
a good subject arrives.
FACING PAGE (BUTTERFLY):
Found at the Seattle Science Center's
year-round exhibit.

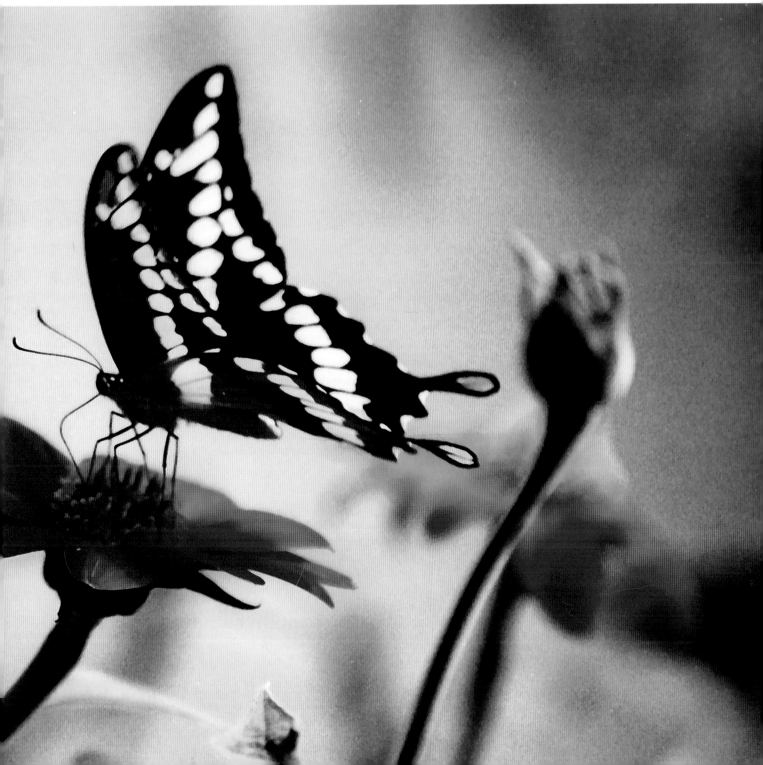

ROGER ERITJA _____

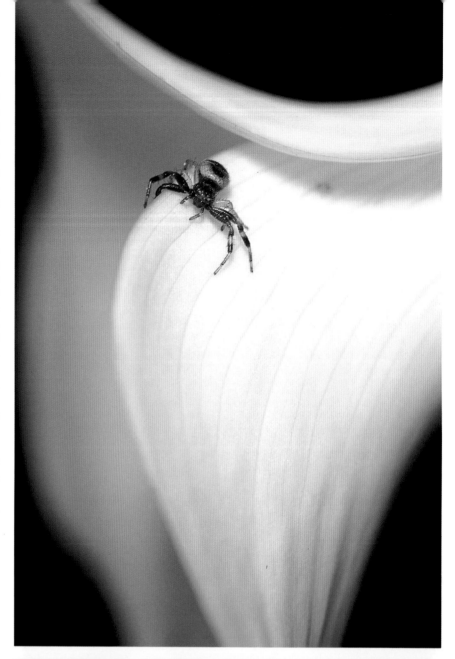

Roger Eritja is a nature photographer who specializes in insect close-ups. Born in Barcelona, Roger received a degree in biology at Barcelona University. Specializing in Entomology, He went on to earn a PhD in mosquito genetics and ecology, so it's not surprising that his interest in photography developed in tandem with his academic interests.

Shooting insects in their natural environment requires special equipment and a trained eye. Roger rarely uses ambient light alone. Instead, he photographs with two flashes mounted on a bracket. The flashes allow Roger to shoot with the high magnification ratios and fast exposures necessary to capture tiny, fast-moving insects. Instead of using a tripod, Roger prefers a monopod. The portability of his monopod and of his flash bracket allows him to successfully stalk his subjects.

While some insect photographers shoot dead, frozen or anesthetized specimens, Roger insists on photographing living creatures in their own habitat. He adamantly opposes any artificial methods to prevent his subjects from moving or escaping.

"I know my work is really quite different compared to most wildlife photographers," acknowledges Roger. Nonetheless, he asks "Would someone accept a photographer anaesthetizing, say, a great purple heron in a studio in order to photograph it more easily?" Instead of using anesthesia or freezing techniques, he recommends lots of patience and perseverance. He often returns to photo-

TOP RIGHT (CRAB SPIDER):
Crab spiders usually do not have webs because they hide inside flowers, where they are a major threat to pollinating insects. This one was having a walk outside its dining room. Nikon F4s, Micro-Nikkor 105/2.8 AFD, extension tube, and two flashes on bracket.
BOTTOM RIGHT (CRICKET):
This friendly Tettigonidae Optopteran was found in the Pyrenees. It sang the entire time Eritja shot it with a Nikon F4, Micro-Nikkor 105mm f/2.8 AFD lens, a flash and Fujichrome Velvia. The reproduction ratio on the slide was about half lifesize.

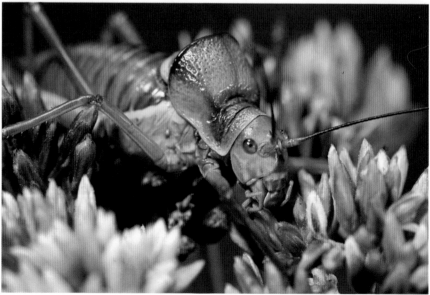

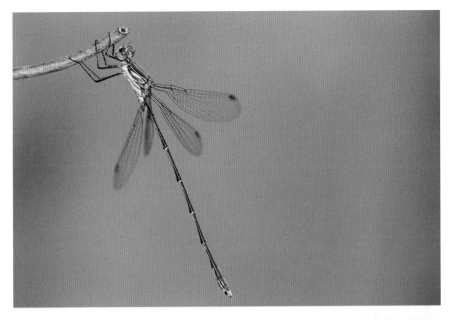

graph a specimen over several days, and might shoot multiple rolls of film.

Again, like wildlife photography, knowing your subjects' habitat and behavior will help you get great insect images—because you'll know where and when to find your subjects.

Roger's web site is www.eritja.com, and he can also be contacted by e-mail at roger@eritja.com.

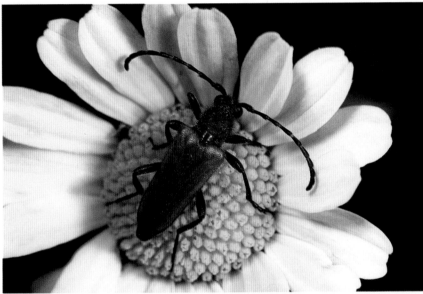

TOP LEFT (DAMSELFLY):
Damselflies are easy to shoot because they love to come back to their fixed stalking points. Nikon F4s, Micro-Nikkor 200/4 AIS, fill flash, Fujichrome Provia 100F.

CENTER LEFT (BEETLE):
Found in the Pyrenees mountains. Nikon F4s, Micro-Nikkor 105/2.8 AFD, extension tube, two flashes on bracket, Fujichrome Velvia.

BOTTOM LEFT (PENTATOMID):
This thistle flower gave Eritja an entire afternoon of activity, as he shot this pentatomid, two species of ants and an Italian cricket. He photographed this pentatomid with two flashes on a bracket.

BELOW (MATING COUPLE):
A pair of mating Coccinellid Coleopterans. Nikon F90x, Micro-Nikkor 105/2.8 AFD, extension tube, two flashes on bracket, Fujichrome Velvia.

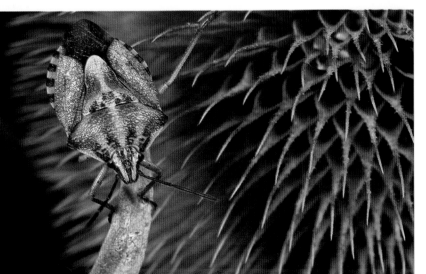

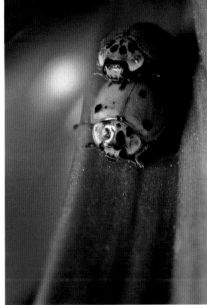

Adam Gibbs is a fine art landscape, nature and garden photographer in Vancouver, British Columbia. In college he studied the ins and outs of running a successful business and shot a few rolls of film along the way. Before long, he embarked on a career in photography.

Currently, Adam works with a 4x5 view camera for all his landscape work, and a 35mm camera for macro and garden photography. The 4x5 large format view camera tends to be quite heavy, requires more time to set up, and the film is considerably more expensive. Nonetheless, Adam readily admits, "The larger format is unparalleled in controlling depth of field, and the images actually sing to me."

One image that unquestionably "sings" is the abstract rendition of the maple on page 37. To create this image Adam exposed two images on one sheet of 4x5 film. The first image focused on the trunk, and he stopped the aperture down accordingly. For the second image he used a wide aperture setting and a deliberately blurry focus, producing an almost ethereal effect.

Adam's photographs have been featured in numerous Canadian and U.S. publications, as well as *Audubon* and *Inner Reflections* calendars. He has won many awards including *Photo Life's* grand prize, and he was twice recognized with BBC's annual Wildlife Photographer of the Year Award. He is an accomplished instructor and offers exceptional nature workshops. Contact Adam Gibbs at adsgibbs@telus.net, via his web site at www3.telus.net/agibbsphoto, or by phone at 604-520-0263.

BOTTOM LEFT (ZION NATIONAL PARK):
The narrows of the Virgin River in Zion National Park, Utah.
BELOW (TATOOSH RANGE):
Wildflowers in Paradise Meadow, Mt. Rainier National Park.
BOTTOM (WEB WITH ASTOR):
Gibbs placed an astor behind this dew-covered web in his backyard.
FACING PAGE TOP LEFT (MAPLE):
This image was created with a double exposure (see text).
FACING PAGE TOP RIGHT (PRIMULA):
The skeleton of a magnolia leaf in front of primula.
FACING PAGE BOTTOM (MAPLES):
Vine Maples at dusk, just a few feet from the freeway.

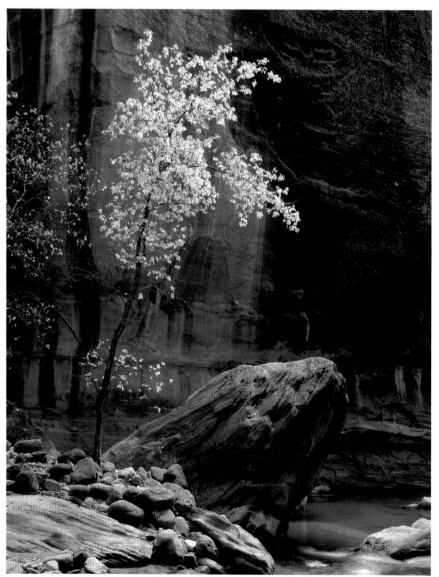

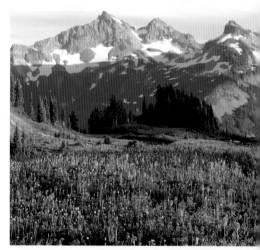

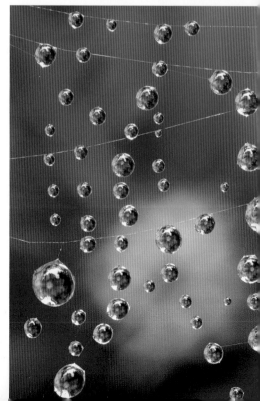

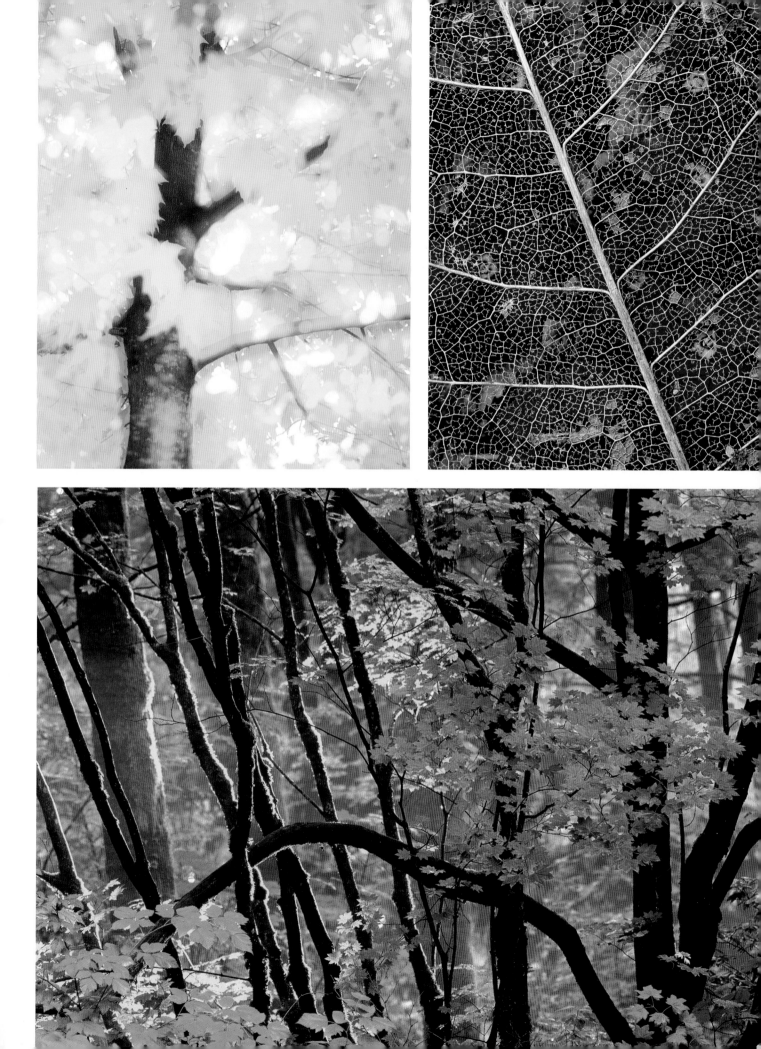

Mundy Hackett is known for his intimate wildlife portraiture and his evocative landscapes. With a sophisticated eye for abstract forms and subtle colors, Mundy's nature photography has a transcendent quality. His wildlife photographs are particularly interesting because of their ability to tell a story. Mundy's background as a wildlife biologist helps him be "at the right place at the right time." He understands his subjects and knows how they interact with one another and their environment. Mundy credits a combination of expert knowledge, detailed planning and the occasional "lucky break" for some of his most memorable photographs. He also recognizes the importance of developing one's craft with lots of hard work and practice. To this end, Mundy has been known to enlist the assistance of his two cats, Ben and Louise, to help him perfect his stalking, panning, and shooting skills.

These skills paid off during a June trip to Alaska's Katmai National Park. Mundy had hoped to catch the annual salmon run at Brook Falls. He mounted his camera on a tripod near the falls and waited. Over the course of several days Mundy watched a brown bear make several fishing trips to the falls. Unfortunately for this young, albeit large bear, the wily salmon proved too elusive. This didn't stop the bear from persevering, and indeed the bear's techniques improved over time. Mundy's photograph of the bear staring at the pool below successfully captures the intensity and determination of this novice fisherman.

Mundy Hackett has an upcoming DVD entitled *Natural Splendor* (Alpha DVD International), which features his images set to music. Contact Mundy by e-mail at Info@naturaldevelopments.com. You can also see more of his images on his website at www.naturaldevelopments.com, or at www.NaturePhotos OnLine.com.

BELOW (YELLING PIKA):
This small rodent was photographed in the wild in the San Juan Mountains of Colorado.
BOTTOM (BROWN BEAR):
A grizzly bear fishing at Brooks Falls in Katmai National Park, Alaska.

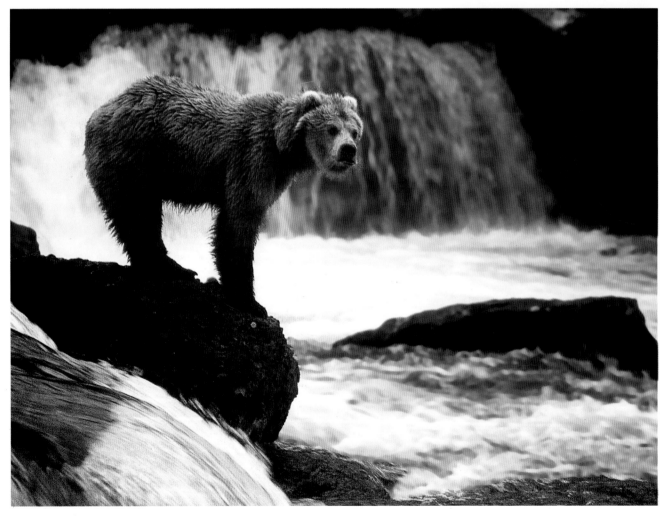

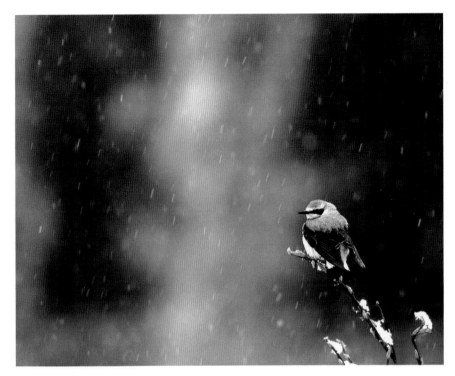

LEFT (NORTHERN WHEATEAR):
Bird in a June snowstorm in Alaska.
BELOW (PINK PAINTBRUSH):
Photographed in the San Juan Mountains of Colorado.
BOTTOM (COLUMBINES):
A field of columbines in Pingree Park, Colorado.

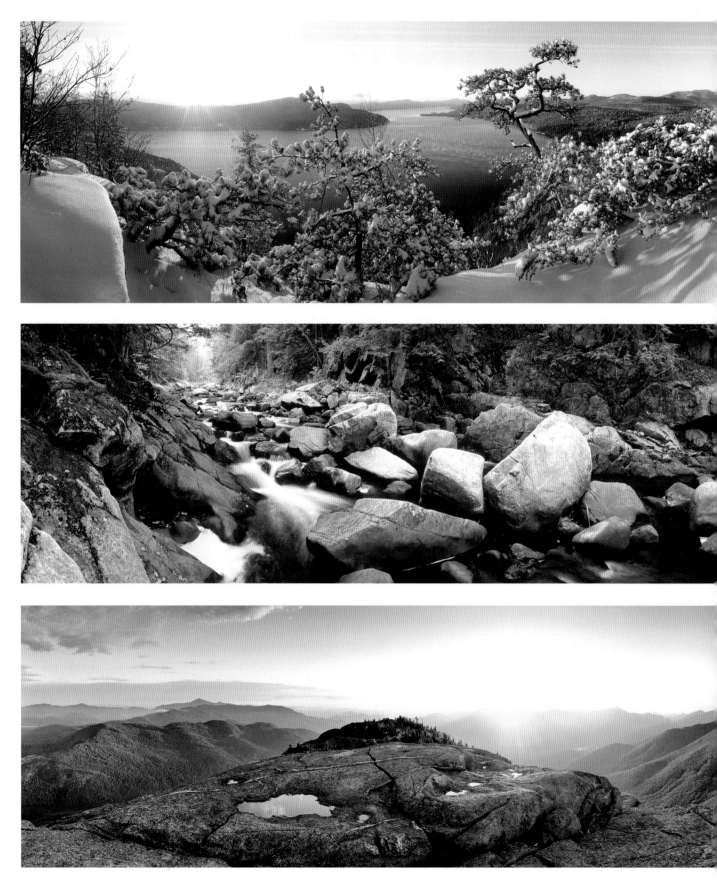

Since moving to the region in 1973, Carl Heilman II has set the standard for documenting the rugged beauty of the Adirondacks. His latest book, *Adirondacks: Views of an American Wilderness*, features dramatic panoramas as well as crisp 35mm images. Carl's work brilliantly captures the unique essence of the Adirondack Park.

Over the years Carl has experimented with several different types of panoramic cameras. Today he uses the state-of-the-art Roundshot Super 35, which is a computerized camera with a 360-degree rotating head that allows you to photograph any preprogrammed view, including full circle panoramic views.

Carl has hiked up Cascade Mountain during every season of the year, but it was June when he found the spectacular image shown below. To ensure that he doesn't miss any opportunities, Carl is particularly attentive to the weather reports when heading out.

With blue skies and mid-level clouds in the next morning's forecast, Carl packed up his equipment, drove to the trailhead, then climbed the 2½ miles to the summit. He arrived in time to shoot the evening light and await the first light of dawn.

Carl began shooting panoramas before sunrise and continued shooting into the morning. The spectacular image on this spread is a cropped version of the full 360-degree view.

"I always hold my breath until I get the final film back," reflects Carl. "There are so many details when working with the panoramic camera that I often question whether I remembered to do everything right," he says.

Obviously, Carl did "do everything just right" that day. The film turned out beautifully and the resulting image reinforces Carl's reputation as the preeminent panoramic photographer of the Adirondack mountains.

To learn more about Carl and his photography, visit www.carlheilman.com. This web site provides an overview of Carl's work and his equipment. The site also gives a detailed schedule for upcoming workshops. You can also e-mail Carl at photos@carlheilman.com.

LEFT (RED EFT IN FALL FOLIAGE):
Heilman photographed a
red eft and fall colors with a wide-angle
lens on a "normal" 35mm SLR camera.
BELOW (ADIRONDACKS):
Dawn over the Adirondack High
Peaks from Cascade Mountain. Originally
360-degree view (cropped here).
FACING PAGE TOP (LAKE GEORGE):
A 230-degree view of Lake George,
New York, from Rogers Rock in January.
FACING PAGE CENTER (SACANDAGA RIVER):
A 230-degree view of the East
Branch of the Sacandaga River,
New York, in October.

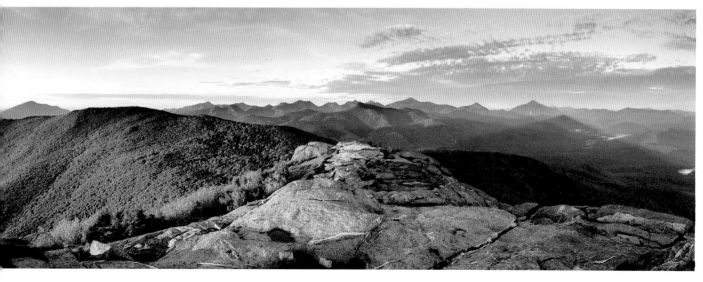

JOHN ISAAC

As the former Chief of the United Nations' Photography Department, John Isaac has traveled to more than 100 countries, documenting the UN's efforts to promote peace, stability and humanitarian interests. His poignant pictures have inspired member states and individuals alike to contribute resources to help end world suffering.

In his retirement, John has found new joy in photographing the world around him, and has a renewed commitment to living life to its fullest. John's personal credo is best summed up in a translation of his favorite Sanskrit poem: "Yesterday was a dream. Tomorrow only a vision. But today well-lived makes every yesterday a dream of happiness and every tomorrow a vision of hope. Look well therefore to this day."

John's interest in Sanskrit is but one manifestation of the bond he has with his native India. Although John immigrated to the United States in 1968, he has returned to India many times. Among his credits is a stunning book about the Indian district of Coorg, titled *The Land of the Kodavas*.

John has also photographed the Indian tiger population extensively, often from atop an elephant's back. "The tigers ignore the elephants, allowing us to approach them quite closely," explains John.

Elephants can be able photo assistants too. John recalls one of his early elephant expeditions, "I was so excited when I saw my first tiger that I fumbled while changing lenses, and it toppled to the ground. No worries

*BELOW (**TIGER SWIMMING**):*
A tiger in a swamp in India.
*LEFT (**EXTINCT KINGFISHER**):*
A captive Micronesian bird,
believed to be extinct in the wild
(eradicated by a non-native snake).
*FACING PAGE TOP LEFT (**MACAW**):*
A macaw in flight in Costa Rica.
FACING PAGE TOP RIGHT
*(**BUTTERFLY IN NEW YORK CITY**):*
A butterfly's momentary stop
on a sunflower in New York City.

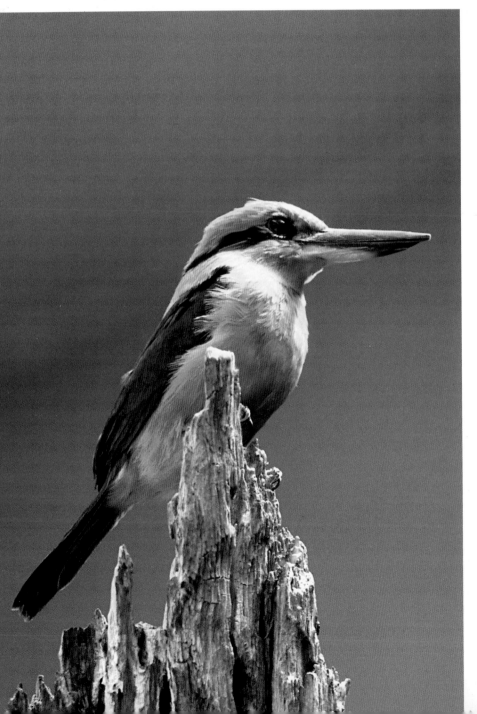

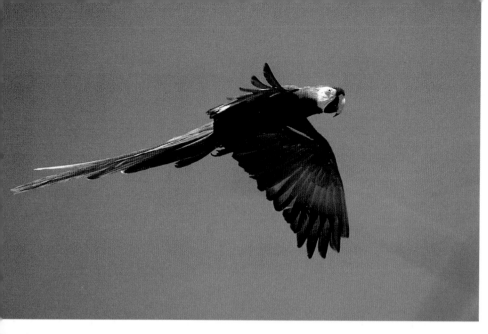
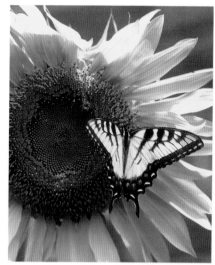
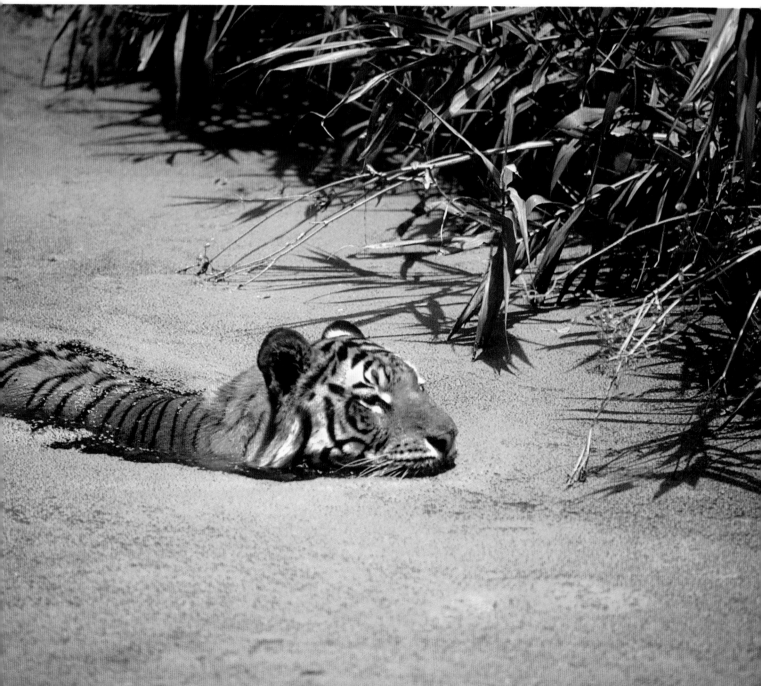

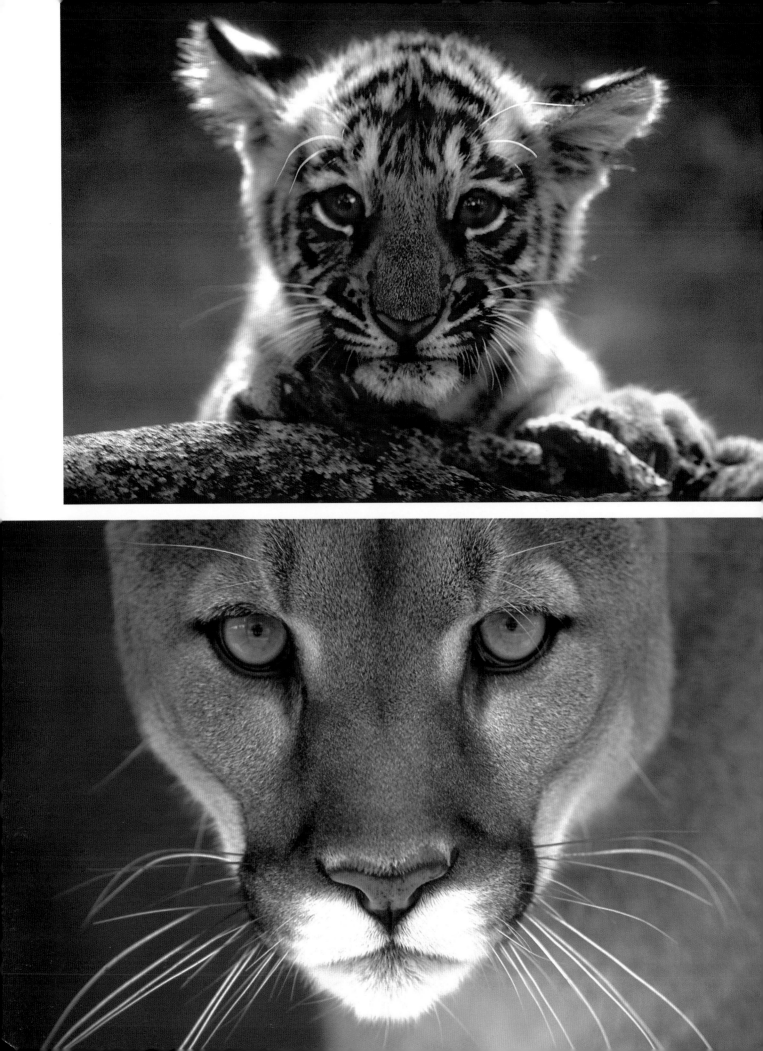

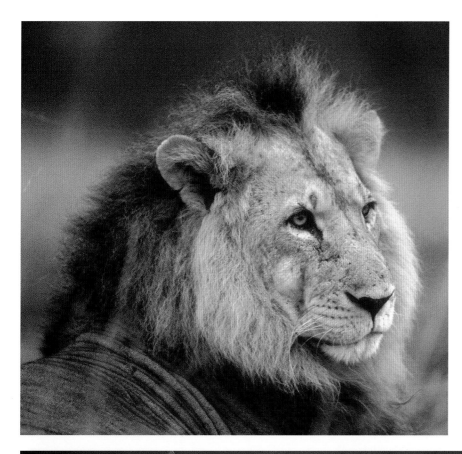

though. A quick command from the elephant's handler (perched behind his ears) and a thick trunk gingerly grasped and returned the lens to me!"

Visit www.johnisaac.com to learn more about John and his photography. In addition to his wildlife shots, you will find a variety of fascinating portraits and fine art images from the past decades. His web site leaves no doubt that John is one of the most traveled photographers in the industry.

LEFT (MALE LION):
A majestic male lion photographed in Kenya with a 300mm lens.
BELOW (LEOPARD RESTING):
John Isaac photographed this leopard as it catnapped on a tree. He then enhanced the print with watercolor paints, scanned it and printed it.
FACING PAGE TOP (TIGER CUB):
A tiger cub in India inspects the photographer.
FACING PAGE BOTTOM (MOUNTAIN LION):
An intimate portrait of an American mountain lion.

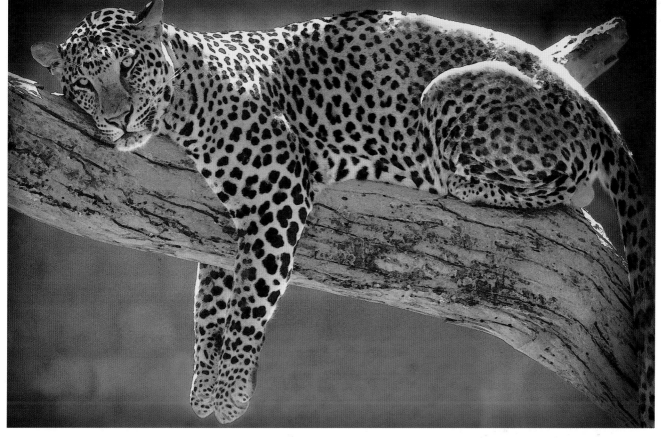

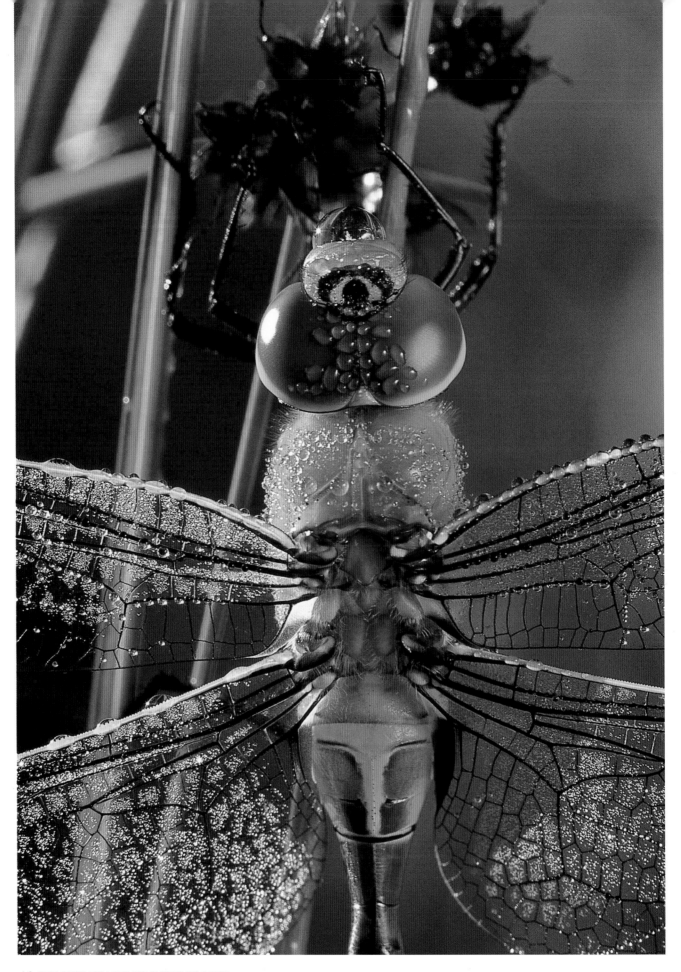

Ken Jacobsen, Jr. is an avid nature enthusiast and photographer. His work has been published in *Nature Photographer*, *Michigan Natural Resources*, and *Birder's World*. Currently, Ken serves on the Board of Directors for the Michigan Audubon Society. The darner green dragonfly on page 46 provides a good example of Ken's photographic versatility. He shot this image shortly after dawn, moving quickly to get it on film before the morning dew evaporated completely. Ken used a gold reflector to produce warm light that he ably directed to fill in the shadows. The shot is taken with a macro lens on a tripod at very close range. The narrow angle of view and close focusing capabilities of the 180mm lens heightens the dramatic effect and limits any background clutter.

Early morning seems to be a lucky time for him, because the waterfall at top right was also shot shortly after dawn. Ken and his wife Stephanie were on their way home from a trip to Michigan's Upper Peninsula when the early morning fog inspired them to take an unplanned side trip to Wagner Falls. Ken thought that the falls might provide the perfect backdrop to convey on film the beauty of the morning light. Indeed, Ken's ability to capture the diffuse rays gave his image an almost magical quality. "I'm glad I made the effort and rearranged my plans, because this is my favorite image from the entire trip," states Ken.

Ken and Stephanie are the creators of www.NaturePhotosOnline.com, a searchable database that sells nature photography prints and donates 5% to environmental non-profit organizations. You can contact them at P.O. Box 84, Milford, MI 48381, or via e-mail at Jacobsen@NaturePhotosOnline.com.

TOP RIGHT (WAGNER FALLS):
Early morning fog gives this waterfall in Michigan's Upper Peninsula a magical quality.
BOTTOM RIGHT (CARDINAL IN SNOW):
Cardinals are normally very active, but this one was a patient subject as he tried to conserve energy on a winter day.
FACING PAGE (DRAGONFLY):
A gold reflector was used to warm the early morning light and fill the shadows on this insect.

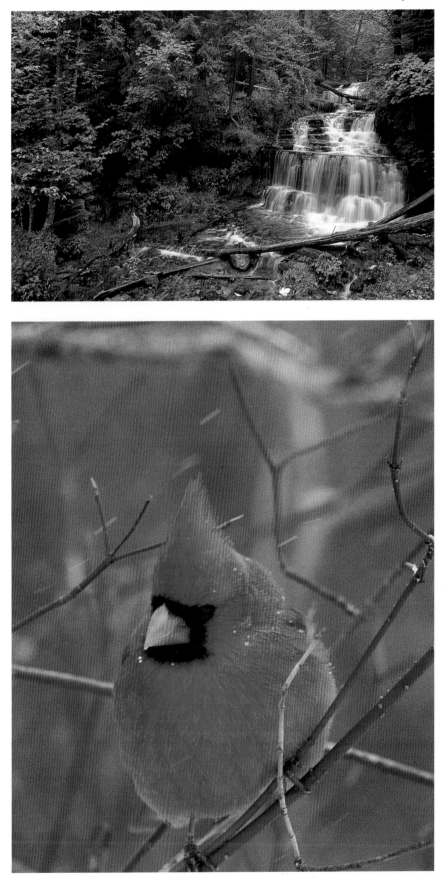

Inge Johnsson relishes being outside with Mother Nature. He concentrates his photographic efforts on landscapes and close-ups, and has also been known to train his lens on wildlife when the opportunity presents itself.

Originally from Sweden, Inge and his wife visited the United States frequently. In 1993 they decided to establish their new home in Texas. Inge has a great fondness for his adopted state and appreciates its varied natural beauty. He has also traveled extensively throughout the other states on the lookout for nature's creative designs.

Each May in Southern Arizona white flowers set the majestic Saguaro cacti ablaze. Inge relates that he was looking for a specimen with beautiful flowers and "human-like" form. He found that specimen in the cactus pictured on this page. Inge decided to use fill flash on the white flowers, thus eliminating any distracting shadows.

The cactus bloom shown on page 51 provides another interesting example of Inge's work with cactus flowers. This particular shot was taken in the Texas "Hill Country," an area that consists of wonderful rolling hills, rivers, and old small towns of mostly German-American origin. Each April this area becomes a mecca for nature photographers eager to photograph the abundant bluebonnets, Indian paintbrush and other colorful wildflowers.

After experimenting with various compositions containing both wildflowers and the claret cup cactus, Inge started to move in closer and closer. After all, it had been the cactus bloom that initially caught his eye. He shot this spectacular close-up with a Canon EF 80–200mm f/2.8L and a close-up filter.

Inge seeks unusual and unexpected perspectives from which he composes images with strong visual impact. His photograph of the Colorado River's Horseshoe Bend pictured on page 50 provides a good example of Inge's sophisticated eye. Shooting from high above on the canyon's rim, Inge conveys a dramatic scene. From this vantage point, the river appears to encircle an ancient colossus. Inge used a blue/yellow polarizing filter to enhance the richness of the blue water. This deep blue water helps express the landscape's mystical allure.

Inge offers another compelling image with his Sandstone Spiral (page 50). Taken somewhere near the Utah-Arizona border, Inge masterfully turns his lens on the sandstone striations in the Paria wilderness. Here the perspective is close and somewhat askew. We are both awed and dizzied by nature's creation. By extending the focal plane all the way from the foreground rock to the distant buttes, Inge achieves a brilliant irony. The entire image is in sharp focus, yet the vastness of the landscape defies our ability to fully comprehend the enormity of his subject. As with the previous photo, Inge enriches the natural colors with a polarizing filter. Inge's composition supports his contention that

BELOW (SAGUARO CACTI):
In May, the majestic Saguaro cacti of Southern Arizona bloom in a spectacular fashion. Johnsson used fill-flash to brighten the foreground flowers.
FACING PAGE (ANTELOPE CANYON):
Inge Johnsson tossed sand in the air before taking the picture to catch the beam of light and add some contrast between the light and the sandstone wall.

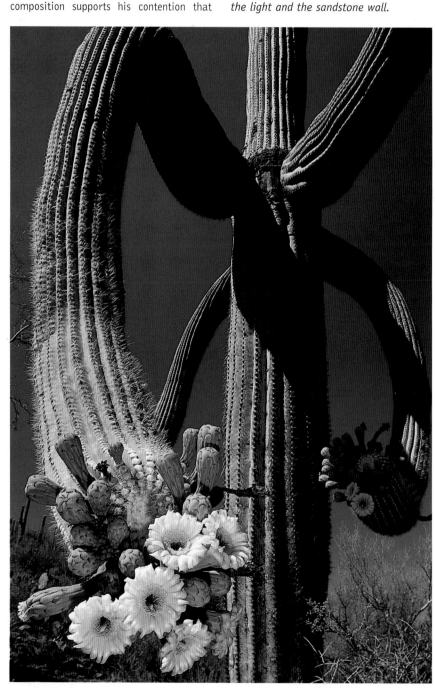

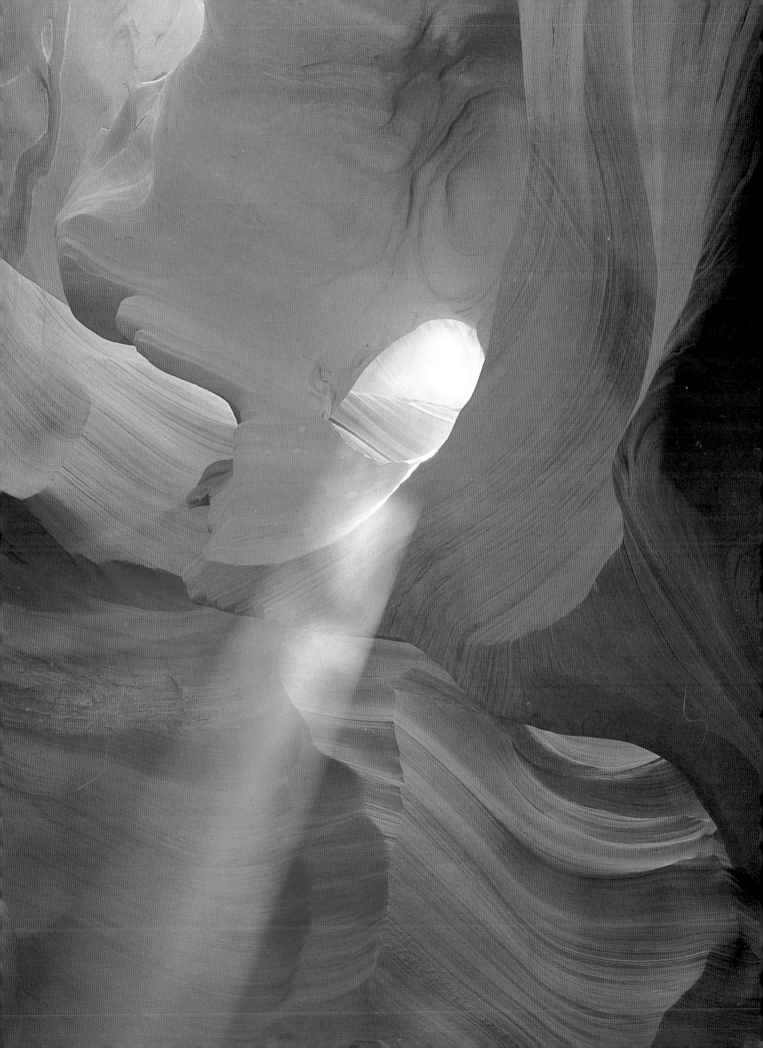

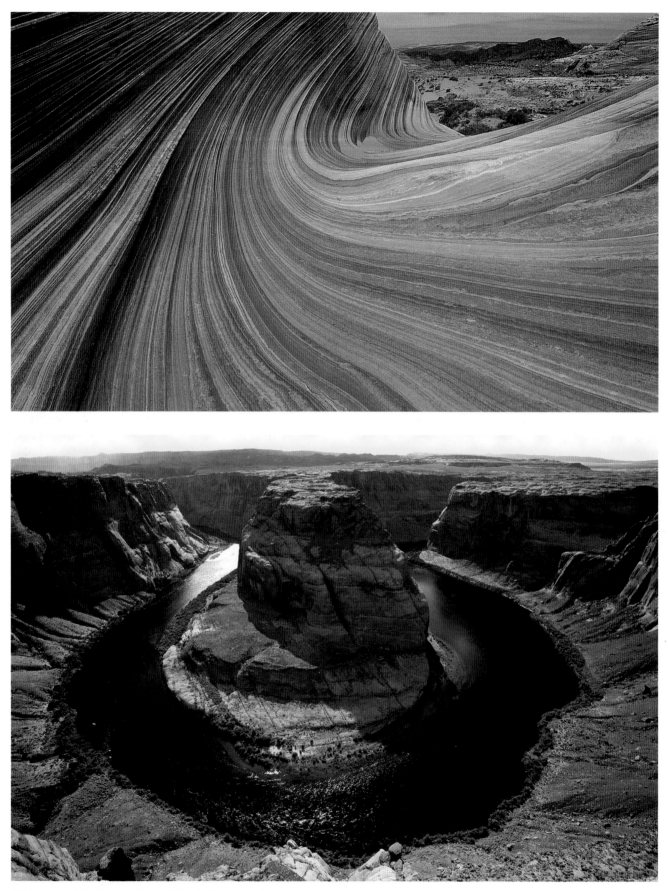

"these landscapes seem to resemble the surface of Mars rather than Earth."

Antelope Canyon outside Page, AZ, seen on page 49, is a breathtaking natural wonder. Formed by water and winds over thousands of years the rock formations present a beautiful and challenging subject. Working in the lower part of a slot canyon, Inge relied on the high summer sun to light the lower recesses of the canyon. He set up his camera on a tripod to capture a particular shaft of light shining through a keyhole opening in sandstone. Inge felt that the rock formation was visually strong, and he knew that cap-

turing the streaming light therein would make his photograph come alive. To enhance the contrast between the light beam and sandstone wall, Inge threw a handful of sand into the air. It took several trips between his camera and the beam of light to get just the right amount of dust into that perfect shaft of light.

Before leaving on a photography trip Inge obtains current solar, lunar and topographical data for his destination. He will know, for example, the times for sunrise and sunset, moonrise and moonset. He knows what moon phase we are in and he studies the topogra-

phy of the area. This information helps Inge plan his trip and allows him to make the best use of available light. Inge also browses books about the area to get himself acquainted with its key features. Arming yourself with information beforehand will allow you to spend your valuable time shooting instead of searching.

You can see more of Inge's images at his web site at http://ingejohnsson.com, or e-mail him at contact@ingejohnsson.com.

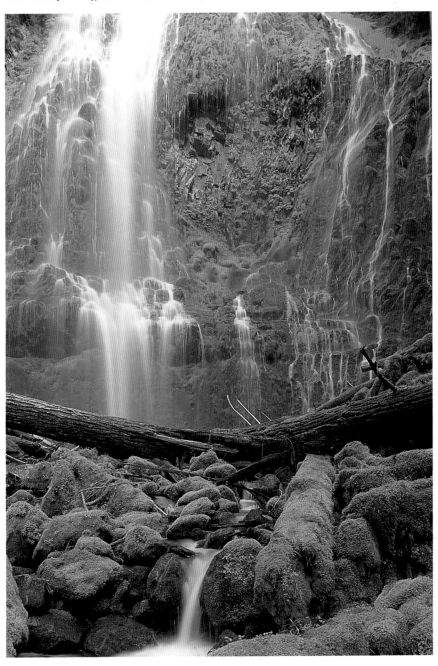

LEFT (LOWER PROXY FALLS):
Johnsson photographed this central Oregon waterfall at dusk on his way to the airport.
BELOW (CLARET CUP CACTI):
April in central Texas is an amazing time for wildflowers, as well as blooming claret cup cacti.
FACING PAGE TOP (PARIA SANDSTONE):
The sandstone striations near the Paria wilderness area on the Utah/ Arizona border. A polarizer helped to deepen the colors of both rocks and sky.
FACING PAGE BOTTOM
(HORSESHOE BEND, COLORADO RIVER):
A Cokin blue/yellow polarizer helped bring out the colors of the Colorado River.

BARBARA JORDAN

Today Barbara Jordan specializes in photographing the native species and landscapes of North America, but her interest in photography began in a very different way. She learned to photograph evidence for presentation in court for her career as a litigation expert.

After retiring, Barbara wanted to spend as much time outdoors as possible. She was able to combine her photographic skills and her love of nature and animals into her next career as a nature and wildlife photographer. When Barbara first began shooting outdoors she experimented with various types of photo equipment. She confesses that she wasted a lot of money on equipment she did not need. With experience she has become partial to Canon lenses, and her favorite is the EOS 70–200mm f/2.8 because it can be used hand-held with a 2X teleconverter for even more versatility.

Barbara likes to experiment with different techniques. To photograph the Hale-Bopp comet, pictured below, she set her camera on a tripod and lined up a shot in Death Valley National Park, near Stovepipe Wells. About two hours after sunset, she took multiple images with exposures as long as 60 seconds. She would end each exposure with a flash to gently light the foreground.

According to Barbara, "The most difficult part about getting this shot was standing in the pitch black of Death Valley, trying to ignore the fact that there were scorpions, rattle snakes and other dangerous wildlife in the area." At one point a coyote walked right by, but she was too busy shooting the comet to take a picture of him.

Barbara is able to create interesting lighting effects because she always brings along a flash and a flash bracket that raises it off the camera. She usually uses her flash to fill in shadows, highlight landscapes during evening shoots, or add catchlights in the eyes of her animal subjects.

As with Barbara's career in the courtroom, her photographic work is fueled by a committed social conscience. She is a champion of the underdog and uses her photography to assist the endangered. The response Barbara received to a photograph she took of an ill-fated bear in Alaska convinced Barbara of the power of photography as a medium to effect change.

"I now photograph with an emphasis on the environment and endangered species," explains Barbara. Through her images Barbara would like to educate children about the environment, and develop their interest in the animals and their habitat needs. She hopes that her photography will have an effect on others, helping them to be touched by the beauty of nature.

Barbara's gallery is located at 501 Maple Lane, Sugarloaf, CA. Her web site is www.barbarajordan.com.

BELOW (YOSEMITE NATIONAL PARK):
Jordan photographed a mist shrouded meadow not far from the main lodge in Yosemite.
BOTTOM (HALE-BOPP COMET):
The landscape near Stovepipe Wells in Death Valley National Park frames this famous comet.
FACING PAGE (CAPTIVE BOBCAT):
This adult bobcat was photographed in a controlled setting near Glacier National Park.

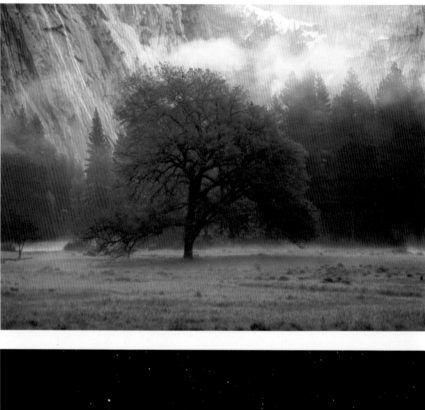

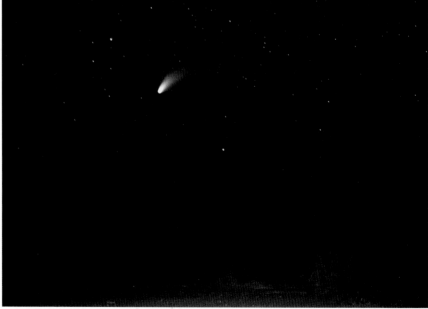

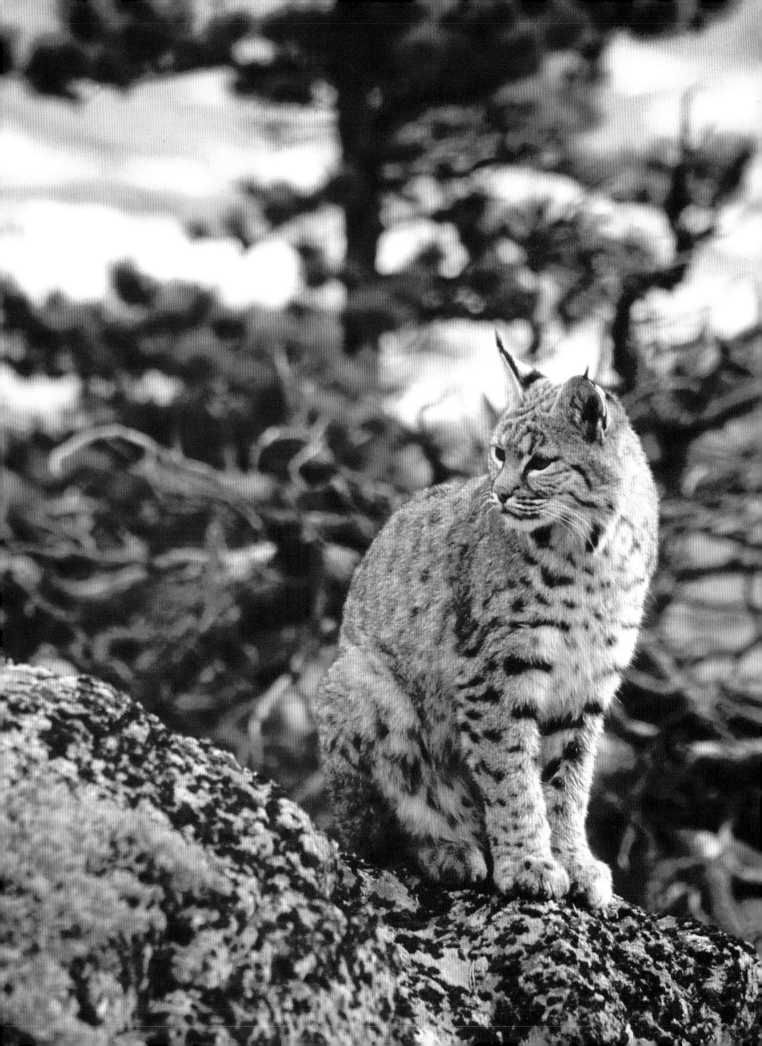

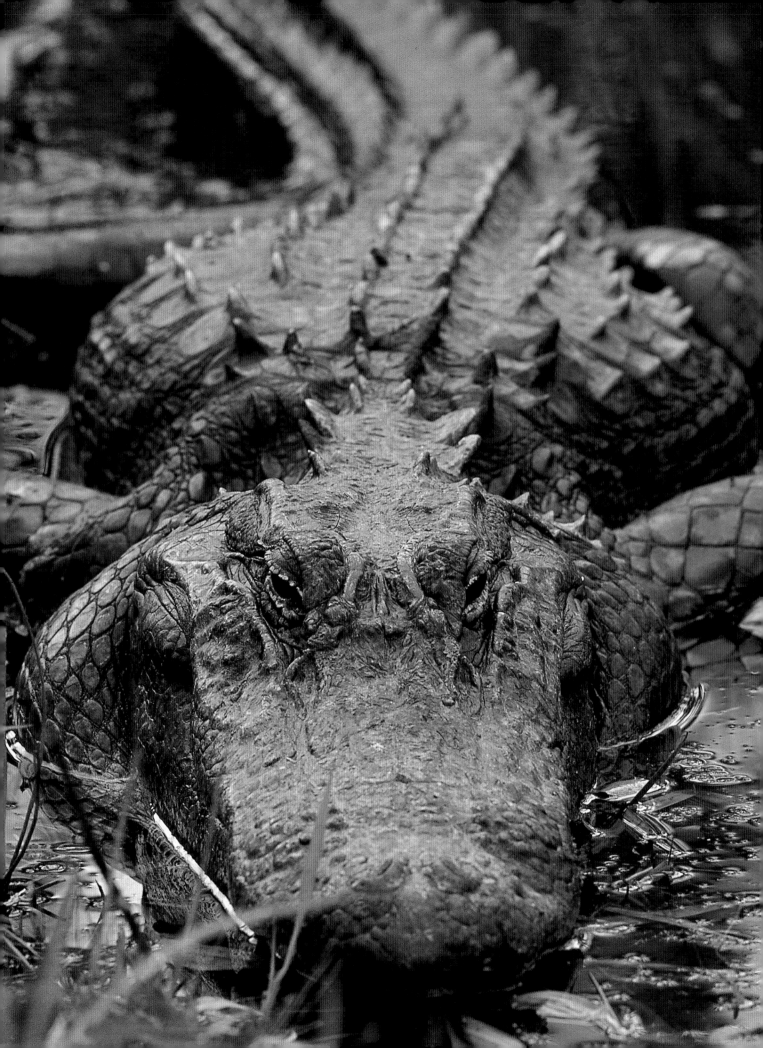

Byron Jorjorian has been capturing the natural world on film for over 25 years. With over 100,000 images in his files, his pictures have appeared on greeting cards, calendars, CD-ROMs, magazines, posters and just about every imaginable medium.

Byron teaches more than 20 workshops each year on a variety of photo related topics. His most popular workshop is entitled "Marketing Your Images: Step by Step Plan for Building Your Own Successful Stock Photography Business." This class explains marketing and organizational strategies for building a successful part-time or full-time stock photography business.

"I'm a business-minded nature photographer," explains Byron, "You can make a good living as a nature photographer if you approach it as a business." He markets his work through heavy Internet promotions, as well as postcard and brochure mailings. He targets current and potential customers alike. Byron carefully analyzes market data to understand what sells and what doesn't. He then adjusts his marketing efforts accordingly. "The tough balance," he says, "is that even though your goal is to make money, you must still be true to your art." Part of being true, in Byron's mind, is to maintain an experimental mindset.

Byron advises each student to "keep growing as a photographer. When you create a really terrific picture, it's tempting to keep repeating it and using the same approach over and over again. Yes, you should add that technique or concept into your repertoire. But in order to be successful over a long term, you must keep evolving, exploring and creating."

He has found that a big stumbling block with novice nature photographers is the temptation to have too much or too many subjects in the picture. To resist this temptation he encourages photographers to con-

BOTTOM LEFT (BUTTERFLY):
Jorjorian was photographing a cosmos flower with an out-of-focus "halo" reflection as the background, when a skipper butterfly landed on it. He captured it with a Canon EOS 1v HS camera and a 180mm macro f/5.6 lens.

BOTTOM RIGHT (PURPLE CROCUS):
Jorjorian spent forty minutes lying on the ground with his Gitzo tripod flattened out at its lowest position while he lined up the film plane with the yellow stamen. He then stopped his 100mm macro lens down to f/11 and shot the image at one second on Fuji Velvia film.

FACING PAGE (ALLIGATOR):
Byron Jorjorian photographed this alligator with a 100–400mm zoom lens set at about 250mm.

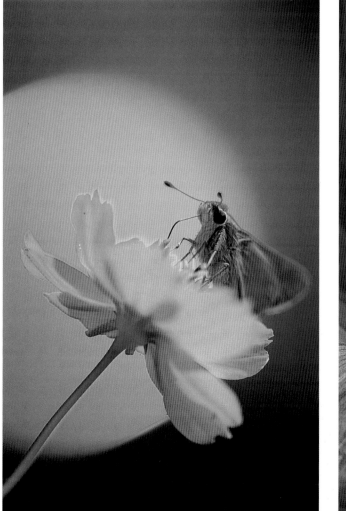

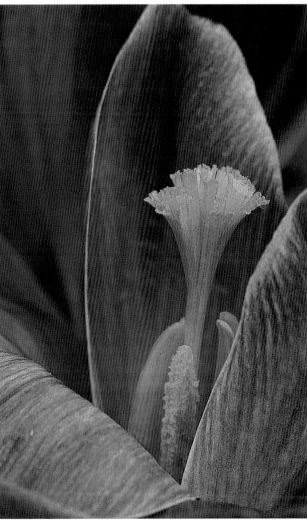

RIGHT (MUSTARD FLOWER):
Jorjorian used a plastic painter's cloth to soften the midday sun on this mustard flower in Cedar Barrens, Tennessee. Then he draped a black cloth behind it to create a dramatic, undistracting dark background. He shot the image with a 100mm macro lens at life-size (1:1) with a tripod-mounted camera. His exposure was f/16 at $\frac{1}{30}$-second with Fuji Velvia film.

BELOW (DEATH VALLEY):
The repeating shapes of the sand dunes and mountains of Death Valley National Park, California were captured with a 200mm lens. This long telephoto lens setting helped to compress the foreground and background together. The exposure was f/8 at $\frac{1}{250}$-second on Fuji Velvia film, with a tripod.

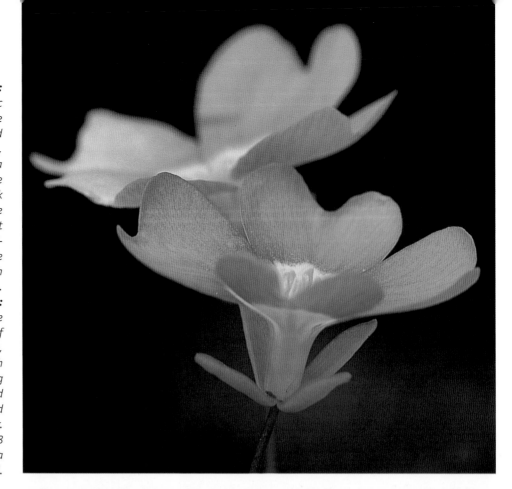

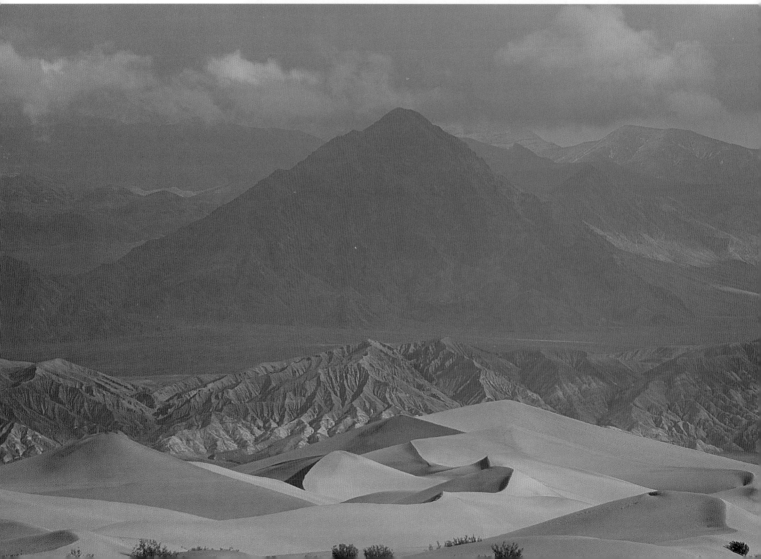

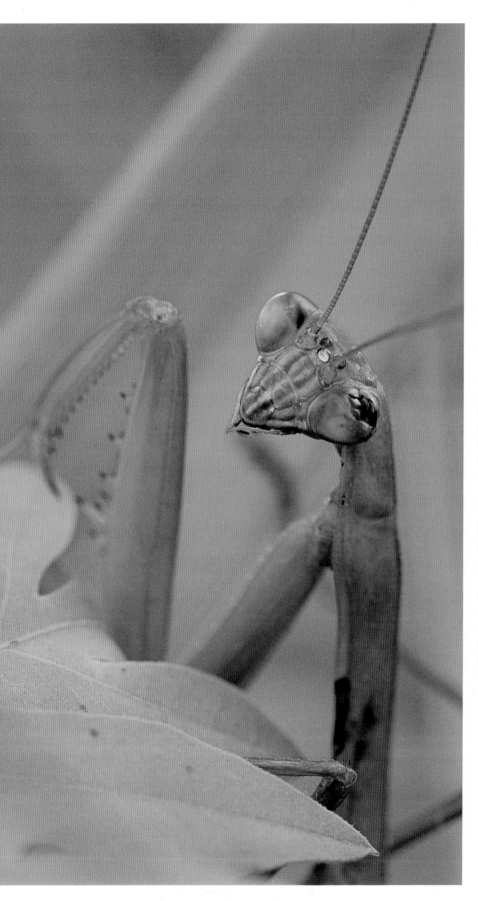

sciously identify the subject of the intended photograph before looking through the viewfinder. He then suggests that photographers question themselves at every step, asking whether this or that element really needs to be in the picture. "If you keep at it, you'll be able to visually isolate the subject and create a much stronger image."

Byron's images are certainly "strong." Part of his success can be attributed to Byron's technical mastery. He knows how to employ the tools of his craft. His standard camera bag always includes extension tubes for close-up work, teleconverters for wildlife, spare batteries, a reflector and a flash. His favorite lens is the Canon EOS 300mm f/2.8 Imaging Stabilizing (IS) lens. He likes the lens for its sharpness and advanced IS technology, which allows him to handhold it even when using a 1.4 teleconverter or extension tubes. For macro close-up work he prefers the Canon EOS 180mm.

Not all of Byron's equipment is high tech. For a reflector he uses a piece of painter's cloth that is so thick it almost stands up by itself. However, it can be folded down to a foot square and squashed in the bottom of the bag. A few small clamps and clothespins make it easy to hang and use either as a reflector or a sunblock.

He currently shoots film, and scans the film when he needs digital versions. "I'm not yet satisfied with digital imaging. The quality is not quite there yet, but I can't wait until it is because I'll switch over without missing a beat," explains Byron.

Byron truly believes that photographers can find very saleable images locally—no matter where in the United States they live. "All the kids in my neighborhood know that if they find a 'cool' insect or plant, they should come running to me," explains Byron. "The youngster who finds the subject

LEFT (PRAYING MANTIS):
All the neighborhood kids know that if they find anything "cool" they should "go get Mr. Jorjorian!" Usually they then gather their friends and all hang around to watch him use it. Byron used a 180mm macro lens to shoot this image, and tried to keep his camera parallel to the plane of the mantis' face to keep it all in focus.

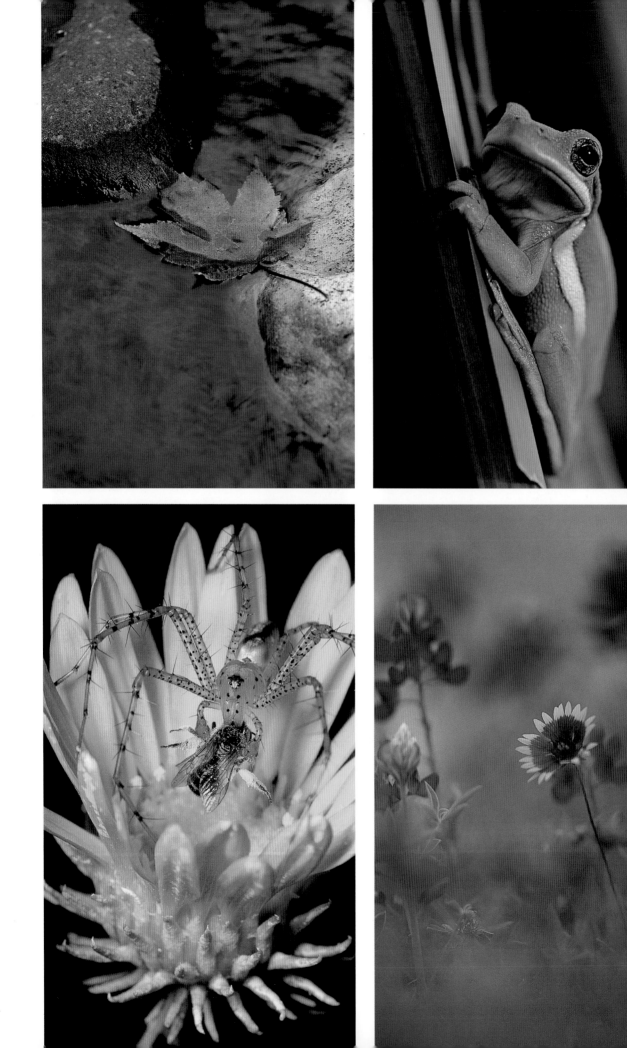

FACING PAGE TOP LEFT (MAPLE LEAF):
The sky reflecting its blue color in the water became the perfect backdrop for a red maple leaf. Jorjorian shot the scene in Great Smoky National Park with a 100mm macro lens, on Fuji Velvia film. He used a tripod and an exposure of f/8 at $\frac{1}{15}$-second.

FACING PAGE TOP RIGHT (TREE FROG):
This green tree frog is missing some of his yellow pigment, making him appear blue, which is even more rare than an albino. Jorjorian used a reflector to add a catchlight in the eye.

usually gathers up his friends, and they all watch me set up and shoot. It makes it a lot of fun for all of us, and it becomes quite an event."

The praying mantis on page 57 is an example of what can come out of these impromptu photo sessions with the neighborhood kids. He shot the insect with a 180mm macro lens at f/5.6 and a $\frac{1}{30}$-second on Fuji Velvia film (at $+\frac{1}{2}$ stop exposure compensation). He successfully lined up the tripod-mounted camera so the film plane was parallel to the praying mantis' face. This kept the eyes in sharp focus and gave the insect a somewhat "human" look.

Byron tells us that shooting a praying mantis can be as rewarding for him as photographing grizzlies in Denali, Alaska. "Wherever I am, I can always find something interesting to shoot."

To see more of Byron's work you can visit his web site at www.naturephotocentral.com. There, you can learn about his workshops, purchase fine art prints of his most popular images, or view over 5000 of his photographs online. Byron's photography is also available through Tony Stone Images and the Bruce Coleman Photo Library.

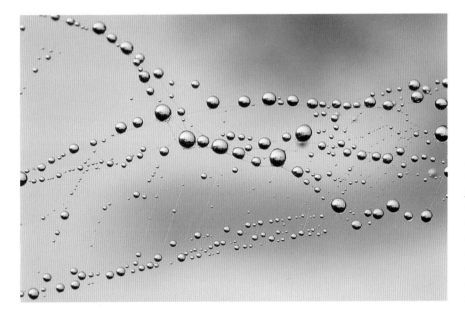

TOP LEFT (DEWDROPS):
Jorjorian often spends quite a bit of time exploring a subject, while looking for different angles to shoot from, and analyzing the lighting options. In this case, he lay down under the spiderweb and shot upwards, using the dark clouds at sunrise as the backdrop. The early morning sun added just a hint of gold to the web strands between the dew drops.

BOTTOM LEFT (DAISIES IN A FIELD):
This photo, taken in Cades Cove, Great Smoky Mountain National Park on a dew soaked cloudy morning, is one of Byron Jorjorian's bestselling images.

FACING PAGE BOTTOM LEFT (SPIDER):
Jorjorian had to act quickly to shoot this greenlynx spider as it captured a bee on a lance-leafed gumweed. He shot with a 100mm macro, and held his flash off-camera, along the front edge of the lens.

FACING PAGE BOTTOM RIGHT (FLOWERS):
While photographing a field of Texas blue bonnets, the photographer noticed a solo Indian blanket flower. He used a 300mm lens set at f/2.8 to take the exposure. The long telephoto, combined with the wide aperture, created selective focus and turned the background and foreground into a green and blue sea of out-of-focus blue bonnets.

WOLFGANG KAEHLER

Few people have traveled as extensively as Wolfgang Kaehler. He has photographed in more than 160 different countries and in every imaginable climate. From the frigid Arctic ice shelf to the searing desert sands of Arabia, Wolfgang has produced hundreds of thousands of nature and travel images.

He first gained notoriety in 1977 after publishing a series of penguin photos taken on an expedition to Antarctica. Over the years, Wolfgang has returned more than twenty times to document the magnificence of the frozen landscapes and its curious animals. The photographs of penguins shown below and on page 62 are but two examples from his extensive Antarctic collection.

Wolfgang's photographs have been credited for inspiring an entire industry. He has been at the forefront of the educational travel movement. Until relatively recently, booking tours to remote locations like the Amazon, Papua New Guinea, or the Galapagos Islands would have been all but impossible. Today, many adventure travel agencies sponsor such outings in response to a strong and ever-increasing public demand.

RIGHT (PENGUINS):
Emperor penguins on fast ice, Atka Iceport, Antarctica.
BELOW (GIANT TORTOISE):
Giant tortoise heading toward the ocean, Bird Island, Seychelles Islands.
FACING PAGE (GANNETS):
Gannets "fencing" (a greeting behavior), Bonaventure Island, Gaspe, Quebec, Canada.

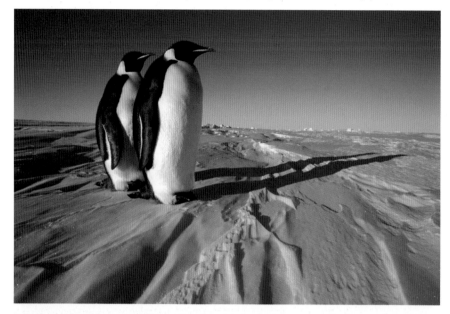

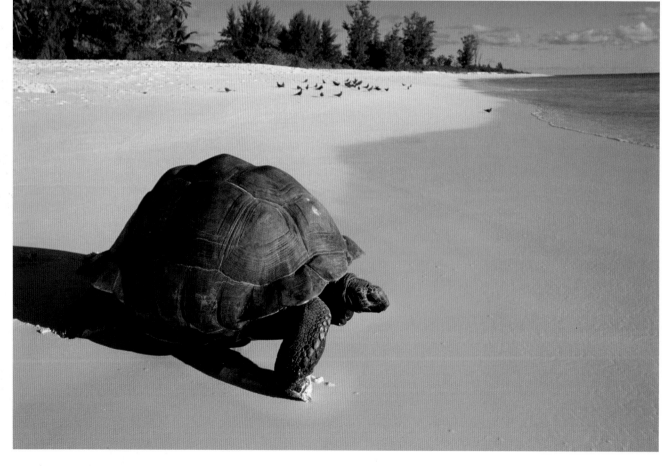

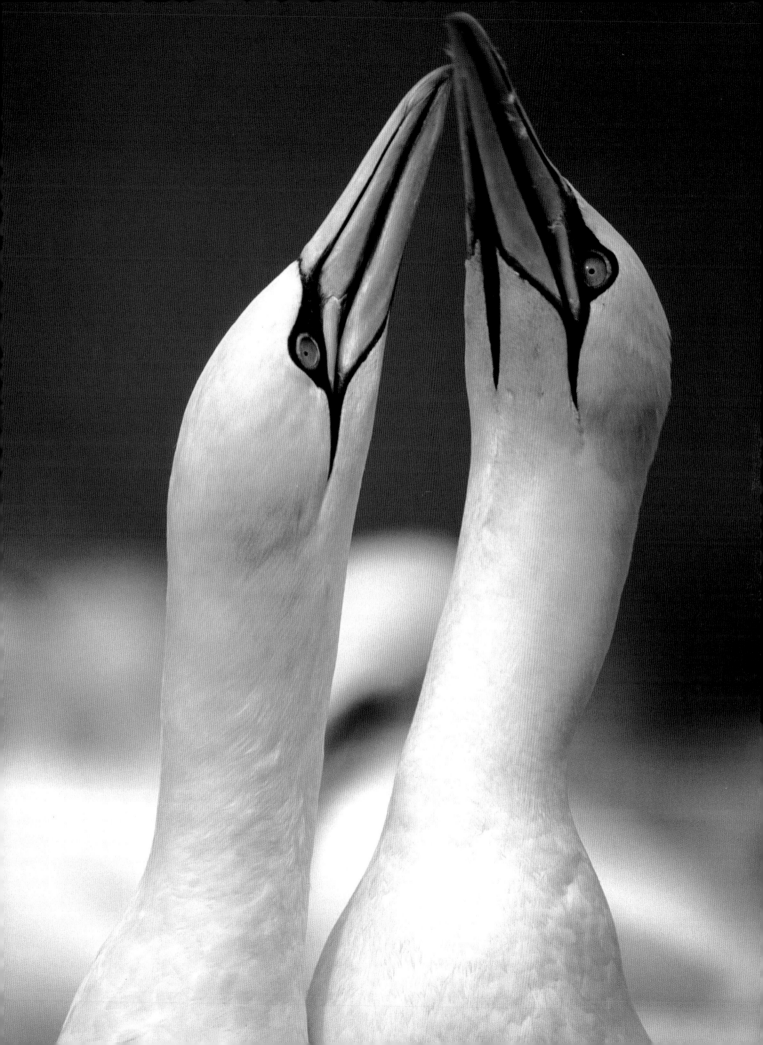

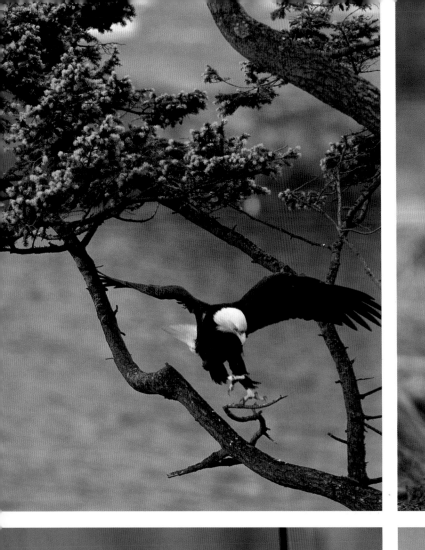
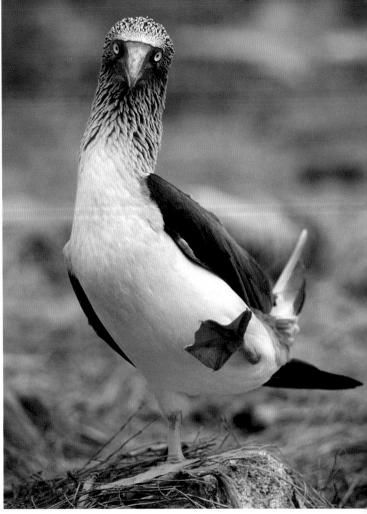
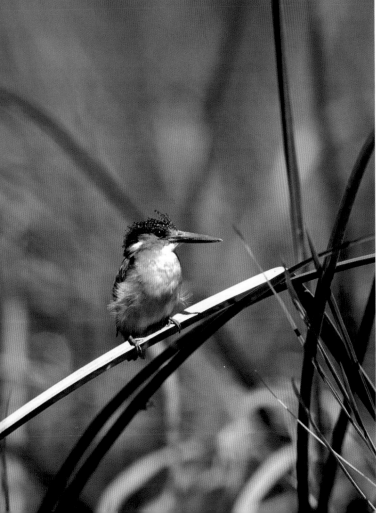
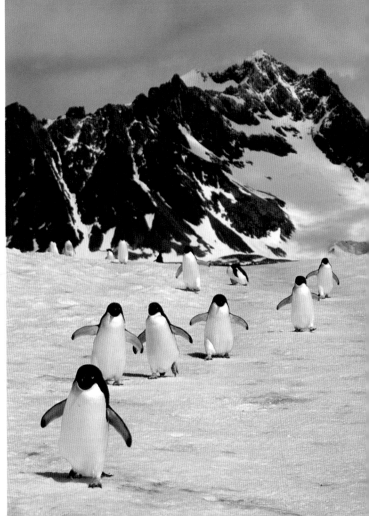

There is little doubt that this demand has been stimulated by the remarkable images of Wolfgang and his associates.

In addition to his in-depth coverage of wildlife and natural habitats, Wolfgang's portfolio includes native peoples, traditional lifestyles, ancient temples and archaeological sites around the world.

Wolfgang Kaehler studied photography and photo engineering in his native Germany before beginning his professional career. He prefers to shoot in the 35mm format. In fact, all of the images seen on these pages were shot with 35mm film. Wolfgang masterfully controls the various elements of composition. The full-page photo of the male chameleon (page 64) evinces Wolfgang's sophisticated eye. He juxtaposes the softness of the flowers with the rough reptilian hide. The pinks contrast with the greens and blues in a manner that mutually reinforces the vibrancy of each color. Wolfgang echoes the entire composition, albeit in muted form, with a background that he deliberately leaves out of

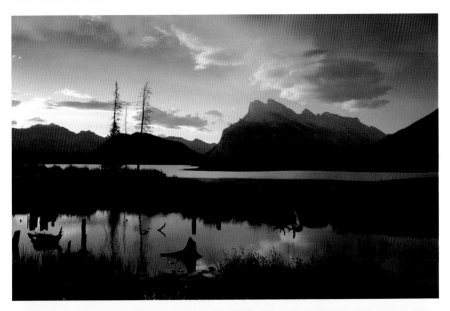

LEFT (VERMILION LAKES):
Sunrise on Vermilion Lakes and the Rocky Mountains, Banff National Park, Alberta, Canada.
BELOW (HUMMINGBIRD):
Tufted Coquette hummingbird on a flower in the Asa Wright Nature Center, Trinidad.
FACING PAGE (CLOCKWISE FROM UPPER LEFT):
Bald eagle in a tree, San Juan Island, Washington; blue-footed booby, Hill Island, Galapagos Islands, Ecuador; adelie penguins, South Orkney Island, Antarctica; and malachite kingfisher perched on reed, Jedibe Island, Okavango Delta, Botswana.

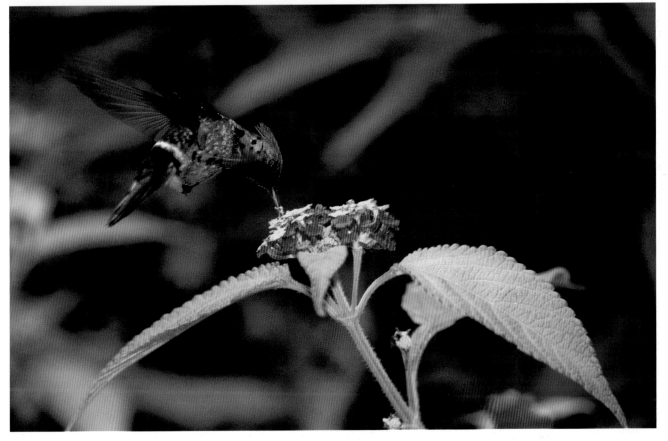

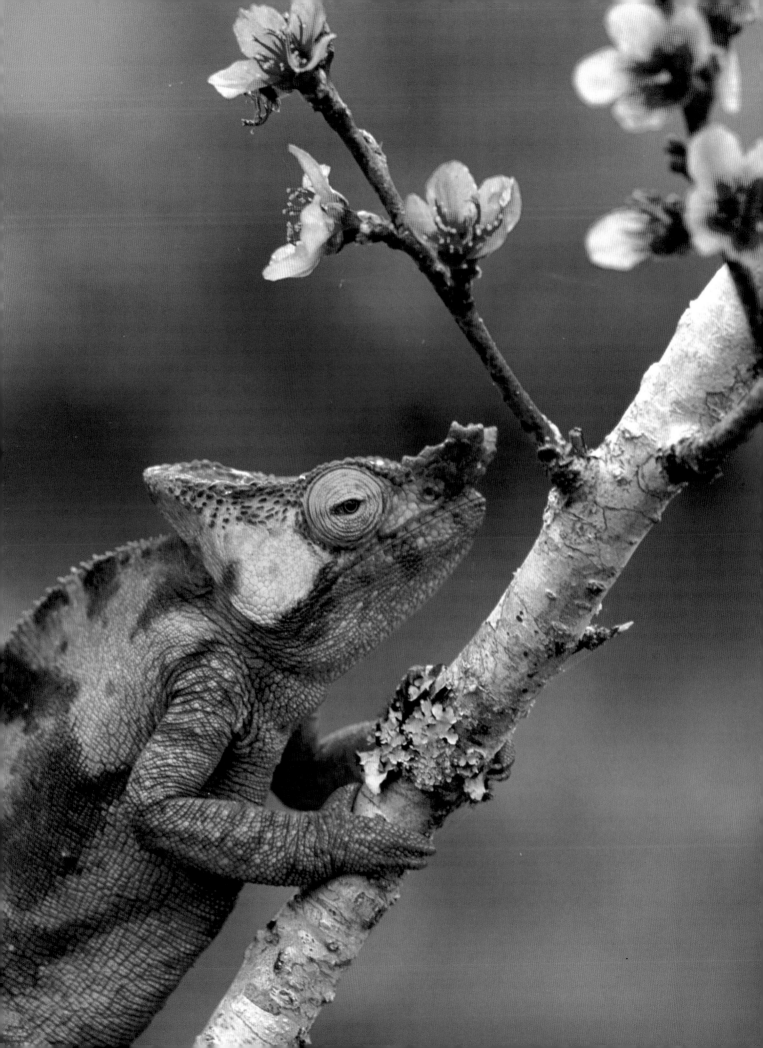

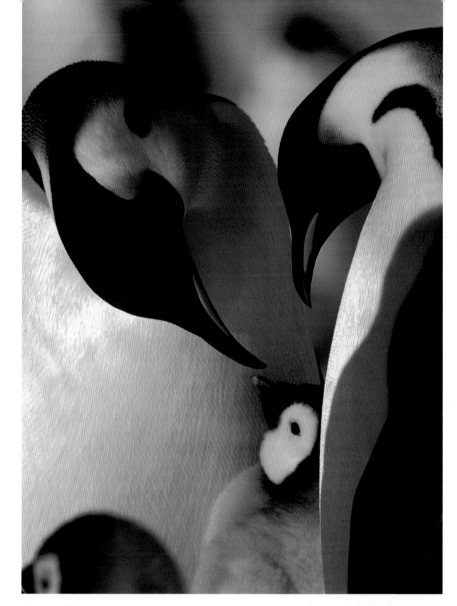

focus. The effect brings both a sense of harmony and integrity to the image.

Wolfgang is widely published and has been the recipient of numerous awards. He has been recognized as the BBC's "Wildlife Photographer of the Year" and has been selected by the National Geographic Society as one of its 100 top photographers. In addition to *National Geographic*, Wolfgang's credits include *Natural History, Smithsonian, Conde Nast Traveler* and *Audubon*, to name a few. You can view his work at www.wkaehlerphoto. com. There you will find thousands of images as well as postcards and calendars. You can also purchase his beautiful book entitled *Penguins*, which features more than seventy-five full color portraits. An additional resource for locating his images is the New York based stock agency AG Editions Inc. at www.AGPix.com. You can contact Wolfgang's office at 425-881-6581 or via e-mail at wkaehler@aol.com.

Left (Emperor Penguins):
Family of penguins, Atka Iceport, Antarctica.
Below (Tiger):
Captive tiger running in the snow.
Far Left (Chameleon):
Male chameleon in a tree with peach flowers, Mandraka, Madagascar.

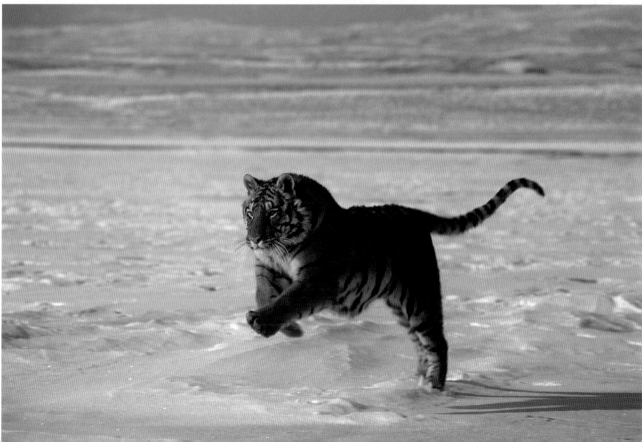

David Lawrence's first camera was a pinhole camera that he made in the seventh grade for a school science fair. By high school he was shooting with a 35mm camera, working as a photographer and editor of his high school yearbook. David's interest in photography continued in college and became his professional calling.

His first commercial work involved shooting and then marketing a series of photo decor prints and posters. He branched out into photographing so-called action sports like sailing, skydiving, and ultralight flying. His first big break came when the Kodak Pavilion at EPCOT Center showcased one of his sailing images. Soon he was covering professional sporting events, football games and car racing. David credits these early assignments for helping him become "an expert at handling long telephoto lenses and quick moving subjects."

For nearly two decades, David has traveled the world employing his considerable photographic skills for corporate clients. Much of David's work chronicles large transportation projects. Although he has mastered a variety of styles and has photographed many different subjects, he describes himself as one who "specializes in photographing landscapes—both natural and man-made." David applies similar techniques whether he is shooting mountain peaks or a major city airport. Wherever his assignments take David, he always makes time to photograph the region's natural attractions.

As a result, David has built a large collection of landscape and travel images. Two different stock agencies, Corbis in New York, and the Panoramic Images Agency in Chicago represent David's work. Together these agencies generate the majority of David's revenues by licensing the use of David's photographs to publishers, advertising agencies and magazines. Virtually everyday somebody, somewhere in the world, is publishing one of David's images.

David credits his continuous pursuit of knowledge as a key element to his success. You have "to know something about your subject" he explains. He holds a degree in biology and is constantly reading and learning new things about nature. He has studied weather patterns for years and intuitively knows where to find the optimal light. Being able to anticipate conditions allows David to be there when opportunities arise.

When he is there, David usually mounts his camera on a tripod because it helps with image sharpness and control. "I find that I pay more attention to details like straight horizon lines or unwanted items in the corner of an image when I use a tripod. I study an image more before I click the shutter." Tripods are absolutely essential when David works with a 6x17cm panoramic camera.

The 6x17cm is "manual everything"—no built-in light meters or autofocus. To successful shoot in this format David simultaneously concentrates on exposure, depth of field, and focus. He also controls the artistic elements through a deliberate approach to composition and camera angle. Since he normally uses slow film (ISO 50) and shoots at f/22 (or narrower), David must watch for unwanted motion in the frame. He avoids shooting when there are birds flying or tree branches moving in the foreground. The limitation of not being able to shoot moving objects is more than offset by the level of detail the 6x17cm panoramic offers.

Panoramic photographs offer different viewing options. You can look at details . . . or look at the whole scene. "When composing a panoramic, you need to visualize how the image might be used. Many times panoramics are printed as double-page spreads—so you don't want an important

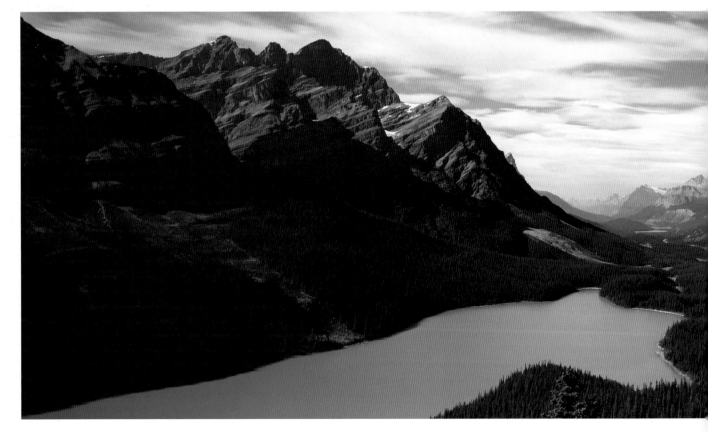

element falling in the center of the image where a fold is going to be. I also try to compose in layers, with something of interest in the foreground, middle ground and background. This gives it a sense of depth." The large panoramic shown below provides a good example of a beautifully "layered" composition.

David Lawrence can be reached through his web site at www.dlawrence.com, via e-mail at david@dlawrence.com, or by phone at 800-251-8419.

RIGHT (AUTUMN WATERFALL):
Raven Cliff Falls near Caesar's Head Mountain in South Carolina. Since there was little wind, Lawrence was able to use a slow sutter speed to blur the cascading water with a tripod-mounted camera.
BELOW (OLYMPIC NATIONAL PARK):
The Hoh Rainforest in Olympic National Park in Washington gets an average of 140 inches of rain per year.
BOTTOM (BANFF NATIONAL PARK):
The panoramic format is perfect for a sweeping view of Peyto Lake and the Mistaya Valley in Banff National Park, Alberta, Canada.

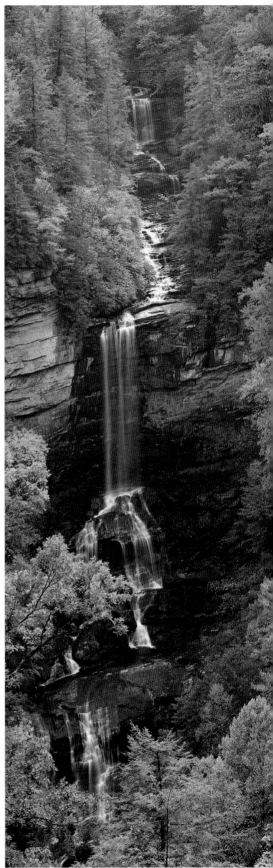

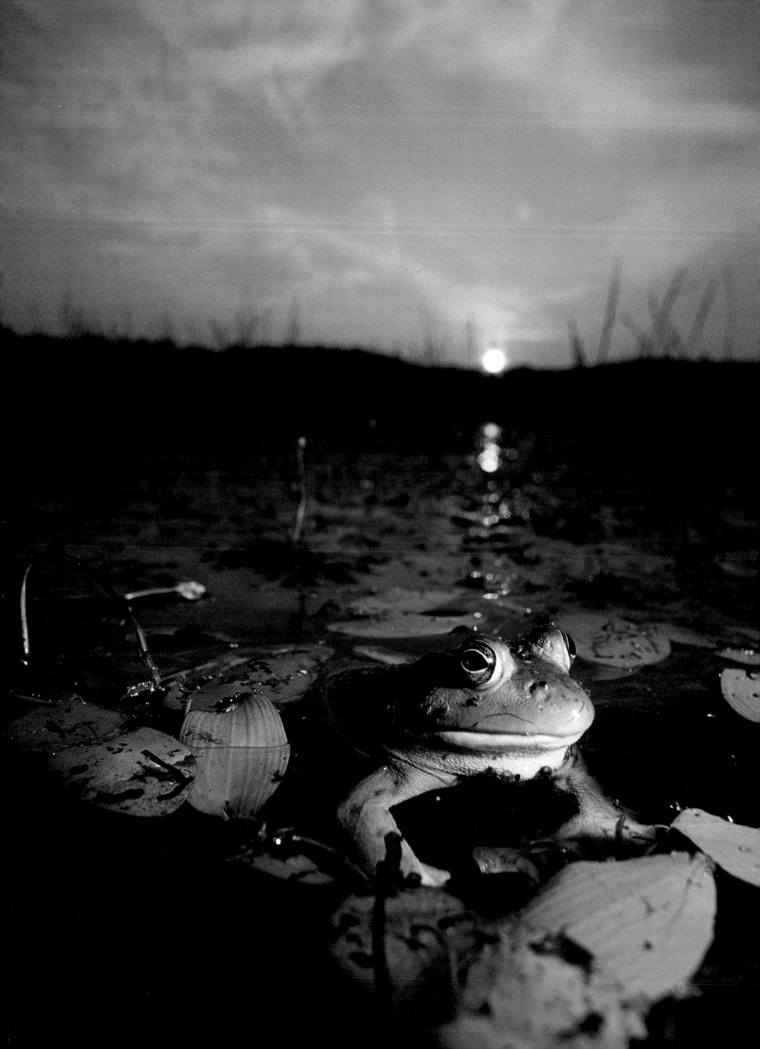

Daniel Minicucci offers three pieces of advice to novice photographers: "Shoot! Shoot! Shoot!" He encourages young photographers to establish their own criteria for success. This recipe has worked well for Daniel. Throughout his career Daniel has set a series of obtainable goals, each successive goal building upon the previous one. He recommends, "Once you become proficient with the technical side of photography you can devote 100 percent of your energy to the art of photography. Take time to master your equipment and technique at home so that when you go on that once-in-a-lifetime trip you will be successful."

In addition to technical proficiency, hard work plays a key role in developing one's portfolio. Daniel's determination to get a particular image of a bullfrog at sunset required him to spend a month of long, wet evenings wading in a cold marsh. He had to learn about the males' territorial outposts

NEAR RIGHT (LOOSESTRIFE):
Purple loosestrife, a beautiful but invasive species from Europe that has taken over many American wetland areas.
FAR RIGHT (LOTUS FLOWERS):
10-inch lotus flower blooms.
BELOW (MOOSE TRIO):
Moose in Baxter State Park in Millonocket, Maine in autumn.
FACING PAGE (BULL FROG AT SUNSET):
A bull frog photographed at a distance of four inches with a homemade outrigger device.

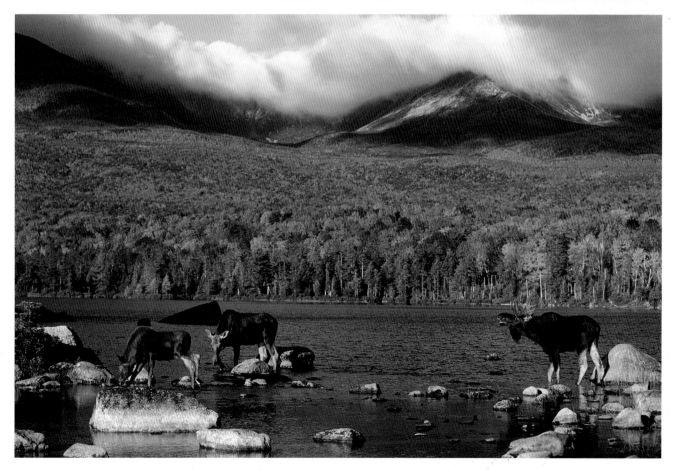

and then he began to condition the frogs to accept his presence. This proved to be somewhat tricky. Daniel had to build an outrigger device for his camera and 20mm wide-angle lens because the frogs simply would not allow him to get as close as he needed. The frogs did, however, become accustomed to the camera on the outrigger. In time, Daniel introduced the frogs to a fill flash. He then experimented with different exposure ratios and compositional arrangements. The result of his efforts can be seen on page 68.

Indeed, many of Daniel's images have required a great deal of preparation. Daniel spent several months building a floating blind designed especially for photographing wetland birds. He used this blind to photograph the heron on page 71. Carefully, he floated this craft into a small heron rookery. Apparently, he was sufficiently unobtrusive. The herons allowed him to shoot at water level, a mere fifteen feet away.

Getting close to his subjects is only half the battle. First you have to locate them. To help him find particular birds, Daniel turns to the Internet's Rare Bird Alert Network. These postings are an invaluable tool for pho-

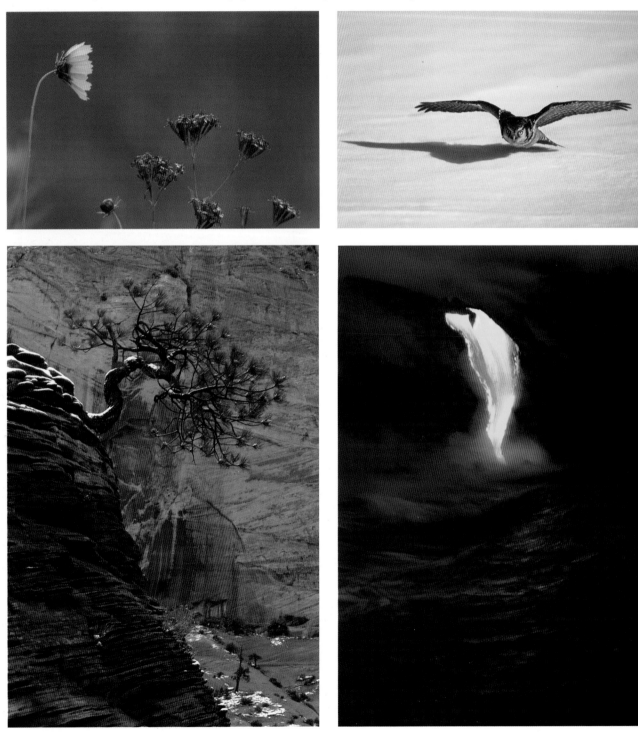

tographers trying to locate specific species. The image of the Northern hawk owl on the facing page was a direct result of an Internet search. "It took three years and lots of film to get this low angle shot," recalls Daniel. This owl had been drawn away from its perch by a strategically placed mouse carcass. The practice of feeding owls is controversial, yet most ornithologists will tell you that it does not harm the birds. Some liken the practice to feeding seed to songbirds.

Each year, Daniel Minicucci's work can be seen in numerous outdoor magazines and calendars. He lectures, teaches workshops and offers personal tutoring. Daniel also sells his beautiful fine art photography. He can be contacted at 413-786-7626 or via e-mail at dmphoto@attbi.com. His images can be viewed at www.naturaleditions.com.

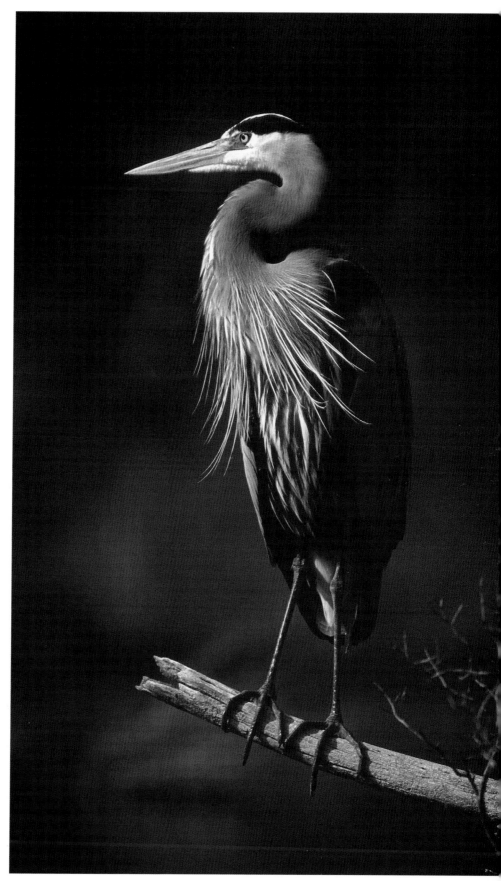

RIGHT (GREAT BLUE HERON):
Daniel Minicucci photographed this great blue heron from a homemade floating blind, which he maneuvered into a small local heron rookery for a water-level view. He was able to approach this heron within fifteen feet without disturbing it.
FACING PAGE TOP LEFT (COREOPSIS):
Lance-leaved coreopsis and silene, photographed on a roadside as Minicucci traveled to a commercial photography assignment.
FACING PAGE TOP RIGHT (HAWK OWL):
A Northern hawk owl in winter, photographed as it hunts field mice in the snow of Vermont.
FACING PAGE LOWER LEFT (PINION):
A piñon pine on a winter morning in Zion National Park, Utah.
FACING PAGE LOWER RIGHT (LAVA):
Lava flowing into the Pacific Ocean from the Kilauea Volcano in Volcano National Park, Hawaii. The temperature of the lava was over 2000 degrees Fahrenheit, making the ambient air temperature about 150 degrees at the 50-foot distance from which the image was taken.

Bruce Montagne believes that his best images come from shooting those subjects for which he has great passion. Bruce's work does not chase the whims of the marketplace. Instead, he follows his own path. "I let my eyes focus, my brain compose, but it is my heart which ultimately takes the picture," he explains. "Just as a writer uses a pen to write a story on paper, a photographer uses light to record a story on film. Nature is a world in which endless stories are told. Photography is a tool by which I can take this 'visual communication' to bring a richer appreciation of the natural world to others."

During his youth, Bruce spent virtually all of his free time in the forest around his home in southeastern Michigan. Looking back, he remembers thinking to himself "what a great thing it would be to be able to do this as a living." In high school Bruce developed an interest in photography. Although he didn't realize it at the time, photography would allow Bruce to realize his youthful fantasy of making a living in the woods. Bruce studied photography through his college years, and by his mid-twenties he had successfully combined his love of the outdoors with his interest in photography.

Over the years Bruce's photographs have been published in the most prestigious and influential nature publications in North America. His credits appear in *National Wildlife, Audubon, Sierra Club, World Wildlife Fund, Nature Conservancy, Voyageur Press, Willow Creek, Birder's World,* and *Smithsonian Nature Guide* books. When he is not working on an assignment, Bruce is busy photographing the Lake Superior region for an upcoming book entitled *Superior Secrets*.

Of all the beautiful places to visit in the region, Pukaskwa National Park in Ontario is Bruce's favorite. Wild and extremely rugged, the northern boreal forest blankets Pukaskwa's hilly terrain. The park provides sanctuary for a tremendous amount of wildlife. Wolves, moose, bears, and lynx are a common sight, and soaring eagles and other great birds fill the sky.

This is magnificent country, although the conditions can be rather harsh if you are unprepared. Bruce never goes into the wilderness ill-equipped. He buys the best outdoor clothing and camping gear that he can afford, knowing that without the proper gear a "photographic trip can turn into complete misery or even a dangerous situation." While he loads up on camping equipment, Bruce

BOTTOM LEFT (FROZEN LAKE):
A winter scene on Lake Superior in Sleeping Giant Provincial Park, Ontario, Canada.
BOTTOM RIGHT (BACKLIT TREE):
A backlit frosted spruce in Ontario's Lake Superior Provincial Park, Canada.

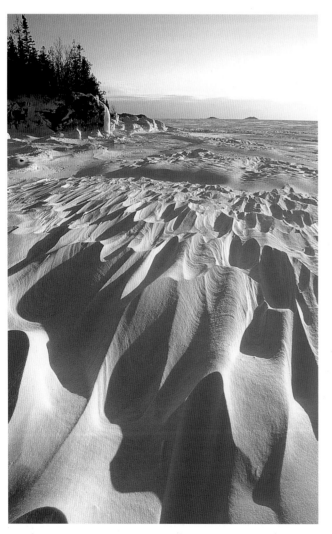

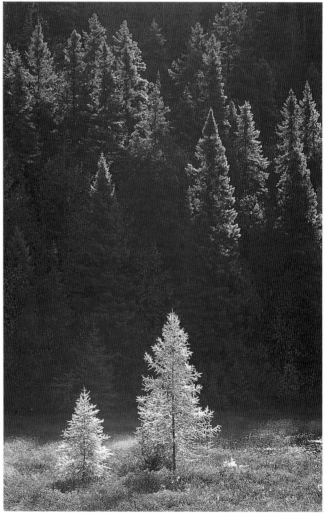

likes to keep his camera gear relatively simple. Bruce believes that the key to good nature photography lies not in the "latest and greatest" gadgetry, but rather in one's ability to concentrate on what is going on in front of the camera.

The photograph on the facing page demonstrates Bruce's eye for what is happening around him. He took this image in Ontario's Lake Superior Provincial Park where he had hoped to photograph a particular bull moose. Bruce set up before dawn next to a pond the moose was known to frequent. As Bruce waited, the sun crested the ridge in the background and back-lit the frosted spruce trees.

As Bruce tells it, "Luckily I had this scene to shoot as that morning turned out to be 'mooseless.'" Had he been single-minded about his pursuit of the bull moose, he may well have missed this shot.

On another outing, this time in Waterton Lakes National Park in Alberta, Bruce awoke to discover the first snow of the season. He grabbed his camera and set out to find the mule deer bucks he had been photographing the previous week. His effort was rewarded when he came upon the buck pictured at right. The fresh and undisturbed snow atop the antlers suggests that the deer had been sleeping. He seems slightly confused. Perhaps he had been oblivious to the falling snow. This remarkable image provides an excellent example of how Bruce's photographs often tell a story.

To see more of Bruce's work check out his web site at www.whisperwood.net. You can e-mail him at bruce@whisperwood.net.

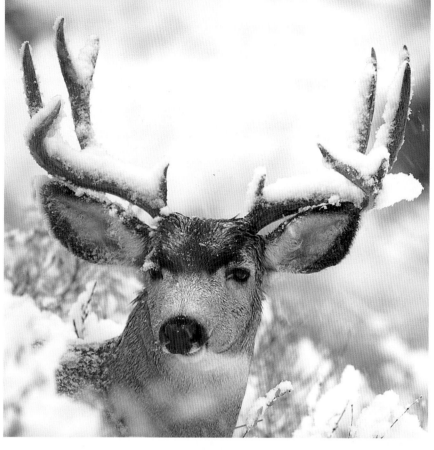

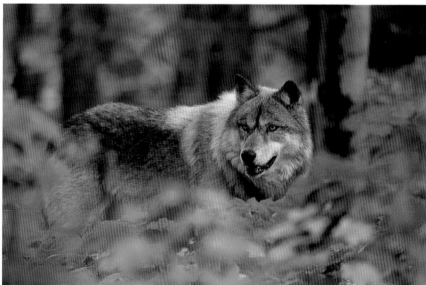

TOP RIGHT (MULE DEER):
A mule deer in the snow in Waterton Lakes National Park, Alberta, Canada.
CENTER RIGHT (GRAY WOLF):
A captive male gray wolf surrounded by autumn colors in Michigan's Upper Peninsula.
BOTTOM RIGHT (SPRUCE):
A lichen-draped spruce in front of reflections of trees on Emerald Lake, Yoho National Park, British Columbia.

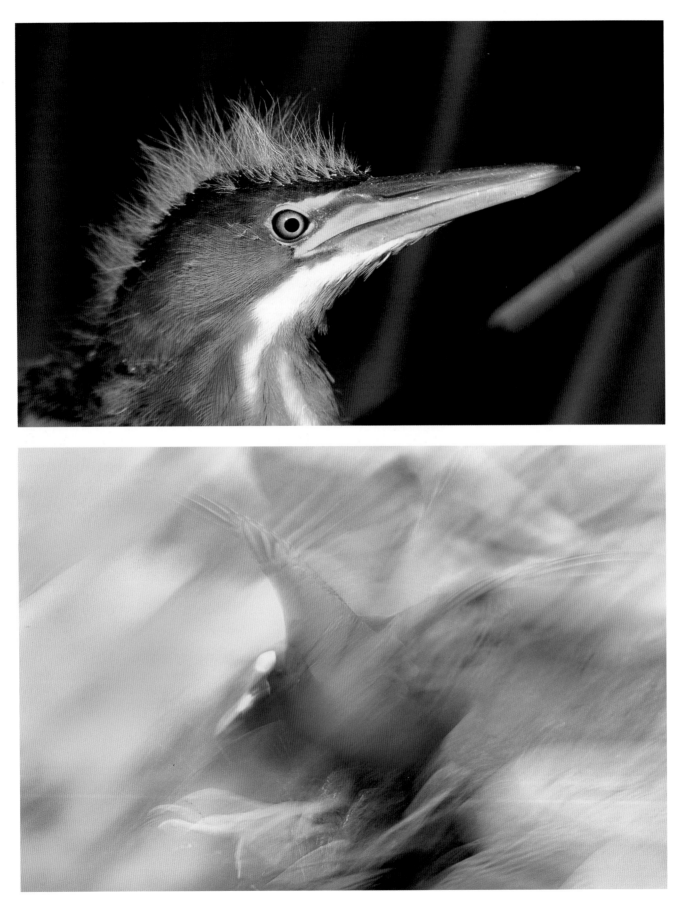

As one of the world's top bird photographers, Florida-based Arthur Morris is living a dream—doing what he loves to do, and making a good living at it. His Birds As Art business is booming, but he is not bogged down by it. Instead, a staff of two, led by his daughter Jennifer, runs the office so Morris can spend his time in the field.

Art had been an avid birder for seven years when the work of some local photographers caught his eye. Art realized that photography was something at which he wanted to excel. He bought a manual-focus SLR and a 400mm lens, but he was disappointed by the "tiny" size of the birds in his first photos. After seven years of working hard to get close and freeze wild birds, he switched to an 800mm lens to quadruple the size of the bird in the frame.

Today he uses autofocus Canon EOS cameras. His big lens is the EF 600mm f/4L IS. The EF 1.4X II teleconverter transforms this lens into a sharp, close-focusing 840mm effective focal length lens. He considers the EF 400mm to be the lens for in-flight bird photography, especially when birds are over-head. The EF 400mm is small enough to handhold while tracking the action, and he usually keeps a camera with this lens on his shoulder—even when he's working with another tripod-mounted camera and lens. "I just never know when I'll have to quickly switch to the handheld outfit to catch that fleeting shot," Arthur explains.

BELOW (MARSH WREN):
You can find marsh wren nests every 50 feet or so at the Bear River Migratory Bird Refuge in Utah.

BELOW (HUDSONIAN GODWIT):
Shot in Churchill, Manitoba.
BOTTOM (WILSON'S WARBLER):
These fast little birds are hard to catch on film. A skilled photographer is lucky to get one good image for every three full days afield.
FACING PAGE TOP (LEAST BITTERN):
Morris realized a long-term dream of photographing a young Least Bittern in a Florida wetland.
FACING PAGE BOTTOM (GALLINULE CANON IMAGE):
Stabilization (Mode 2) and a ¹/₁₅-second exposure created an artistic blur of a Purple Gallinule.

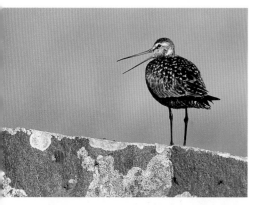

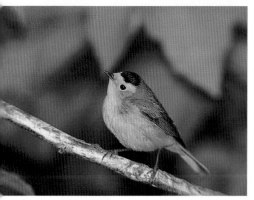

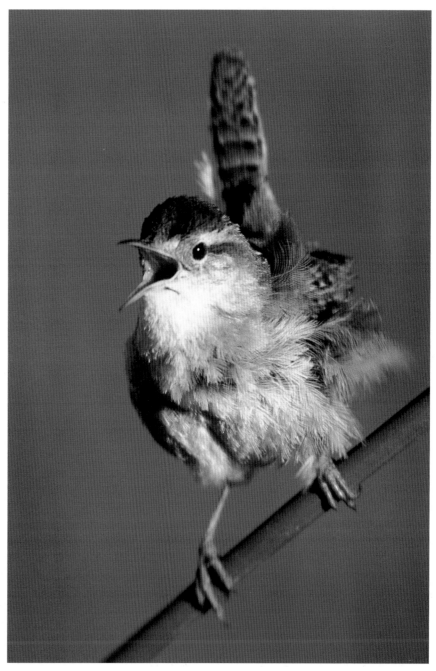

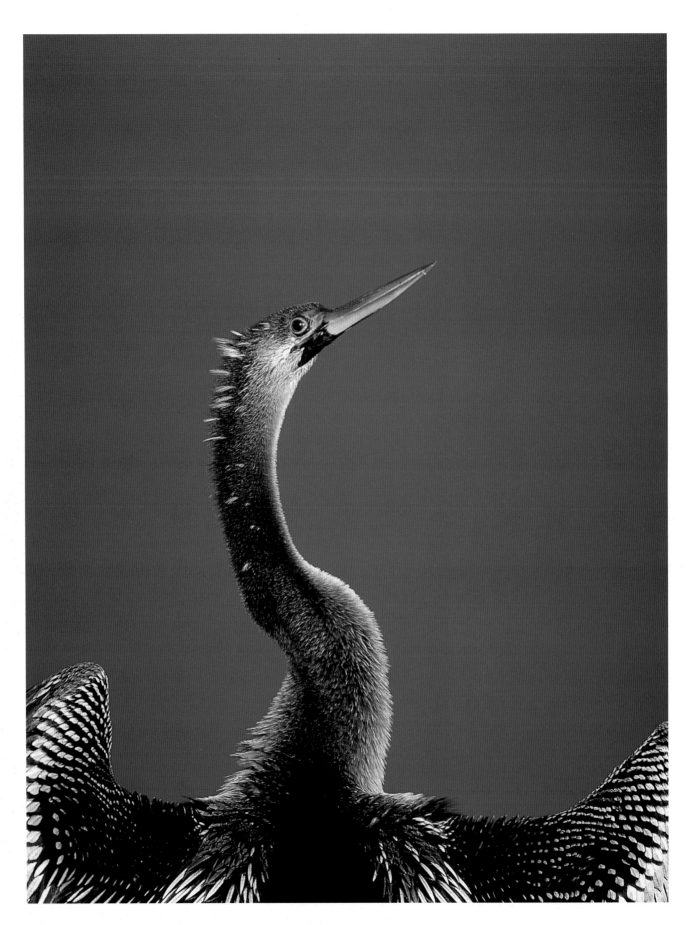

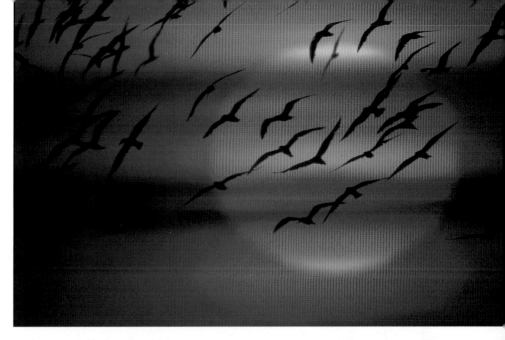

Many attribute Art's photographic success to his in-depth knowledge of bird behavior. "If you know where your subjects hang out and their migration routes and schedules, you can be in the right place at the right time," he explains. "From there, it is just a matter of patience, practice and hard work. Patience is a virtue in bird photography, but be careful," warns Art. "It is important to train yourself to push the button when unexpected action occurs. If you wait to make the image perfect, you usually wind up with nothing. It's better to waste a little film than waste the whole day."

While he prefers natural light, he will not hesitate to pull out a powerful electronic flash on dreary days. The flash adds catchlights to the bird's eyes and restores the film's color balance. When working with a super-telephoto lens at long range, Art employs a device called the Better Beamer that concentrates the flash's output. Information on this and other specialized bird photography gear (including Wimberly tripod heads and accessories) can be found on his web site at www.birdsasart.com.

Bird photography, of course, requires more than just good equipment. You have to be able to locate the birds and get within a reasonable proximity. Fixed blinds often provide enough concealment to allow photographers to operate without disturbing their subjects. Art has found that when employed correctly, a car can become a very effective

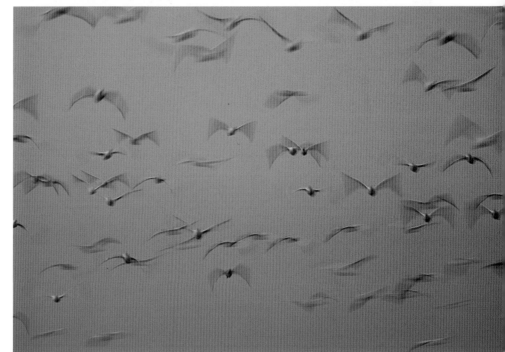

RIGHT (DAWN FLOCKS):
All three images at right were photographed at dawn on different days, with different effects. The top image is a silhouette of black skimmers in Cape May, NJ. The center image shows the pink-blue dawn typical of the Western sky. The bottom award-winning images of snow geese were purposely blurred.
FACING PAGE (ANHINGA IN FLORIDA):
A wide aperture was used to create a pleasing out-of-focus background in the Everglades.

BELOW (THREE IMAGES):
A flying Northern Fulmar,
a Herman's gull, and two Forster's
terns were photographed
with 300mm, 600mm and
800mm lenses respectively, all
with Fuji Velvia film pushed one stop.
FACING PAGE (GREAT BLUE HERONS):
Males at the Venice Rookery
can be seen bringing fresh sprigs
of greenery to their mates.

"mobile blind." Experience has taught him that approaching slowly in a vehicle will usuallt get you far closer than getting out of your car and attempting to approach a bird on foot.

Not all of Arthur Morris's stalking is done from behind the wheel. When maximum stealth is required Art has been known to crawl along the ground. "If you get down low and approach slowly, you can sometimes get ridiculously close to normally wary birds. You just have to check your pride at the door,

because those watching you will think you're crazy as you inch forward on your belly." However, this low angle gives an intimate, eye-level view of the bird and keeps both the background and foreground pleasingly out of focus. This technique dramatizes the sharpness of the bird itself.

For information on Art's signed photographic books and prints, photo tours and workshops, or to receive his free on-line bird photography newsletter, visit his web site at www.birdsasart.com.

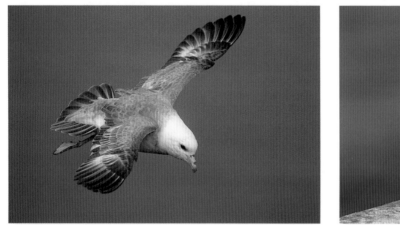

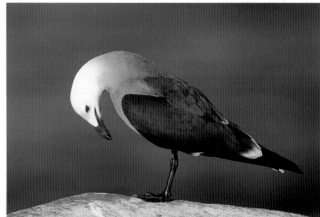

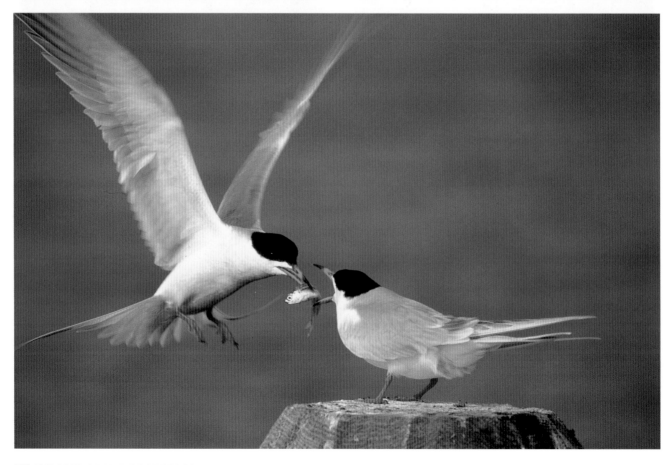

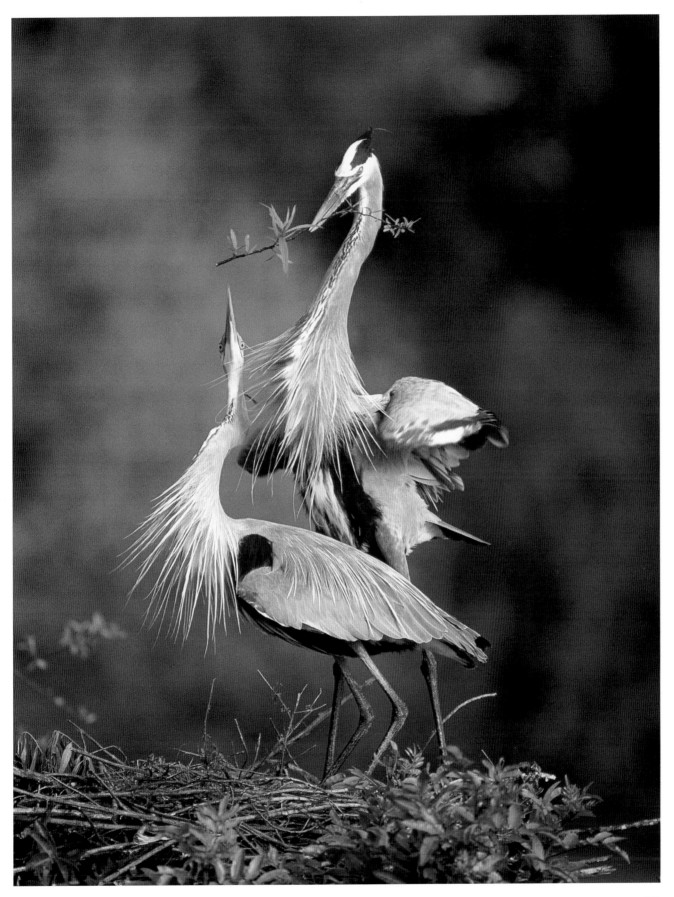

Boyd Norton is a renowned wildlife and environmental photographer who has been shooting and writing about his work for more than three decades. He often logs more than 100,000 miles a year, traveling to some of the most remote regions on the planet. He has made more than 25 trips to Africa alone.

Norton has traveled extensively in Siberia and is among the first international photographers to document this region. His passport bears stamps from Peru, Venezuela, Indonesia, Malaysia, and countless other countries. He has photographed in Borneo, Bali, and the Galapagos Islands.

During the course of his travels, Boyd has established many strong and enduring relationships. These friendships have enabled Boyd to gain access to areas that are normally beyond the reach of outsiders. Boyd is currently building an extensive digital video file of his travels.

Boyd considers Alaska "a second home." He frequently visits Alaska's McNeil River State Game Sanctuary where, for many years, he has followed and photographed "Teddy." This female grizzly bear is pictured with her cub at right. She was the subject of an article that Boyd wrote for *Smithsonian* magazine. Each spring, Teddy congregates with other bears along Mikfik Creek (seen in background) to feed on the migrating salmon. Because the McNeil Sanctuary is off-limits to hunters, the bears generally do not feel threatened by the presence of people. The bears' acceptance of people is good news for wildlife photographers, but it poses a danger to the bears when they range beyond the confines of the sanctuary.

Boyd has long been an advocate for the protection of wildlife and fragile ecosystems. He patronizes some of the world's most exotic wildlife preserves. During a visit to the Tambopata-Candamo Reserve in the upper Amazon Basin of Peru, Boyd photographed the green tree frog perched on a helliconia flower (pictured on page 82). This photograph conveys a sense of delicate beauty and invites us to consider the symbiosis between flora and fauna. The Tambopata-Candamo rain forest is home to one of the most biological diverse ecosystems on earth.

Siberia's Lake Baikel is another fascinating ecosystem. Over 25 million years old, Lake Baikal is more than 5000 feet deep and holds approximately 20 percent of the world's fresh water. The lake and its spectacular environs nurture an estimated 1800 species that cannot be found anywhere else on earth.

The underwater photograph on page 83 depicts a school of indigenous fish known as omul. The sheer volume of fish and their relative position to one another creates a sense of perpetual motion. Ironically, it is the compositional balance of this 35mm image that so effectively disorients us. We feel as if we are among the swirling school, uncertain of our origin or destination. Indeed, this photograph engages the viewer.

BELOW (GRIZZLY MOTHER AND CUB): *"Teddy" and her cub at the McNeil River Game Sanctuary in Alaska.*
BOTTOM (VOLCANO AT SUNSET): *Augustine Volcano, Kamishak Bay, Alaska, photographed three months after a major eruption.*
FACING PAGE (ORANGUTAN HANDS): *The hands of an adult female orangutan grasp a tree trunk in Tanjung Puting National Park, Borneo, Kalimantan, Indonesia.*

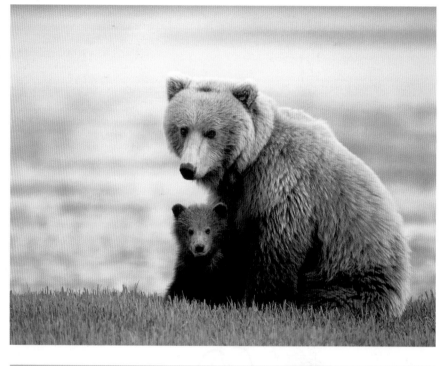

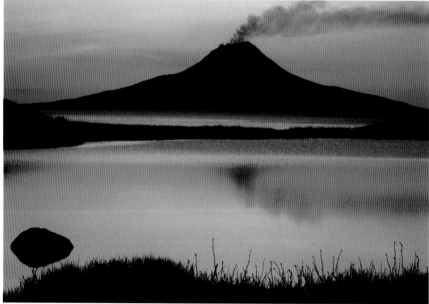

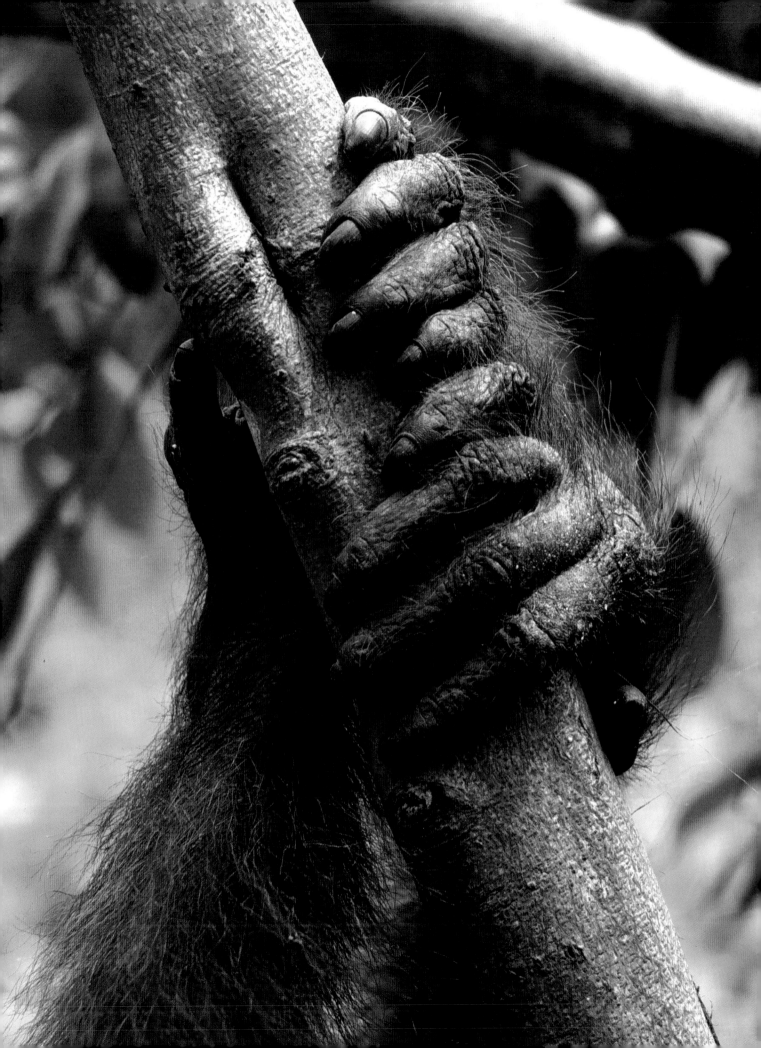

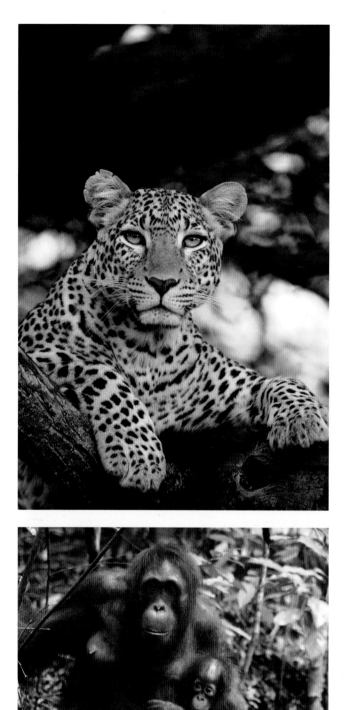

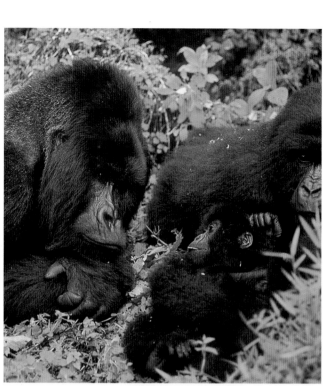

Boyd started traveling to Lake Baikal in the mid 1980s under the old Soviet system and has made nearly a dozen trips to the region since. His files contain the largest selection of Lake Baikal photos found outside Russia. Many of these images can be seen in Boyd's books *Baikal: Sacred Sea Of Siberia* and *Divided Twins: Alaska And Siberia*. These are but two of Boyd's thirteen acclaimed books, which he has both photographed and authored. He has also contributed to more than sixty other books.

Boyd's client list is one of the most impressive in the business. His images have been featured in *National Geographic*, *TIME Inc.* publications, *Smithsonian*, *Audubon*, *Conde Nast's Traveler*, *Vogue*, *Travel & Leisure*, *Sierra Club*, and *Outside* (to mention just a few). He is member of the American Society of Media Photographers and he sits on the Board of Trustees for the Dian Fossey Gorilla Fund and Baikal Watch.

View more of Boyd's spectacular images at www.evergreenphotoalliance.com and www.agpix.com. To learn about the Norton Slide Captioning System for Windows, visit www.nscspro.com. This system provides a powerful picture management database for photographers.

Those interested in photo workshops should consider contacting Boyd. He conducted his first outdoor workshop in 1973 and today he is widely regarded as a pioneer in the workshop field. In a typical year Boyd will lead trips to three or more countries (on as many different continents). E-mail Boyd at boydn@earthlink.net or reach him through his agents Evergreen Photo Alliance and Image Works.

LEFT (LAKE BAIKAL FISH):
School of omul fish, Lake Baikal, Siberia, Russia.
BELOW (ELEPHANTS GREETING):
Elephants in the Masai Mara National Reserve, Kenya.
FACING PAGE (CLOCKWISE FROM TOP LEFT):
Leopard in acacia tree, Kenya; Silverback mountain gorillas, Democratic Republic of the Congo; Green tree frog on a helliconia, Peru; Female orangutan with youngster, Borneo, Indonesia.

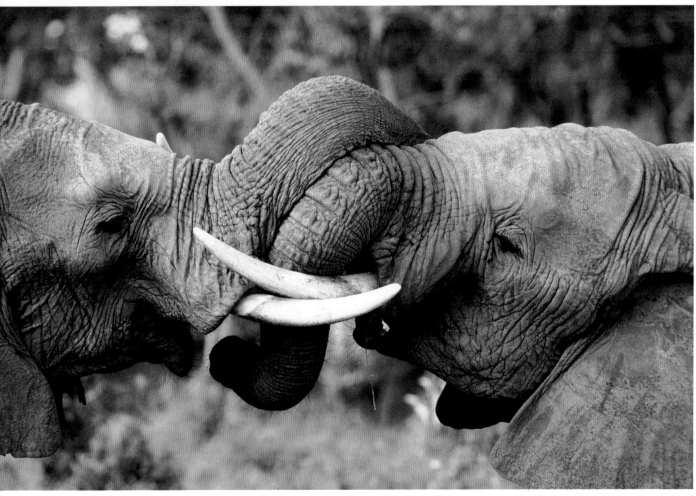

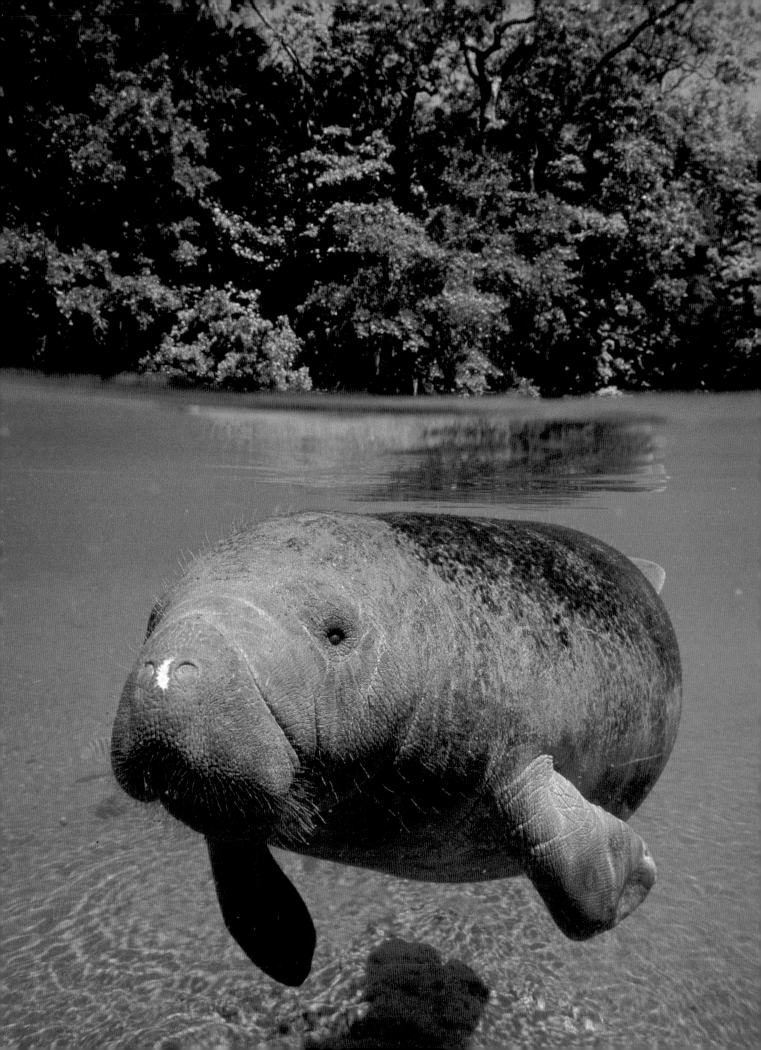

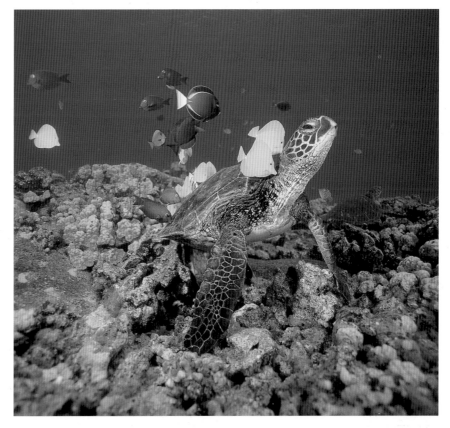

The sea has always fascinated Doug Perrine and it has inspired many of Doug's accomplishments. He possesses both a bachelor's and master's degree in Marine Biology. He has been a Coast Guard certified boat captain and SCUBA instructor, and is now one of the world's finest underwater photographers. Doug's photos appear frequently in calendars, posters, postcards, and other graphic products, and they have been published in hundreds of books and magazines.

Underwater photography presents several unique challenges. The light-absorbing qualities of seawater require photographers to shoot within a few feet of their subjects. This can create some rather perilous situations. Doug tells us that he has been "stung by

RIGHT (GREEN SEA TURTLE):
Photographed in Hawaii.
BELOW (DOLPHIN):
Bottlenose dolphin and tube sponges, Cayman Islands.
FACING PAGE (FLORIDA MANATEE):
A manatee photographed with the lens half under the water.

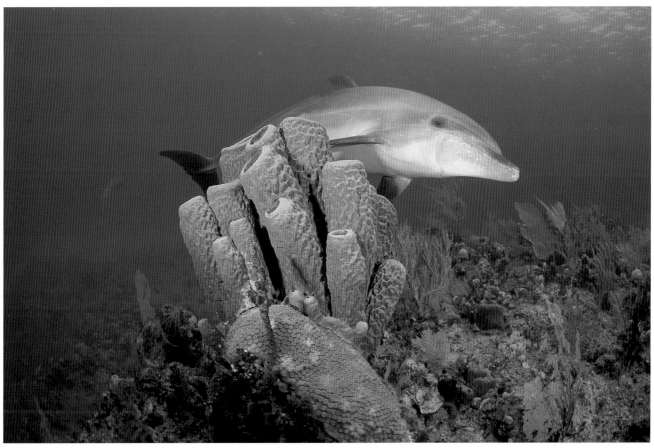

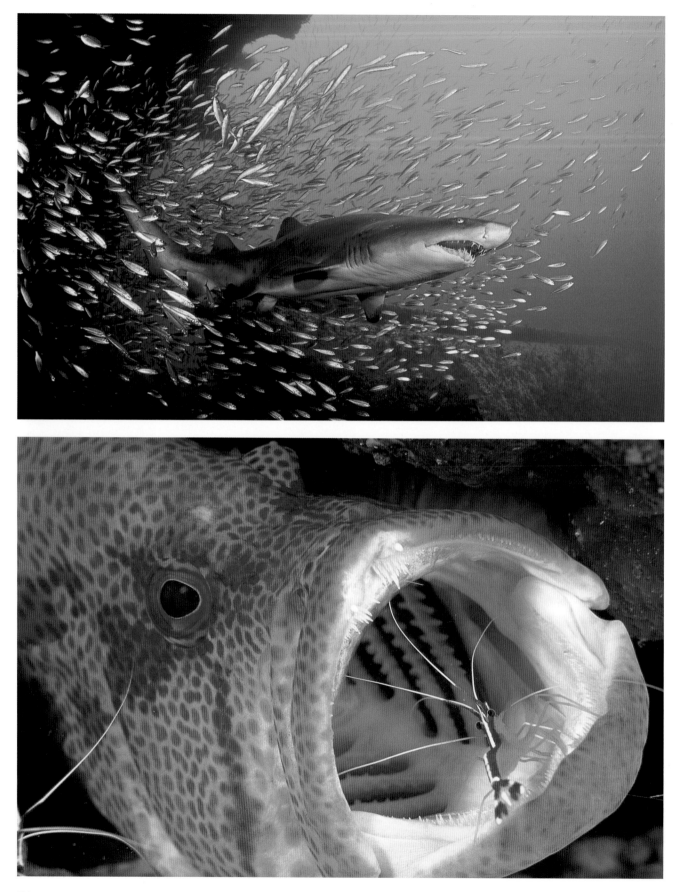

hydroids, jellyfish, and man-of-war, and bitten by sharks, fish, crabs, and even a nautilus." He once had a sea cow pin him underwater. Unfortunately for Doug, he was without an air supply at the time. He has also been used as a "play toy by a 30-foot whale," and he's even had to repel the advances of amorous dolphins.

Most of the animals Doug encounters, however, are not aggressive. In fact, many are extremely shy and will avoid contact with humans at all cost. Understandably, there are thousands of marine animals that have never been photographed. In hopes of photographing these diffident creatures and learning more about their natural behaviors, Doug has started to experiment with remotely operated cameras and strobes. As always, Doug's work is as much about knowledge and understanding as it is about beauty and artistic composition.

Doug's credits include *National Geographic, Audubon, Smithsonian, Time, Natural History, Elle, Esquire, Newsweek, U.S. News & World Report.* He is the author of the books *Sharks, Mysteries of the Sea, Sharks & Rays, Whales & Dolphins, Coral Colony Creatures, The Living Sea* and *Sea Turtles of the World.* Doug has worked as consultant for a several film projects including films produced by the National Geographic Society, the Discovery Channel, and Disney. Doug's photography has received numerous awards, and he has won the Animal Behavior category in the BG Wildlife Photographer of the Year competition.

Doug Perrine is president of Innerspace Visions/Seapics.com, a stock photography library in Kona, Hawaii. His e-mail address is photorequest@seapics.com.

Top Right (Sperm Whale):
Azores Islands, Portugal.
Bottom Right (Silky Shark):
Shot in the Bahamas.
Facing Page Top (Shark):
Sand tiger shark at the wreck of the Papoose off the coast of North Carolina.
Facing Page Bottom (Grouper):
Tomato grouper being cleaned by humpback cleaner shrimp, Mabul Island, Malaysia.

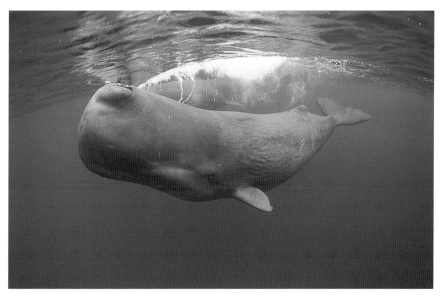

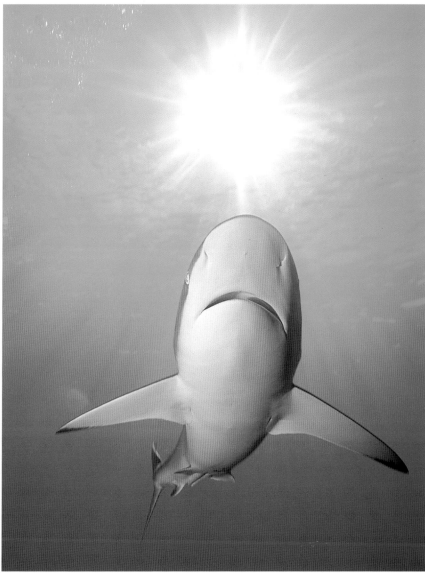

RICCARDO POLINI

More than two decades ago Riccardo Polini saw his first heron through a Praktica viewfinder. The event was a turning point in his life, for as Riccardo explains it, "I immediately fell in love with nature photography." As a professor of General and Inorganic Chemistry, Riccardo has always sought meaning at the molecular level. It is not surprising then that Riccardo's photographic interests gravitated toward the highly-magnified macro images.

The photograph of the longhorn beetle seen on the facing page was taken as part of an assignment for an entomology museum. Riccardo's challenge was to produce an image that had scientific value, and also conveyed the "gorgeous beauty" of the creature. The diminutive size of the beetle required a 4X film magnification. Riccardo shot this photo with a Nikon 50mm f/1.8 E reversed on his AIS Nikkor 200m f/4. To light his subject, Riccardo used his preferred lighting method of two flashes in the TTL mode. The two toads (pictured on the next page) were also lit by this method.

There are times, however, when Riccardo relies on natural light. The image of the praying mantis was shot without a flash using a Nikon F301 with an AI Micro-Nikkor 200mm f/4 IF lens on a tripod. The use of a long tele-macro lens allows the insect to "pop out" against a hazy background.

Riccardo understands the importance of deliberate and thoughtful composition. Indeed, he sounds like a professor when he advises his students that the "most valuable piece of equipment that a photographer possesses is the lens between his ears."

Contact Riccardo Polini at ripolin@tin.it or at http://space.tin.it/arte/ripolini.

RIGHT (PRAYING MANTIS):
Praying mantis in Manziana
Natural Park, near Rome, Italy.
FACING PAGE TOP LEFT (BEETLE):
A 4x enlargement of a longhorn
beetle photographed for an
entomological museum.
FACING PAGE TOP RIGHT (FROG):
A European tree frog along
a trail near Lake of Penne, Italy.
FACING PAGE BOTTOM (TOADS):
Young toads emerging
from the waters in Treja River
Natural Park, Lazio, Italy.

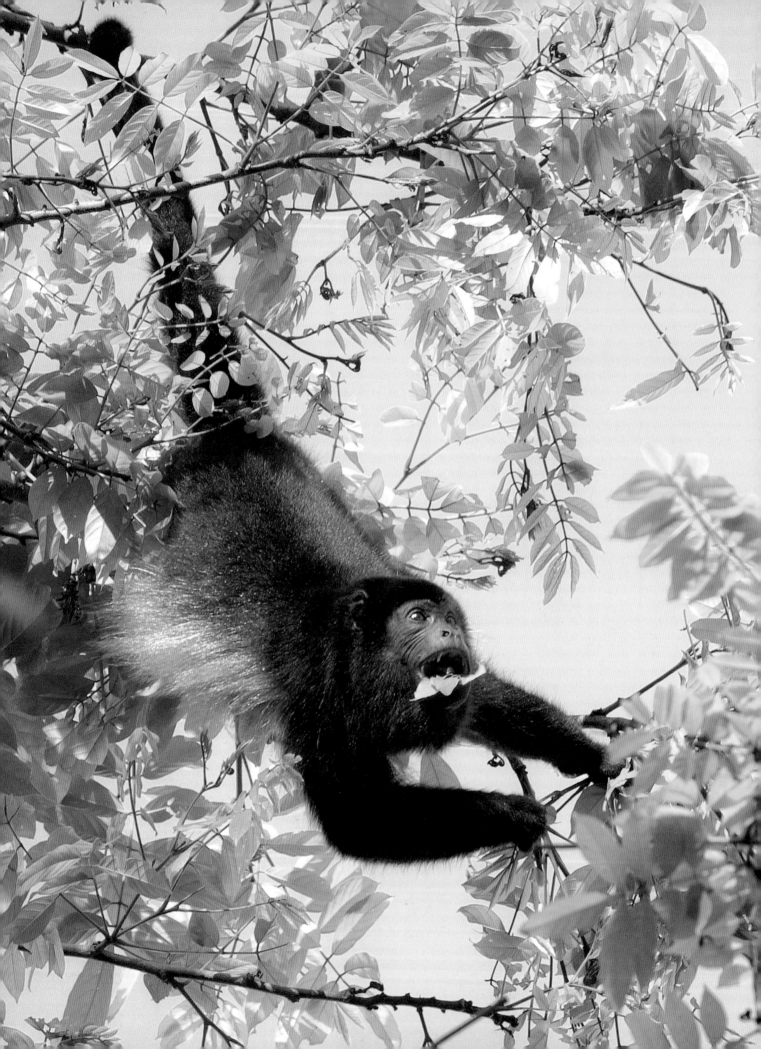

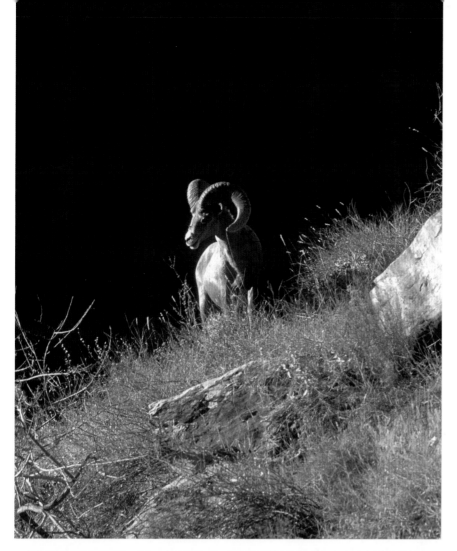

MICHAEL H. REICHMANN

Michael H. Reichmann has been a professional photographer for more than 35 years, in a variety of specialities. He began his photo career in a commercial studio, then worked as a staff photographer for the Canadian Broadcasting Corporation for nearly a decade. He has been a freelancer in the motion picture industry, and is currently a contributing editor to *Photo Techniques* magazine. Michael is also the publisher of the *Luminous Landscape* video journal.

Born in England, Michael grew up in Quebec and now resides in Toronto. Today he devotes much of his energy to landscape and nature photography. And while he finds many opportunities for images in his own backyard, Michael prefers to travel to find his photographic subjects.

Although he sometimes shoots in well-photographed areas, Michael tries to cast the familiar in new and interesting ways. For example, Michael reveals that "no matter where you go on the sand dunes near Stovepipe Wells in Death Valley, there are footprints." Occasionally high winds sweep them clean, but most of the time photographers have to incorporate these footprints in a meaningful way. Michael's photograph on this page demonstrates his mastery of the various elements of composition.

"Sometimes one sets out to photograph one thing and instead you find something else that interests or pleases you more." The strong shadows of the setting sun add tremendous texture and detail to the footprints and dunes beyond.

Visit Michael H. Reichmann's web site at www.luminous-landscape.com. It is a great resource for those interested in nature photography and digital image processing.

FACING PAGE (HOWLER MONKEY):
Reichmann photographed this monkey on his first hike in the Costa Rican rainforest.
TOP LEFT (BIG HORN SHEEP):
Photographed on a rafting trip in the Grand Canyon.
CENTER LEFT (SUNSET):
Clingman's Dome, Great Smoky National Park at sunset.
BOTTOM LEFT (DEATH VALLEY):
The striped dunes near Stovepipe Wells in Death Valley.

John Sexton is one of the premiere black & white fine art photographers in the United States. Collectors prize his original photographic prints, and his three photography books have garnered critical acclaim. John's interest in landscape photography evolved from his lifelong love of exploring the natural environment.

When John was a photography major in college, his primary medium was color. "While attending an Ansel Adams Yosemite workshop I decided I wanted to concentrate on black & white photography for my own personal work," he says. Years later, he became Ansel's assistant and eventually set-

tled in Carmel Valley, California, where he still resides.

"I decided the best way to try and gain control over the medium of black & white was to concentrate on it exclusively," he tells us. "When you photograph in black & white, you really need to understand the science of photography. Even in this digital age, photographers must appreciate the scientific aspects of their work.

"For someone to adequately understand the controls, techniques, and approaches available in the digital capture and printing of images, a basic

FACING PAGE (MONTEREY PINES): Sexton photographed a pine forest on a foggy morning in Pebble Beach, California. He used a 4x5 camera, 210mm lens, and Kodak Tri-X Professional film at f/45 for 10 seconds. Developed at "N+1" for a slight increase in contrast.
BELOW (FERN AND LOG): His delicate natural Yosemite still life was photographed with a 4x5 view camera, 210mm lens, No. 11 green filter, Kodak Tri-X Professional film at f/45 for 5 seconds. Developed at "N+1".

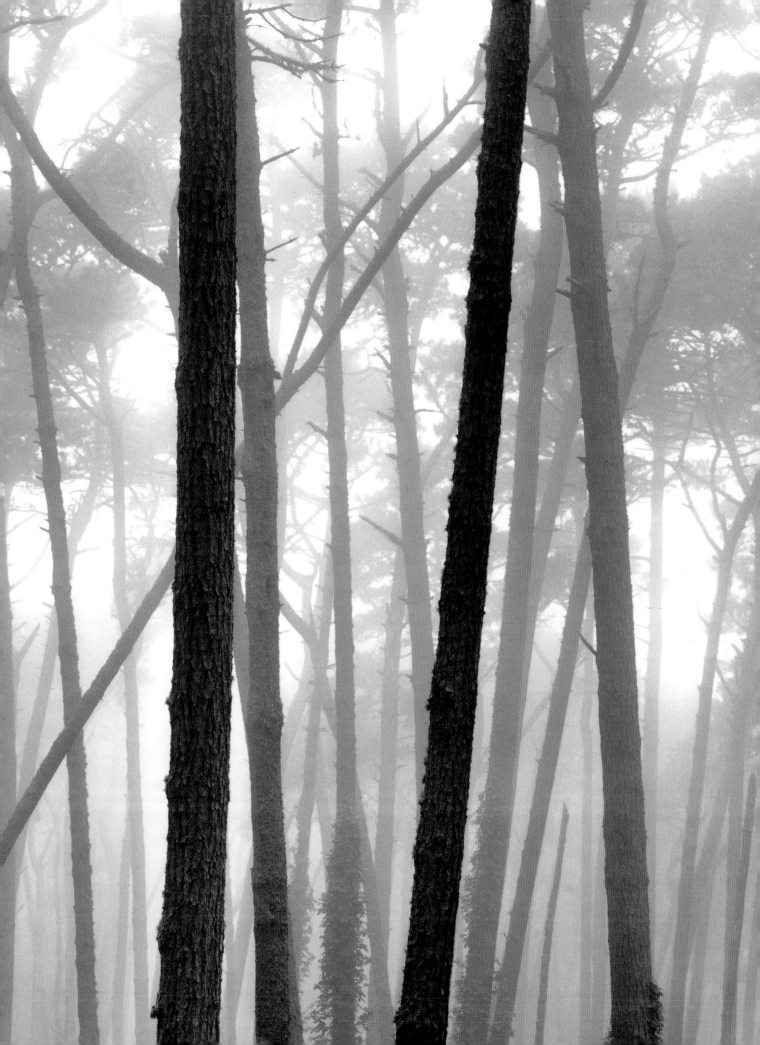

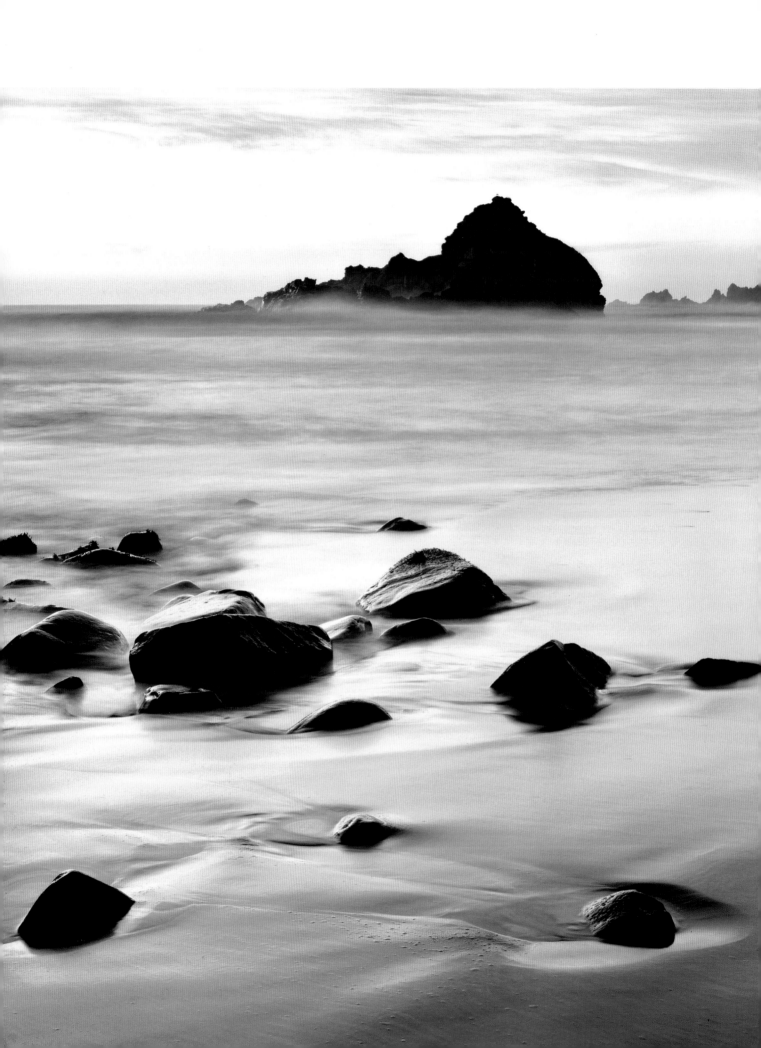

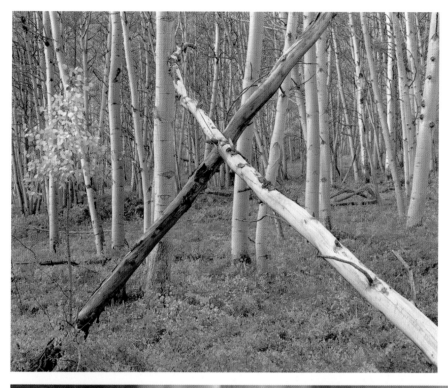

LEFT (CROSSED TREES):
Crossed aspens and sapling near
Ashcroft, Colorado, photographed
with a 4x5 camera and a 210mm lens
with a No. 12 yellow filter. Exposure
was f/45 for 5 seconds with Kodak
T-Max 400 film.

BELOW (VERNAL FALL):
A mist shrouded tree in front of
Vernal Fall in Yosemite National Park,
California. Photographed with a 4x5
camera and 500mm lens. The exposure
was f/22 for ¼-second with Kodak
T-Max 400 film. Developed to "N-1"
for a slight decrease in contrast.

FACING PAGE (PFEIFFER BEACH):
Pfeiffer Beach at dusk, photographed
with a 4x5 camera and 120mm lens.
Exposure f/32 for 1 minute with
Agfapan 100 film. Developed at
"N-1" to slightly decrease contrast.

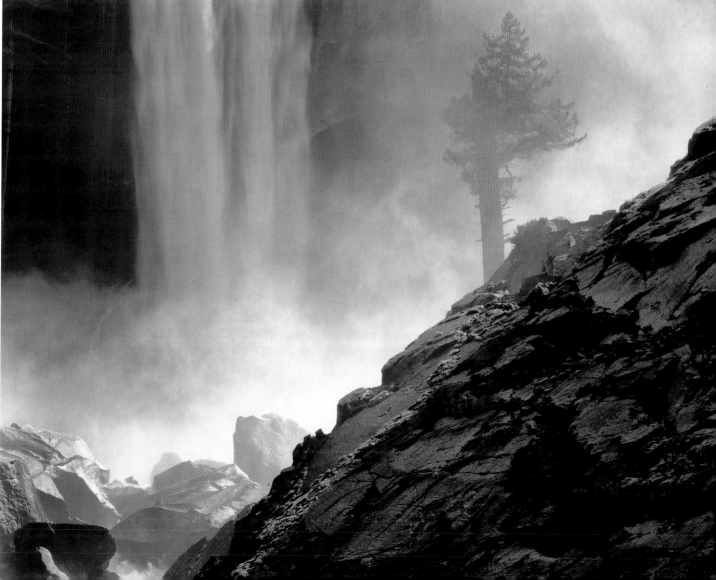

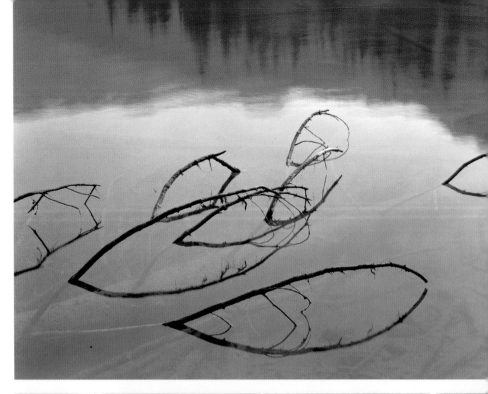

knowledge of how traditional photography works is essential," he explains. "Regardless of the technologies employed, light continues to be photography's essential variable." John speaks of light as "intangible material." He reminds us that a digital image relies upon this same "material," but gives us new and different ways to render an image. John looks forward to experimenting with the next generation of high-resolution digital cameras.

John has used a large format Linhof Technika 4x5 view camera for the past 20 years, and considers it a "good friend." He has consistently achieved extraordinary levels of detail in his images. He likes the versatility of this camera, which allows him to process each exposure separately utilizing the Zone System. Overdeveloping (N+1 for example) can increase contrast; and underdeveloping (N-1 for example) can decrease contrast.

Many of John's images on these pages and in his books were made with a 210mm view camera lens. He was "forced" to use only one lens for the first seven years of his serious photography, because he couldn't afford an additional lens.

"For that reason, I feel very comfortable with the 210mm focal length, and find myself reaching for it most often even though I now have numerous lens choices," John says.

John followed up his award-winning *Quiet Light* monograph with *Listen to the Trees*. This poetic title for his second book came from John's personal philosophy on photography: "As photographers, we need not only look for opportunities to make exposures on film, but to also be observing, sensing, and

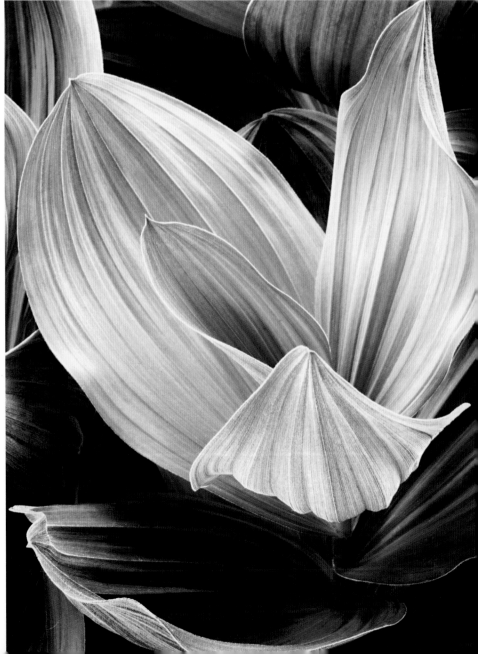

TOP (FALLEN BRANCHES):
Reflections on Emerald Lake, Canada, photographed with a 4x5 view camera with a 210mm lens. Exposed on Kodak T-Max 100 film at f/32 for 1 second.
BOTTOM (CORN LILY):
Photographed in the Eastern Sierra Nevada area of California with a 4x5 view camera and a 210mm lens. The exposure was f/64 for 4 seconds on Kodak Tri-X Professional 400 film. It was developed at "N+1" for a slight increase in contrast.

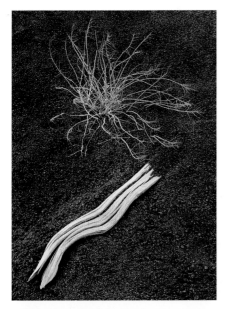

hearing at all times—listening to the voice of the subject."

His newest book, *Places of Power: The Aesthetics of Technology*, is a departure from his nature series. *Places of Power* explores the idea of technological achievement as art. His subjects are diverse and span centuries. He photographs the ancient Anasazi cliff dwellings in the Southwest, the Hoover Dam, steam power plants in the Midwest, and the United States Space Shuttle.

John Sexton teaches photography workshops in his Carmel Valley studio and at a few select locations during the year. For information about his workshops, original photographic prints, books, posters, and calendars, contact his office by telephone at 831-659-3130 or visit his web site at www.johnsexton.com.

LEFT (MONO LAKE, CALIFORNIA):
John Sexton found this bleached branch and bush on the volcanic shore of Mono Lake, California. Photographed with a 4x5 view camera and 210mm lens. The exposure was f/45 for 6 minutes on Kodak T-Max 100 film.

BELOW (MYTHIC FOREST):
Streaming sunlight created a magical moment in this Yosemite high country forest. Photographed with a 4x5 camera and 210mm lens. The exposure was f/45 for 2 seconds on Kodak Tri-X Professional film. The negative was given greatly reduced development to accommodate this very high contrast situation.

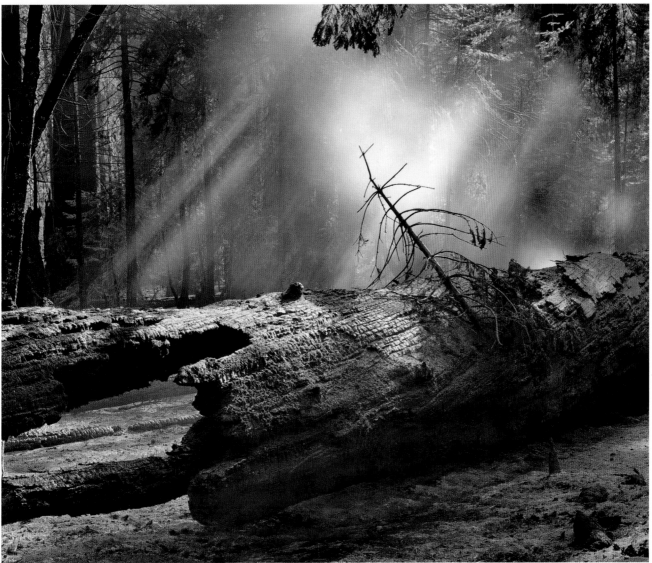

Bill Silliker, Jr. is both a nature photographer and a writer. His photographic career began when he picked up an old Minolta camera to photograph a nearby endangered coastal wetland ecosystem near the Goosefare Marsh. He set out to prove that the Marsh was worth saving and that the proposed 1000 condo units along this pristine 450 acres were not necessarily in the community's best long-term interest.

"In the process of preserving the marsh, guess what?" exclaims Bill. "I got hooked on doing wildlife photography. I was 40 years old and I felt as if I'd finally discovered why I was on the planet." Today the Goosefare Marsh is part of the Rachel Carson National Wildlife Refuge and Bill is a well-known specialist in wildlife photography of the northern forests.

"As a camera hunter, I often need to hide from sensitive subjects, so I'm usually packing either special 3-D camouflage clothing or a camouflage cloth blind that I can throw over myself to hide completely if needed," comments Bill. This was helpful when he was working with a wary fox mother who accepted Bill's presence after he spent over a week with her from a respectful distance. Because he had earned her trust, she called two of her five pups out from a culvert to feed. This, of course, provided the opportunity for which Bill had so patiently waited, as seen in the photo on the facing page.

The two bald eagles, seen on page 99, were photographed in Alaska. One is a juvenile, while the other is a mature adult. Bill suspects that the birds were probably not related to each other, yet they came together to share a snag above the same food source. Bill explains that he metered the available light with a gray card and then cut the exposure by ⅓ stop. This ensured sufficient detail in the mature eagle's white-feathered head. The American Eagle Foundation selected this

TOP (WHITE-TAILED BUCK):
Silliker spot-metered off the buck to ensure detail in the image.
CENTER (BISON HERD):
A Yellowstone herd in the snow, shot from the photographer's car.
BOTTOM (GRIZZLY BEAR):
Silliker photographed this brown bear in the wild in Denali National Park with a 500mm lens.

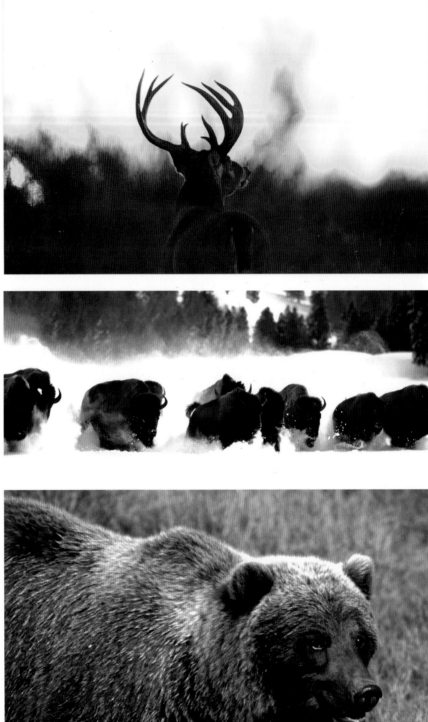

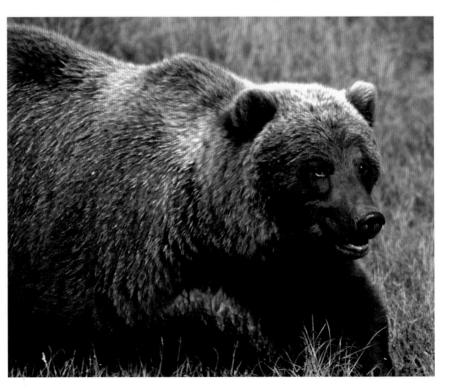

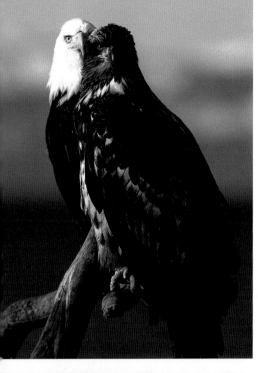

image for a special limited-edition print and chose Bill as their Photographer of the Year for 2000.

When Bill is not out shooting for himself he is working for clients like L. L. Bean, The Nature Conservancy, the Forest Society of Maine and the Trust for Public Land. His images are often seen in magazines, from *Audubon,* to *Outdoor Life, National Wildlife, Outdoor Photographer,* and many others.

Bill has written and photographed *Moose: Giant of the Northern Forest* (Key Porter/ Firefly Books); *Uses for Mooses* (Down East Books); and *Maine Moose Watcher's Guide* (R.L. Lemke). His work also appears in *Just Eagles* and *Just Loons* (Willow Creek Press). He has just completed work on two new books, one of which tells the story of protecting some of Maine's special places.

Bill has taught wildlife and nature photography for L. L. Bean's Outdoor Discovery Schools since 1992. He has taught for Great American Photography Weekend. As a member of the Fuji Talent Team, Bill regularly gives slide talks sponsored by Fujifilm Professional.

Visit Bill Silliker's web site, the Camera Hunter, at www.camerahunter.com or e-mail him at bill@themooseman.com. Bill edits www.wildlifewatcher.com, a web site for wildlife enthusiasts. His images are available through Animals Animals/Earth Scenes and Image Finders.

LEFT (BALD EAGLES, ALASKA):
Two bald eagles on a snag near a food source in the Kenai Peninsula.
BELOW (RED FOX KIT, MAINE):
A wild red fox nurses her pups in the woods of Baring, Maine.

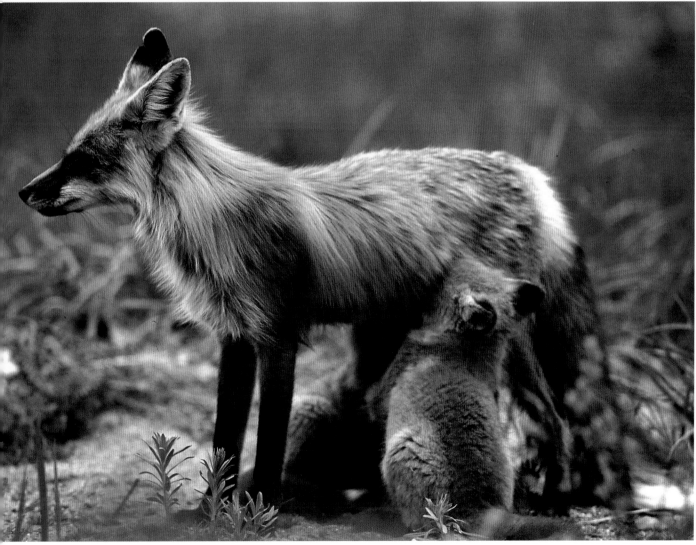

"I see the photographic possibilities in almost everything," shares Greg Summers. "For the most part I shoot nature and wildlife, but as my love of photography has grown, I can't resist almost any subject."

Greg was born in Toronto, Canada but came to the United States in 1965 to work for the Ski Patrol in Colorado, and never left. He has always loved the outdoors, and he had dabbled with nature photography for many years before deciding to pursue it seriously. Now he spends more time outdoors than ever, roaming the state and finding inspiration all around him.

Greg advises that photographers should not overlook their own backyard, because great photographs can be found anywhere. He found the pine cone image on this page near his home on a warm winter afternoon. "This picture happened because of a lot of trial and error," explains Greg. "The first shot I took was not as good, but I kept working until it turned out the way I wanted it." It must have worked because this image is one of his best-selling images.

Even in the middle of a subdivision in Boulder, Colorado, he can find wildlife subjects. Although there are thousands of houses nearby, man's encroachment has not deterred an owl and her babies from making a home in a hollow, half-dead tree.

Greg photographed this owl family using a Sigma 500mm f/4.5 lens with 2X teleconverter, mounted on a Bogen tripod with a pan-tilt head. He returned many times before achieving the remarkable shot shown here. But he always shot from a respectful distance with the equivalent of a 1000mm focal length lens, to make as little impact as possible on the subject and its habitat.

"Don't assume you 'got it' after the first shot," suggests Greg. "I recommend returning to the same places over and over again, because you start seeing ways to improve the picture, or you get even luckier with the lighting or subject changes."

Greg Summer's images can be viewed at www.coloradophotos.com.

TOP (GOLDEN FOG):
Sunrise, Boulder Creek, CO.
CENTER (PINE CONE):
A winter backyard image.
BOTTOM (REFLECTIONS):
The moonrise over a lake.

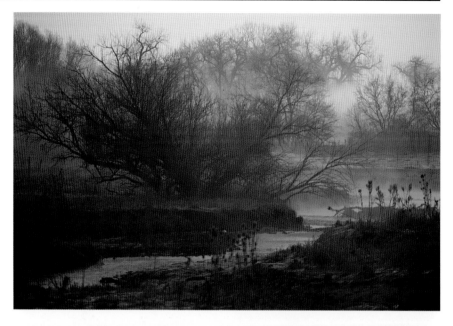

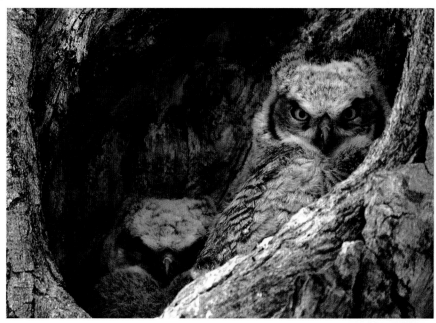

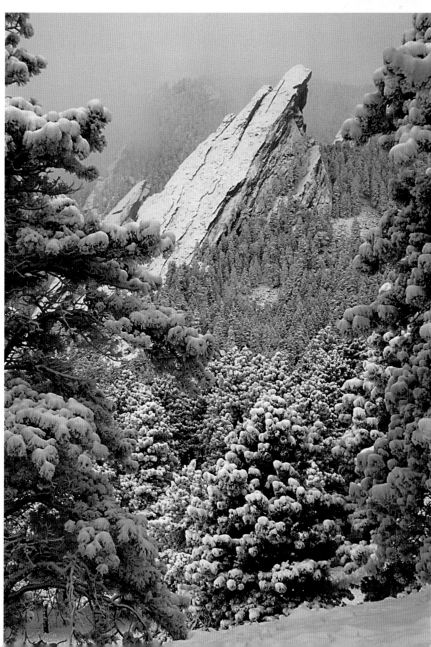

TOP LEFT (OWL CHICKS):
A suburban wildlife family.
BOTTOM LEFT (FLATIRONS):
The third of the Flatiron rock
formations near Boulder, CO.
BELOW (HEIDI'S FOXGLOVES):
A neighbor's garden is a macro
wonderland for Summers.
BOTTOM (ORANGE TEARS):
Summers was surprised to find
"everything" planted in the local
community garden—including flowers.

GREG SUMMERS 101

After 20 years as a professional jazz musician, Tony Sweet redirected his creative energies toward nature photography. To some, this seems like a radical career change, but Tony views it as a logical progression. "The improvisational, spontaneous and abstract nature of jazz are also integral elements of nature photography," explains Tony. Indeed, Tony describes the transition as "seamless." He became a full-time professional photographer in only five years.

Tony enjoys experimenting with black & white infrared film. Infrared photographs give us insight into a spectrum of light, which normally defies our ability to perceive. One of the characteristic traits of this film is that it turns leafy green foliage white. This often imbues the photograph with ethereal qualities.

Exposure can be tricky, frequently requiring trial and error. Depending upon the situation, Tony rates the film from ISO 50 to ISO 640. He uses a B+W 092 opaque filter and adjusts his focus to accommodate the distinct wavelength of infrared light.

Tony has developed a technique whereby he shoots the same subject with two different films and then overlays them digitally. The image of Sherwood Gardens (bottom right) provides an excellent example of this.

Tony Sweet conducts nature workshops in the eastern United States, and is a frequent contributor to www.Nikonnet.com and *Shutterbug* magazine. He is represented by several stock agencies. Tony offers personal critiques to aspiring photographers who seek his constructive and comprehensive feedback. Vist his web site at tonysweetphotography.com.

BELOW RIGHT (SHERWOOD GARDENS):
Sweet took two exposures and combined them in a computer. The first was on Velvia slide film, the second was on Kodak HIE infrared film.

BELOW LEFT (EVERGLADES):
The Everglades were shot with a Nikkor 80–200mm f/2.8 lens with a B+W 092 opaque infrared filter on Kodak HIE infrared film rated at ISO 50.

FACING PAGE TOP (ANGULAR TREE):
Shot with a Nikkor 20–35mm f/2.8 lens and a Hoya 25A red filter on Kodak HIE infrared film rated at ISO 640.

FACING PAGE BOTTOM (FERN):
Shot with a Nikkor 105mm f/2.8 macro lens and a B+W 092 opaque filter on Kodak HIE infrared film rated at ISO 50.

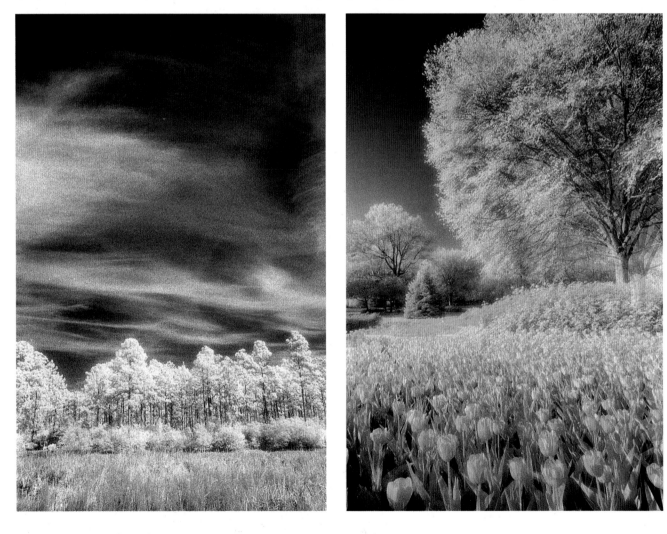

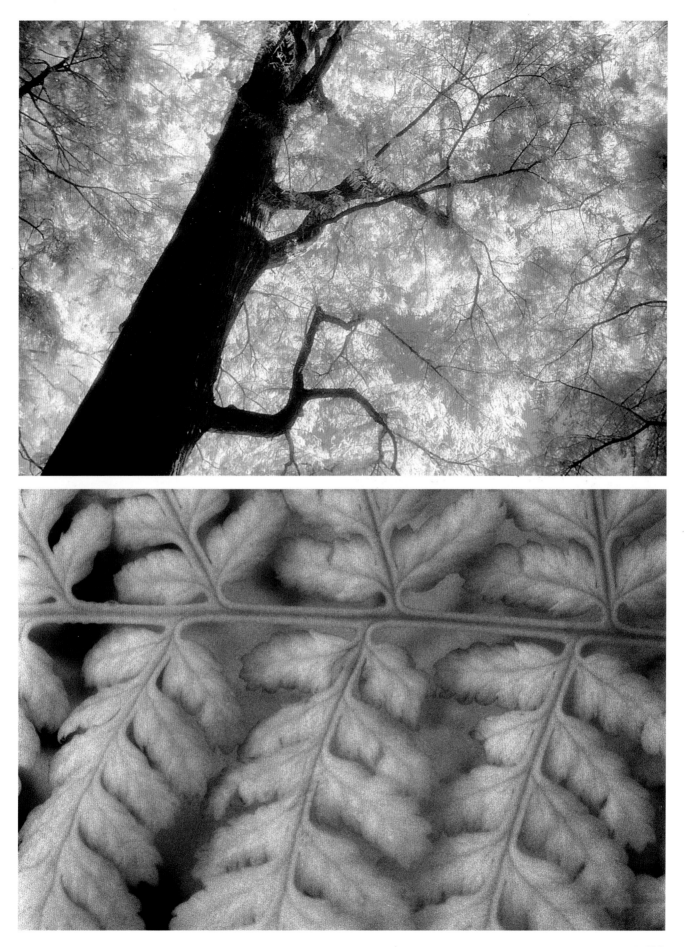

BRENDA THARP

When Brenda Tharp walked away from a corporate management position many years ago, she immediately headed for the outdoors with her camera and a new business plan. Today, she specializes in travel, outdoor and location photography—and she has llama-trekked, sea-kayaked, flown in helicopters and hot-air balloons, cycled, and hiked to get those pictures!

"Too often, photographers flock to the same picturesque areas, and their images look common because they've been seen on thousands of postcards," explains Brenda. "With a little research and perseverance, you can explore off the beaten path, making it easier to make unique photographs."

Brenda used to say that "everyplace" was her favorite shooting location. She still loves to travel extensively, but more and more she finds herself rediscovering her own backyard. Luckily for her, her "backyard" is Northern California, which offers beautiful (and not too crowded) places like Point Reyes National Seashore, Redwoods National Park, the Sierra foothills and mountains and the wildlife refuges in the central valley.

Even when photographing at major monuments, like Yosemite National Park, Brenda resists the temptation to photograph familiar scenes. She encourages aspiring photographers to remember that there is more than just the "big picture." For instance, the dogwood image shown on this page was taken along the Merced River, literally in the shadow of El Capitan, the most photographed rock formation in California.

To create the dogwood image, Brenda used her Canon EOS 80-200mm f/2.8 lens at 200mm. She metered off the background water and set the exposure to f/16 at 1–3 seconds. This effectively blurred the water, while the dogwoods recorded sharply.

Brenda deliberately avoids falling into creative ruts. "I generally use either aperture or shutter priority setting," says this long-time Canon EOS user, "so I can select the depth of field that I want or control the effect of motion of my subject. It is essential for me to have creative control over the camera."

Being creative is an essential quality for photographers working with captive wildlife. Zoos and rehabilitation centers provide excellent photographic opportunities, but they also present certain compositional challenges. The best animal photography usually evokes a sense of the unrestrained wild. This

can be hard to achieve in a captive setting. Brenda, however, has managed to do just that in her photograph on page 105. During a particularly harsh winter at the Grizzly Discovery Center, snow had accumulated in the various animal pens. The effect was to lower the height of the fencing relative to the ground. This allowed Brenda to get an "almost eye level" view of the animals within. She remembers standing vigil outside a pen of napping wolves, waiting for them to awake. "I stood around in the cold for hours—when the wolves woke up, they greeted each other gently, and I was ready for the

RIGHT (DOGWOOD):
Dogwood flowers photographed against the backdrop of the Merced River in Yosemite.
BELOW (CALIFORNIA QUAIL):
Tharp spotted this "scout" for a covey of quail while driving down a dirt road. She set up her monopod in the car, and photographed the bird with a Canon EOS 1-n and an EOS 300mm lens with a 1.4X teleconverter. She took a spot-meter reading off the neck of the bird.

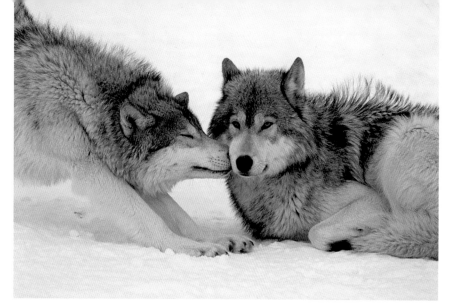

Right (Captive Wolves):
Tharp photographed captive wolves as they interacted at the Grizzly Discovery Center in Montana. Deep snow cover brought them high in their pen, allowing her to have an eye-level view—an unusual opportunity for a zoo-like setting. She used a tripod-mounted Canon EOS 1-n camera, EOS 300mm f/4 lens and a 1.4X teleconverter to record the image on Fuji RDPII transparency film.

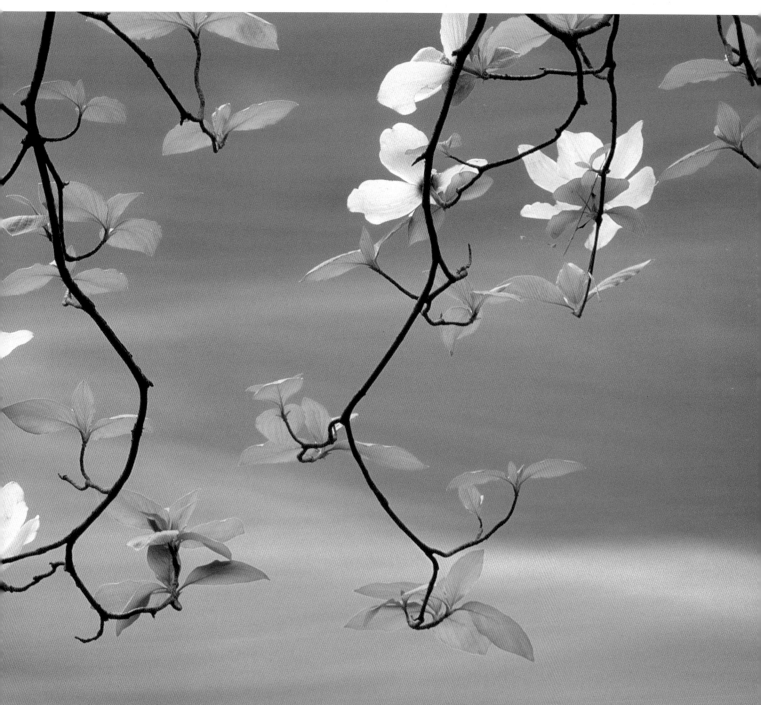

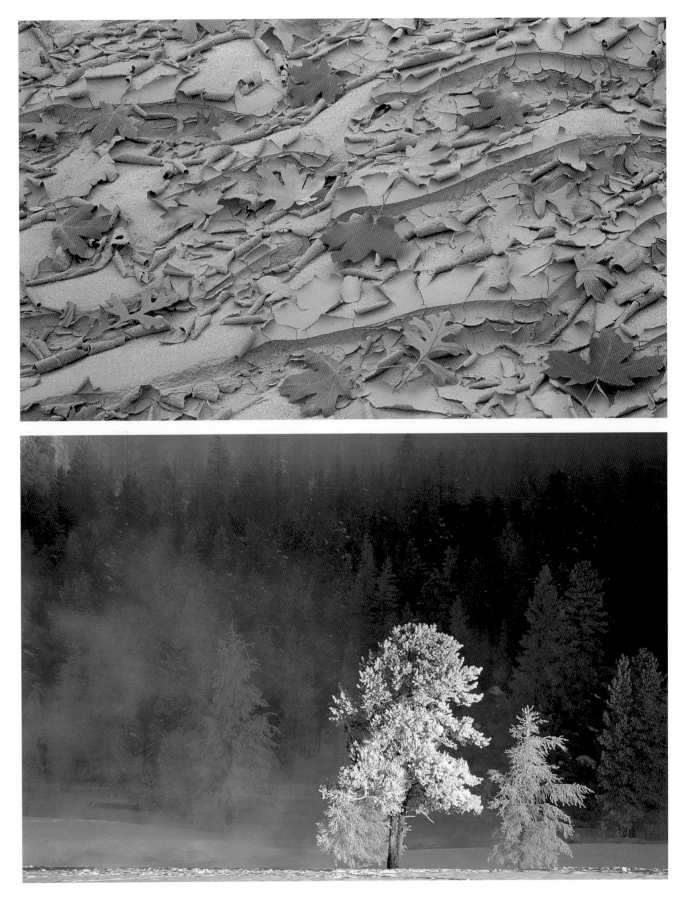

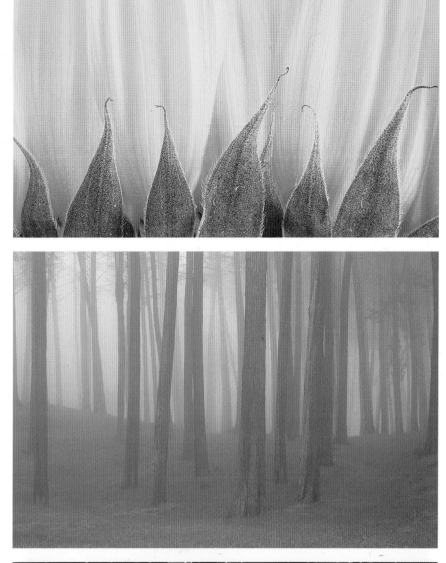

moment of tenderness. My exposure was cal-
culated using a spot meter, off the middle
tones on the fur on the side of the wolf."

Learning patience is one of the key lessons
Brenda has gleaned during her photographic
journey. This journey has been one of ongoing
discovery and growth. With each passing
year she strengthens her commitment to
making excellent images and to pursuing her
personal vision.

Brenda shows persistence in her approach
to both photography and business. She pro-
motes her business through mailings that
direct people to her impressive web site
www.brendatharp.com. Here you can sample
some of Brenda's most interesting work and
learn about her upcoming workshops and
lectures.

Brenda Tharp has written several articles
about her photographs, and she has been
published in many magazines and books. She
has photographed two award-winning books:
Muir Woods: Redwood Refuge, and *Marin
Headlands: Portals of Time*.

TOP RIGHT (SUNFLOWER):
*Brenda created this sunflower
still life with a Canon EOS-1n
and a Canon 100mm f/2.8 macro lens.
She diffused the sunlight with
a flexible translucent disc.*
CENTER RIGHT (TREES IN FOG):
*A rainy spring day brought ground
fog to a grove of Cypress trees
in the Presidio Forest in
San Francisco. She used a Canon
EOS-1 and Canon 28mm lens.*
BOTTOM RIGHT (AGAVE):
*Agave at the Arizona-Sonora
Desert Museum near Tucson.
She diffused the sunlight with
a translucent disc. Sidelight came from
reflections off the nearby sidewalk.*
FACING PAGE TOP (LEAVES ON MUD):
*Brenda discovered this autumn
scene in Zion National Park. Using
a Canon 90mm Tilt/Shift lens,
she tilted the lens to obtain maximum
depth-of-field for the scene.*
FACING PAGE BOTTOM (YELLOWSTONE):
*Sunlight makes hoar-frosted trees
glow in the wintery landscape of
Yellowstone National Park.*

TOM J. ULRICH

Tom J. Ulrich has been a wildlife photographer for over 25 years. During that time, he has produced more than a quarter million images, photographing nearly 500 bird species and nearly 100 mammal species in North America alone.

Like many successful wildlife photographers, Tom is also well traveled. He has led photography expeditions to Patagonia, Terra del Fuego, the Galapagos Islands, Costa Rica, East Africa and Pantanal, Brazil. This last location is the subject of his latest of six books.

In addition to shooting and writing about photography, Tom teaches three- and five-day seminars.

He can be reached at P.O. Box 361, West Glacier, MT 59936; 406-387-5521 or via e-mail at tjulrich@cyberport.net. Visit Tom's web site at www.tomulrichphotos.com.

RIGHT (TOUCAN):
Tom J. Ulrich photographed a wild keel-billed toucan after it flew into the dining room of a Costa Rican lodge to pilfer food.
BELOW (HUMMINGBIRD):
A male snowcap hummingbird in Costa Rica.
FACING PAGE TOP LEFT (RATTLER):
A Western diamondback rattlesnake photographed in the Texas Panhandle.
FACING PAGE TOP RIGHT (FRIGATEBIRD):
A male great frigatebird displaying for a female in the Galapagos Islands, Ecuador.
FACING PAGE BOTTOM (MARMOT):
A hoary marmot looks over his mountain domain in Glacier National Park, Montana.

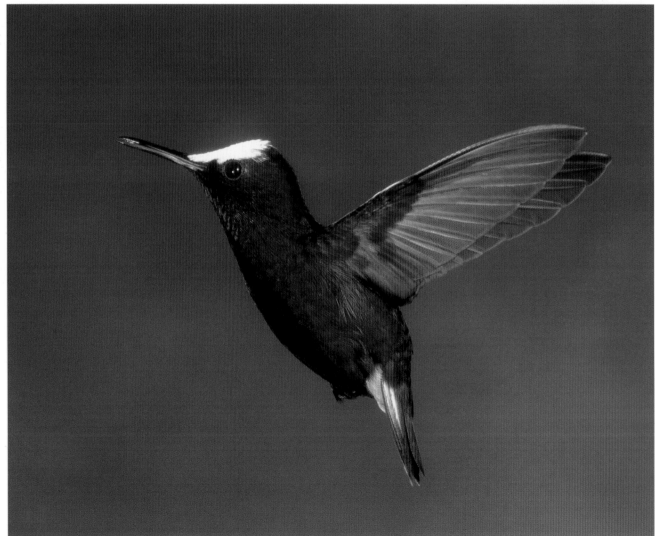

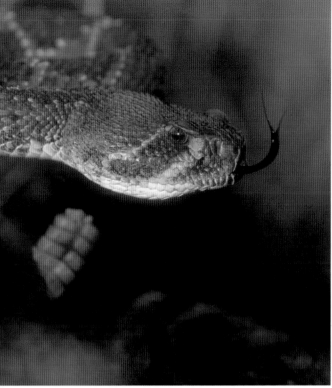
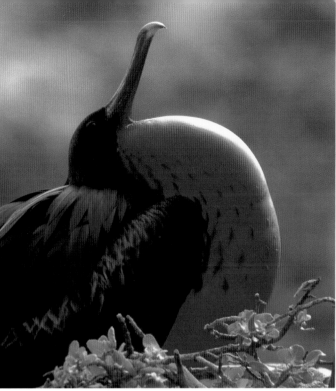
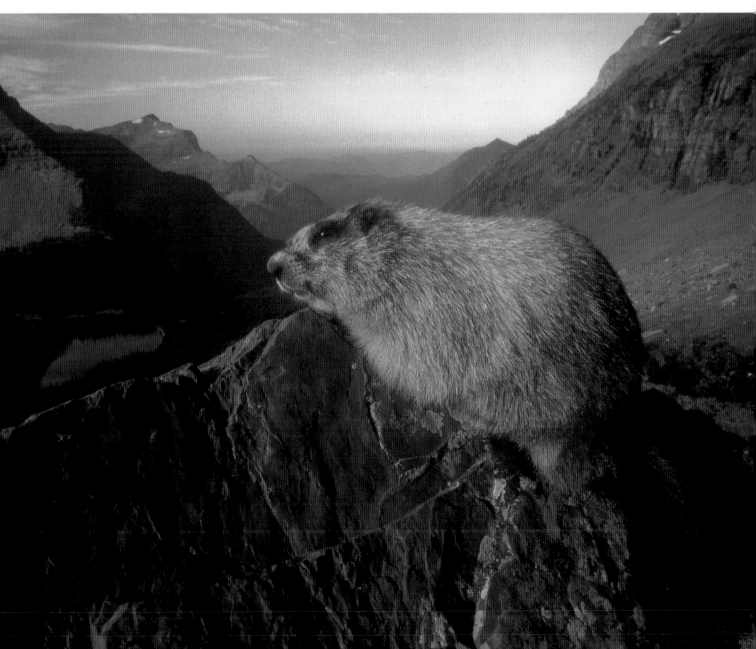

L. F. VAN LANDINGHAM

Patience is the key to wildlife photography, and L. F. Van Landingham is living proof—the patience to locate, and the patience to wait for the right lighting and pose.

His own disciplined patience has produced some remarkable photographic opportunities. To shoot the bison on the facing page, L. F. had to snowmobile 40 minutes to a remote section of Yellowstone National Park. Day after day he would make the trek waiting for the perfect moment to photograph the solitary bison bull that he had located near the thermals at West Thumb. For three days the bison laid low and refused to give L. F. the image that he was after. Finally on the fourth day, in a heavy snowstorm, the bison got up, shook the snow off and walked up the creek into the nearby trees and disappeared. The result was an image with a certain mystic and haunting quality.

Another memorable bison photo was the one L. F. took of a mother and her offspring pictured at the bottom of the facing page. As with the other photo, this one was taken at Yellowstone National Park, but during a different season. This mother and baby team was part of a herd of twenty bison.

One of the qualities that make this image so memorable is the intense rust color of the young bison. L. F. knows that to achieve this sort of vibrancy he must have the right lighting.

"Wildlife photographers should plan on shooting in the early morning and late evening," he advises. "Then spend the mid-day hours resting or scouting, when the lighting is not as good—because, after all, great photos are made with great light."

Not all of his photographs are shot in National Parks. L. F. has produced some remarkable shots at a raptor rehabilitation center, including the picture below of a great horned owl. Captive wildlife enables the photographer to work quite close to the animals, and therefore he can use shorter focal length lenses, such as the Nikon 70–210mm lens he used here. Unfortunately for this magnificent owl, his injuries are too severe to permit him to be rereleased into the wild anytime soon. For now, the owl helps teach visiting school children about wildlife conservation and the environment.

L. F. has leveraged his critical acclaim to form Van Landingham Nature Photography, a company that is dedicated to advancing the interests of nature. Together with his wife, Marbrey, L. F. tours the country educating audiences and raising funds for various nature related organizations. L. F. and Marbrey are accomplished speakers and they put on entertaining and informative shows comprised of words, music and pictures.

Contact Van Landingham Nature Photography by telephone at 972-393-3932 or via e-mail at VanNature@aol.com.

RIGHT (GREAT HORNED OWL):
This captive owl was photographed at a rehabilitation center, allowing the photographer to approach closely.
BELOW (FOXGLOVE):
Foxglove can be found in bloom in Olympic National Park throughout June and July.
FACING PAGE BOTTOM (BISON AND CALF):
May is the perfect time to photograph young bison in Yellowstone National Park.
FACING PAGE TOP LEFT (BISON):
A heavy snowstorm lends mystery to this picture of a Bison in Yellowstone National Park.

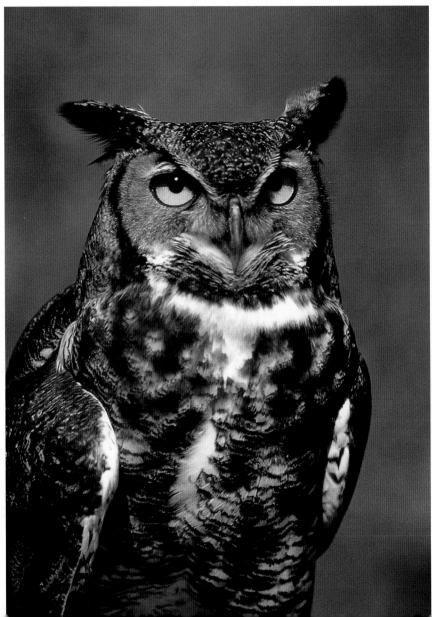

RIGHT (PRAIRIE DOGS):
These "kissing" prairie dogs were about 20 feet from L.F. Van Landingham when the golden sunset light hit. Photographed in the Wichita Mountain National Wildlife Refuge near Lawton, Oklahoma with a Nikon F5 camera and a 500mm lens.

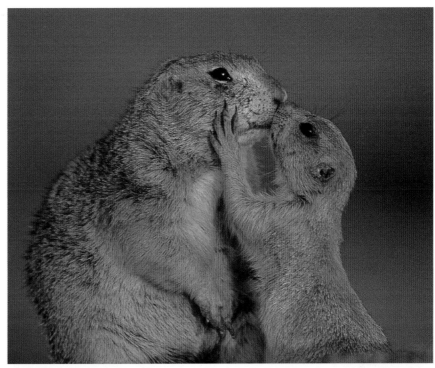

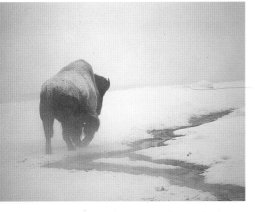

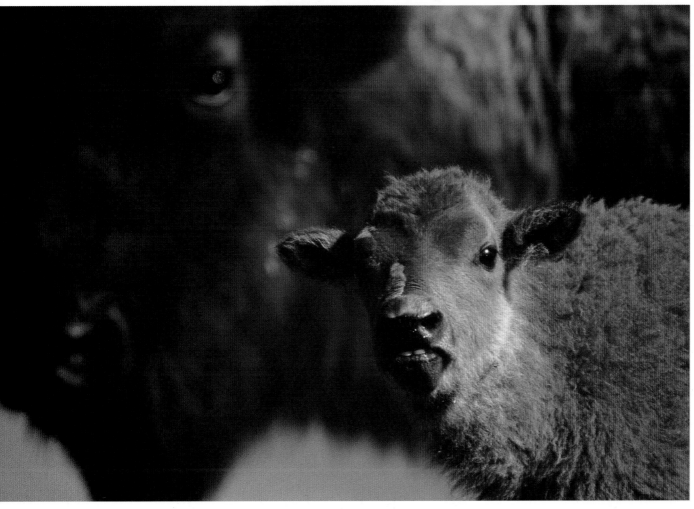

Peter Van Rhijn is a nature photographer par excellence. The vast wilderness of his adopted Canadian homeland provides plenty of opportunity for Peter to exercise his craft. It was "the natural beauty of Canada," says Peter, that "played a significant role in the decision to relocate" from his native Holland.

Since he was 9 years old, Peter has been interested in photography. As a young boy, Peter balanced this burgeoning passion for photography with his love of competitive sports. When Peter's sporting days came to an end, he poured all his energies into photography.

Although he began as a 35mm photographer, Peter now prefers the 6x7 format. He was already a stock photographer with the SuperStock agency when he switched to the

6x7 format in 1985. Peter believes that this format has improved the marketability of his images. This larger format also lends itself to grand audiovisual presentations, which have become Peter's trademark.

Over the years Peter has given countless presentations, talks and seminars. More often than not, Peter combines audio tracks with his visual displays. In 1992 he purchased three Goetschmann 67 AV projectors. These industrial-caliber workhorses are capable of 6000-lumen light output, and they deliver outstanding image quality. Many of Peter's recent shows have featured originally composed music. The audio component underscores the strength of his images. These presentations foster a deep appreciation of nature and a commitment to its preservation. Peter finds satisfaction in knowing that his presentations are "helping to keep this world green."

Peter's use of selective focus makes his images particularly compelling. The photographs on this page provide good examples of his mastery. Peter focuses a long and fast lens on small subjects. He then leaves his aperture wide-open. The effect is powerful in its simplicity. His keen eye for color harmony and composition allows Peter to build strong images without any internal distractions.

Peter explains how he controls the various elements in the blue-eyed grass photo on this page. "Simplicity is the most basic element of visual order. Colors of the foreground flowers are often repeated in the muted soft background due to the presence of very out-of-focus similar flowers in that background. This gives the image harmony of color between the main subject and the background. The critical challenge in an image of this kind is the need for reasonable focus on

FACING PAGE TOP (DAISIES):
Daisies and ragweed.
FACING PAGE BOTTOM (GRASS IN FIELD):
Grass blooming in a field of yellow mustard and purple dame's rocket.
TOP RIGHT (BLUE-EYED GRASS):
A small wildflower (about one inch) common in Ontario.
BOTTOM RIGHT (LOOSESTRIFE):
Van Rhijn used selective focus to shoot purple loosestrife.

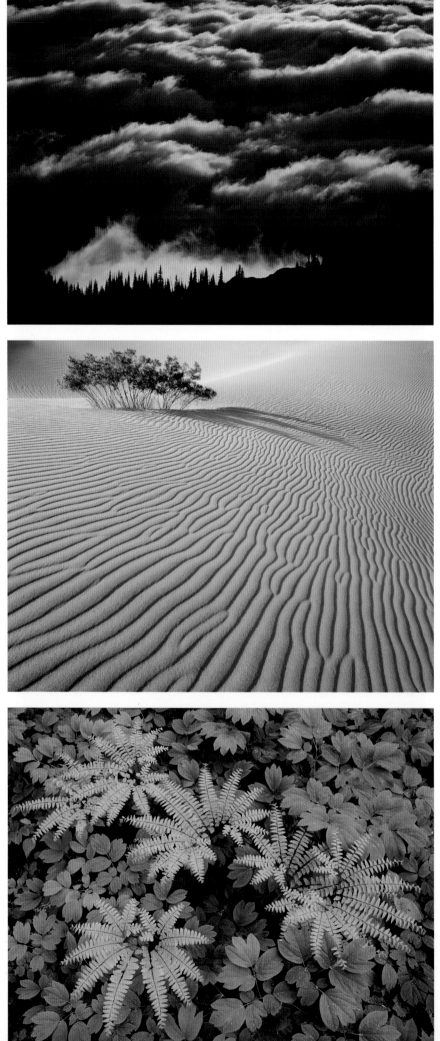

the center of the flowers and preferably some part of the petals. Selective focus with multiple-flower subjects is quite difficult. The trick is to try to visualize the imaginary plane in which the three flower centers are contained. The camera should be angled perpendicular to that plane to obtain sharp focus on the flower hearts while the lens remains wide open."

The image of the grass (see bottom photo on page 112) provides another example of Peter's stylized use of focus. Peter found inspiration in the juxtaposition of the vibrant yellows and purples. Interesting contrasts delight Peter. The idea of benign daisies among sneeze-inducing ragweed (page 112) evokes associations that extend beyond mere aesthetics. Indeed Peter's photographs appeal to us on a variety of levels.

For Peter, the pursuit of a photograph can be as rich an experience as the resulting image. He recalls an expedition to the Arctic Circle deep in the Yukon Territory. It was early September. The air temperature hovered at minus 2 degrees and the sky was perfectly clear. Peter stumbled upon some frost-covered bearberry leaves (page 116). He hastily scribbled the following mock news dispatch in his journal: "Photographer's condition: imminent adrenaline poisoning due to excessive coffee and extremely promising subject. Greatly concerned that skyrocketing body temperature will melt the frost on leaves." Peter then slipped on an 81-series filter to attenuate the blueness of the early morning light. This crisp and beautiful image tells the story of nature in the throes of seasonal change. The fragile leaves will soon yield to the arctic chill.

Peter finds opportunity in extreme natural settings. He enjoys working in the sand dunes of Death Valley, and even refers to them as being "manageable." He says that these dunes are relatively accessible, not excessively high and easy to hike in. Peter prefers to shoot as the sun rises and tries to avoid the windy days, because "wind, sand and cameras do not coexist well."

Sand dunes provide him with an endless variety of patterns, each with its own distinct rhythm. Peter notes that these "rhythms move with lines, with sensuous shapes, with sandy sculptures, all soft and seductively monochromatic." In his dune image on this page, Peter remarks that "the lines in the left lower corner take the eye by the hand

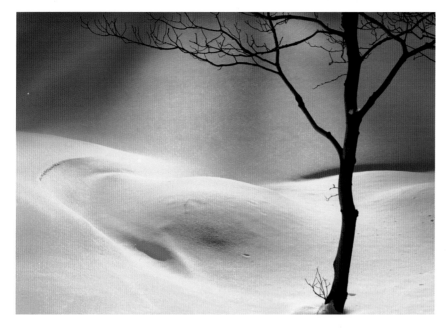

LEFT (DORSET TREE):
A tree on the shore of a lake in Dorset, Ontario.

BELOW (CADILLAC MOUNTAIN):
Fall colors near the peak of Cadillac Mountain (1530 feet) in Acadia National Park, Maine.

FACING PAGE TOP (SUNRISE):
Sunrise in Deerpark, Olympic Peninsula, Washington.

FACING PAGE CENTER (DEATH VALLEY):
Windblown sand in Death Valley National Park.

FACING PAGE BOTTOM (FERNS):
Maidenhair ferns are common in Southern Ontario, and can be found in dark forests, usually in close proximity to a lake, stream or body of water.

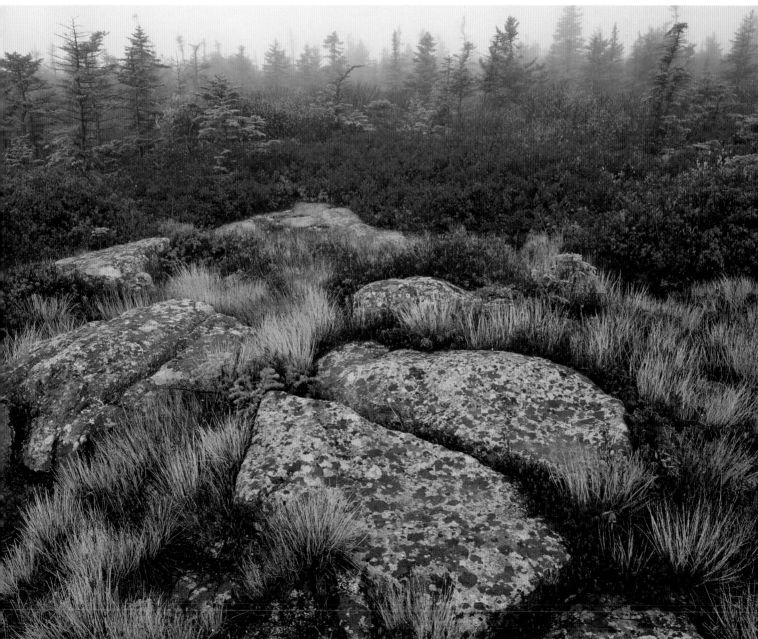

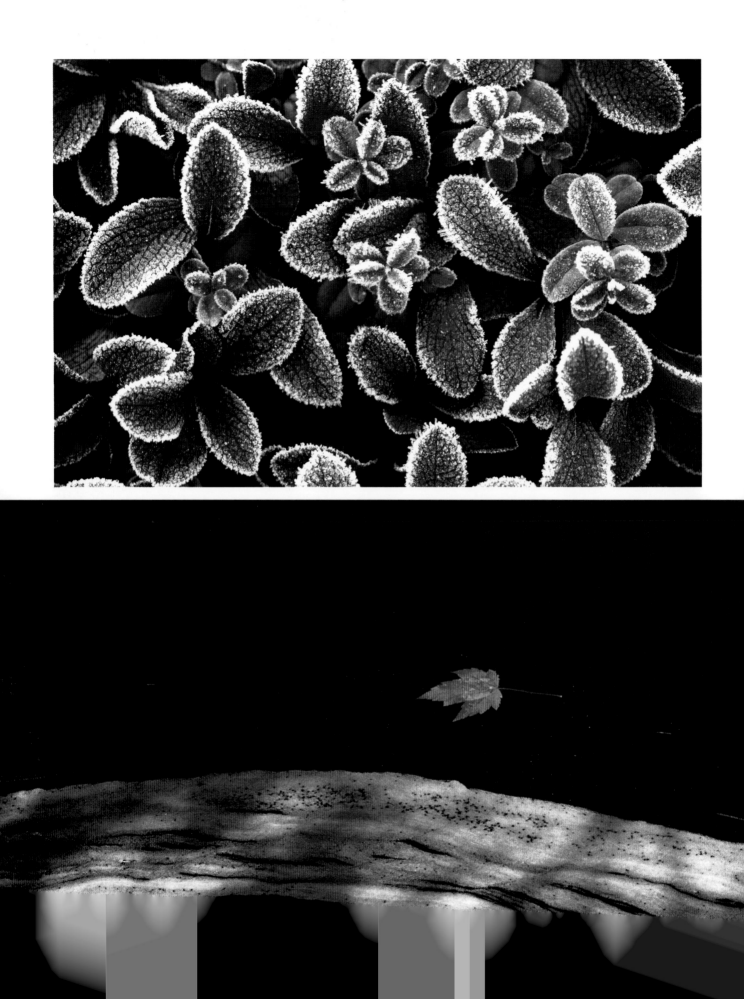

and show it around the entire picture space in a counterclockwise direction."

An image of lava can produce a similar effect. Peter traveled to Hawaii's Big Island to photograph its active volcano. He had a particular image in mind that he wanted to capture for one of his audiovisual presentations. He attempted to hike to the rim of the volcano and was tantalized by what he saw. It soon became apparent, however, that the shot Peter wanted would require the use of a helicopter.

As Peter tells the story: "I knew that helicopter engines do not like volcanic ash. I had heard of helicopters crashing into active volcanoes. We were married just a few days earlier on a beach on Kauai. It would have made an eye-catching headline: 'Newlyweds Crash into Volcano.' Nevertheless, we rose at 4 a.m. and headed for the airfield.

"Our pilot had been helpful enough to point out that the best time to photograph lava was around dawn because for about half an hour the light of the sun and the glow of the lava are nicely balanced." Indeed the aerial photograph of the volcano (pictured at right) has extraordinary balance and harmony. The image's various elements—the smoke, the flowing lava, the mountainous contours, and the drifting clouds—invite our eye to explore the photograph's organic texture.

Peter is a member of the Fujifilm U.S.A. Talent Team. He has received many honors for his photographs and continues to be highly regarded for his large format audiovisual presentations. Peter's images can be viewed at www.naturephotos.com. He can also be reached at pvr@naturephotos.com.

TOP RIGHT (VOLCANO):
A helicopter aerial shot
of Puu O'o Crater, Hawaii.
CENTER RIGHT (DESERT):
Flowers spring from cracked desert
ground near Page, Utah.
BOTTOM RIGHT (OREGON):
Surf along the Oregon coast.
FACING PAGE TOP (BEARBERRY):
Frosty bearberry leaves along the
Dempster Highway, Yukon Territory.
FACING PAGE BOTTOM (MAPLE LEAF):
A maple leaf floating
alongside natural foam from
a waterfall and rapids.

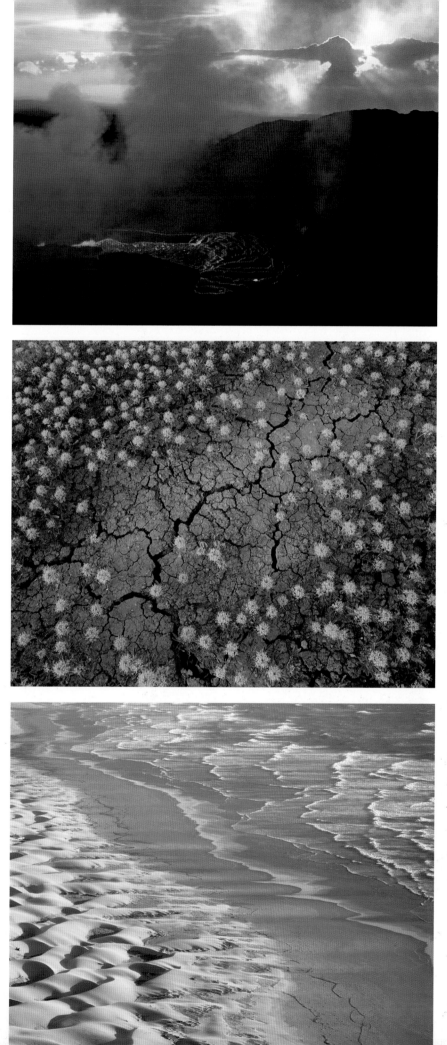

G. ARNELL WILLIAMS

G. Arnell Williams's highly stylized landscapes achieve a measure of drama that often eludes the images of more traditional landscape photographers. His selection of unique vantage points and his unorthodox use of light lend an otherworldliness to Arnell's magnificent work.

His interest in photography began during his years as a college student when he would take cross-country bus trips to and from school. Arnell remembers witnessing "spectacular sunsets and sunrises on those journeys," and yearned to capture their essence on film. He purchased a 110 camera and began shooting landscapes through the bus window. Not surprisingly, his first attempts failed to convey the sense of majesty that now characterizes Arnell's landscapes. Before long Arnell traded his 110 camera for a 35mm point & shoot. He eventually graduated to 35mm SLR cameras and large format 4x5 cameras.

Arnell has always been his own toughest critic. He painstakingly examines each and every photograph to determine what worked and what didn't. In the early years, Arnell recalls shooting thousands of images. He photographed "everything that appealed to [him] and experimented with all sorts of filters." The discipline required to sift through and analyze all those photographs paid off, and Arnell quickly achieved critical acclaim.

Arnell's two favorite shooting locations are Pyramid Lake in Nevada and Gros Morne National Park in Newfoundland, Canada. Both of these locations offer spectacular landscapes, and relatively speaking, they are undiscovered by the general tourist population. The photograph of Ten Mile Pond, facing page, was taken at Gros Morne. This image provides a good example of Arnell's gift for transforming a natural scene into a magical and mysterious space.

Visit his web site to see more of his images at www.dramainnature.com. There you will also find his best-selling posters "The Enchanted Landscape" and "The Lamb of God."

RIGHT (RESERVOIR): Groundhog Reservoir, San Juan Mountains, Colorado.
BOTTOM ROW (FROM LEFT TO RIGHT): Horsetails Falls, Columbia River Gorge National Scenic Area, Oregon; rock window at Rocks Provincial Park, New Brunswick; waterfall in a cave, Lookout Mountain, Tennessee.
FACING PAGE TOP (10-MILE POND): Gros Morne National Park, Newfoundland, Canada.
FACING PAGE BOTTOM (SOUTH FALLS): Silver Falls State Park, Oregon.

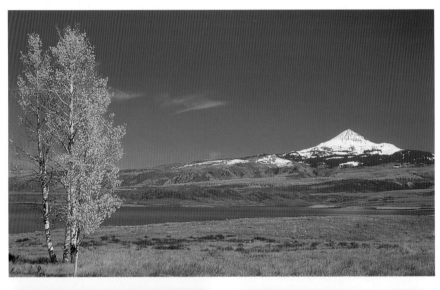

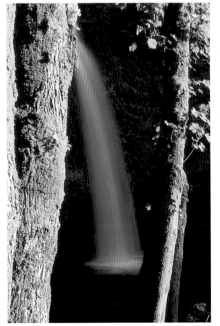

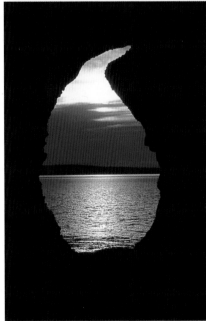

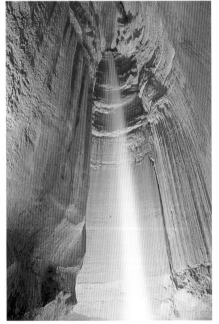

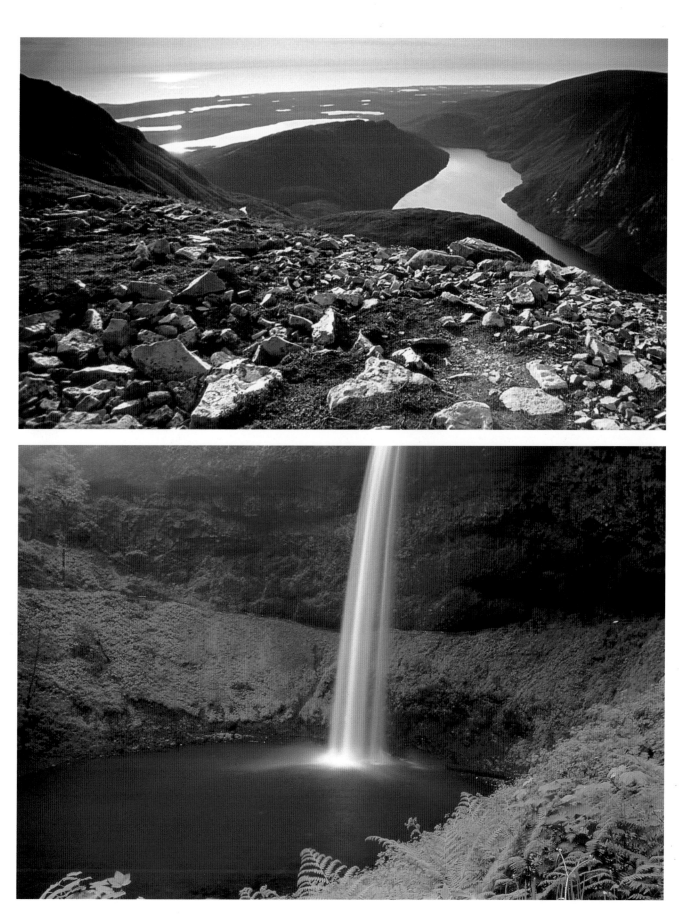

Scott Eliot Yokie is a nature and wildlife photographer who lives in Anchorage, Alaska. He moved there from "The Lower 48" in 1992 because of Alaska's beautiful scenery and vast photographic opportunities, met his wife, Charlotte, and stayed. Scott has a great love for the Alaskan outdoors, which he experiences not only through photography but also through hiking, camping, canoeing, fishing, and mountain-biking activities.

"My most memorable wildlife encounter," comments Scott, "involved a group of four large Dall sheep rams in the mountains just outside of Anchorage." He spotted these rams about halfway up a mountain trail, and watched to see in which direction they were heading before hiking up a half mile ahead of their current location from a different path. Sure enough, a couple hours later, he spotted them again. Instead of trying to approach them and possibly spook them away, Scott found a spot near their trail that appeared to have some nice background possibilities. He laid down in this open area so as not to pres-ent a threatening presence and patiently waited. After they noticed him and decided that he was not a threat, all four came with-in 20–25 feet of him. It turned out even bet-ter than imagined when, after some time, the ram pictured below decided to walk over and lay down four feet from his position over-looking Turnagain Arm (part of Cook Inlet).

To capture this image, Scott used a polar-izer and spot-metered a gray rock in the same light, just out of the camera's frame. He was able to shoot a roll and a half of film over the next half hour, until this stately looking ram decided to get up and rejoin the others. Scott says that the six hours he spent on the mountain, overlooking the inlet, and in the presence of these wild animals were among the most inspiring in his life.

Another memorable day took Scott to the tide flats of Turnagain Arm (near Anchorage, Alaska) in late summer. He tried to get clos-er to these beautiful greens, in order to fill the frame with them; but at the same time trying to find the right pattern. Before he knew it, he was hopping out on the rocks, getting muddier by the moment, till finally he reached this fjord-like area.

He set up his tripod and included the white rock to add scale and keep the image from becoming static. Although the majority of his shots were taken at f/16, he made a few vari-ations and prefers this f/11 shot with less depth of field. Scott likes the slightly out-of-focus area at the top of the frame, which makes it feel more dimensional.

Besides changing the f-stop on his cam-era, many times Scott will shoot with differ-ent lenses to test a situation. In the Chugach mountain range in Alaska, Scott was drawn to a particular mountain because of the wind-swept snow patterns. He set up his tri-pod and contemplated his various lenses and how he wanted to portray this scene. In the end he decided to use his 300mm lens to pro-vide a tightly compressed image in order to emphasize the detail in the snow.

Sometimes it's not changing equipment that alters a shot but the seasons themselves.

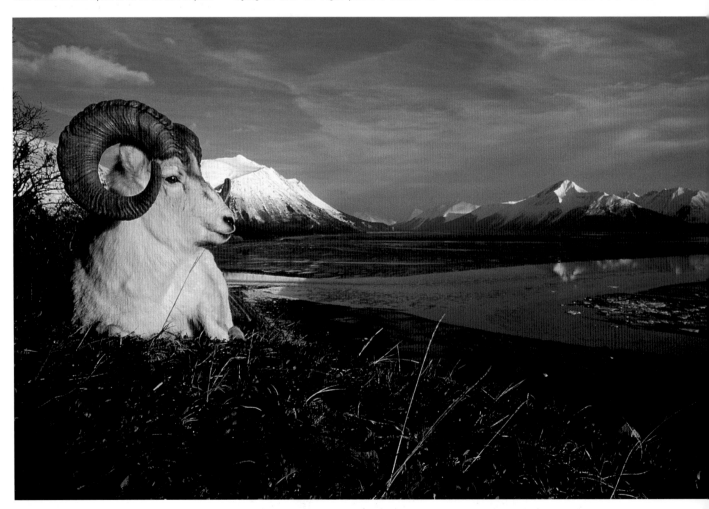

Scott's eye was caught by a contrast of colors, and upon further investigation he saw the red bunchberries, dried bark and yellowed grasses, pictured at the bottom left. He composed the image in a way that would break it up into thirds.

"I've since gone back to this same spot during the different seasons. It is also conveniently near one of my favorite fishing spots," proclaims Scott. In spring and summer the same picture has such a totally different look to it when the grass and berry leaves are green.

Scott owns a photography-based web business, called Bigglass.net, which is for fellow nature and wildlife photographers. It is a business that not only supplies affordable high-quality photographic equipment, such as used telephoto lenses, but also provides helpful information to people that love the same things Scott does. The site also features a collection of Scott's photos and links to other photo sites by nature and wildlife photographers whose work continues "to inspire and humble him" on a regular basis.

To sum it up, he declares "I want to keep doing what I enjoy and somehow manage to make a decent living at it. Life is too short for settling for less."

Scott can best be reached by e-mail at scottchar@gci.net or through his web site at www.Bigglass.net.

FACING PAGE (DALL RAM):
Scott Yokie waited several hours in Turnagain Arm, Alaska, hoping a group of rams he had scouted would pass by. He was rewarded when one approached within four feet and laid down for a rest.
TOP LEFT (CHUGACH RANGE):
A snow-swept Alaskan scene.
CENTER LEFT (TIDAL FLATS):
Late summer near Turnagain Arm, Alaska. The white rock in the foreground added scale and anchored the picture.
BOTTOM LEFT (WILDBERRIES):
The fall season provided a nice contrast between the red bunchberries, the dried bark and the yellowed grasses.

SCOTT ELIOT YOKIE 121

Known for his wildlife, nature and travel photography, Jim Zuckerman has mastered a variety of imaging styles and techniques. He prefers medium format cameras, though he acknowledges the challenges this format presents.

"Shooting with medium format cameras is different than 35mm photography because I have to have much more patience," explains Jim. "I must constantly temper my level of frustration because it's so much harder to get a great shot. The camera is bigger and heavier and has no motordrive. But I keep with it, because when I get the shot, the larger medium format film is pretty awesome."

In addition to camera, lens and film, Jim always carries a handheld meter. "I don't trust automatic in-camera meters in many situations." He has more faith in the reliability of handheld meters, yet he is not totally dependent on them either. Like many top professionals, Jim has learned to read light without the use of a meter. This allows him to get the right exposure even when his meter fails.

The image of the giraffe on the facing page showcases Jim's eye for attractive lighting. Jim took this photograph during his first trip to Kenya. The experience inspired his love affair with the African wild.

Jim tells how "twenty minutes after I took this picture, I was photographing cheetahs at a kill, and then a half hour later I was composing a pride of lions in the golden light of sunset. This was just too good to be true—I thought then, and I still feel, that a wildlife safari in Africa is the most exciting experience for anyone who loves nature. In southern Africa, at the end of the dry season, the photographic opportunities are amazing as the animals congregate at the waterholes."

Although Jim loves the photographic possibilities of Africa he recognizes that there are plenty of compelling wildlife and natural images to be had in his native United States. Jim's favorite type of landscape photography is shooting in the wintertime in the Western United States. He believes that "winter reveals the graphic forms, the diversity of subject matter, and the sheer grandeur of our national parks." On one outing to Bryce Canyon, Utah, Jim was busy composing an image that contrasted the orange canyon walls against the snowy sky (below). It was at this point, Jim explains, "when the mule

BOTTOM LEFT (MULE DEER):
A mule deer made a one-exposure "cameo" appearance in Zuckerman's landscape picture from Bryce Canyon National Park. Shot with a Mamiya RZ 67 II, 250mm telephoto lens, Fujichrome Velvia, and a tripod. The exposure was 1/60-second at f/8.

BOTTOM RIGHT (HAVASU FALLS):
Jim hiked twelve miles with his Mamiya RZ 67 to photograph this waterfall on the west end of the Grand Canyon.

FACING PAGE (GIRAFFE IN KENYA):
Zuckerman photographed this giraffe on his first trip to Kenya. He used a Mamiya RZ 67 medium format camera, and a 250mm telephoto that was rested in a beanbag on a landrover. His exposure was 1/250-second at f/8 on Fujichrome Provia 100 film.

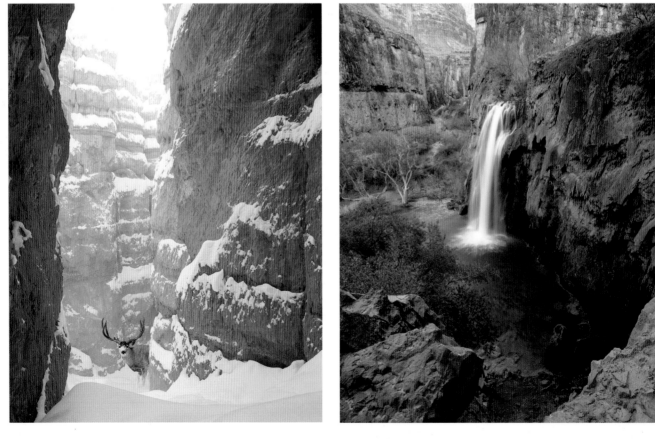

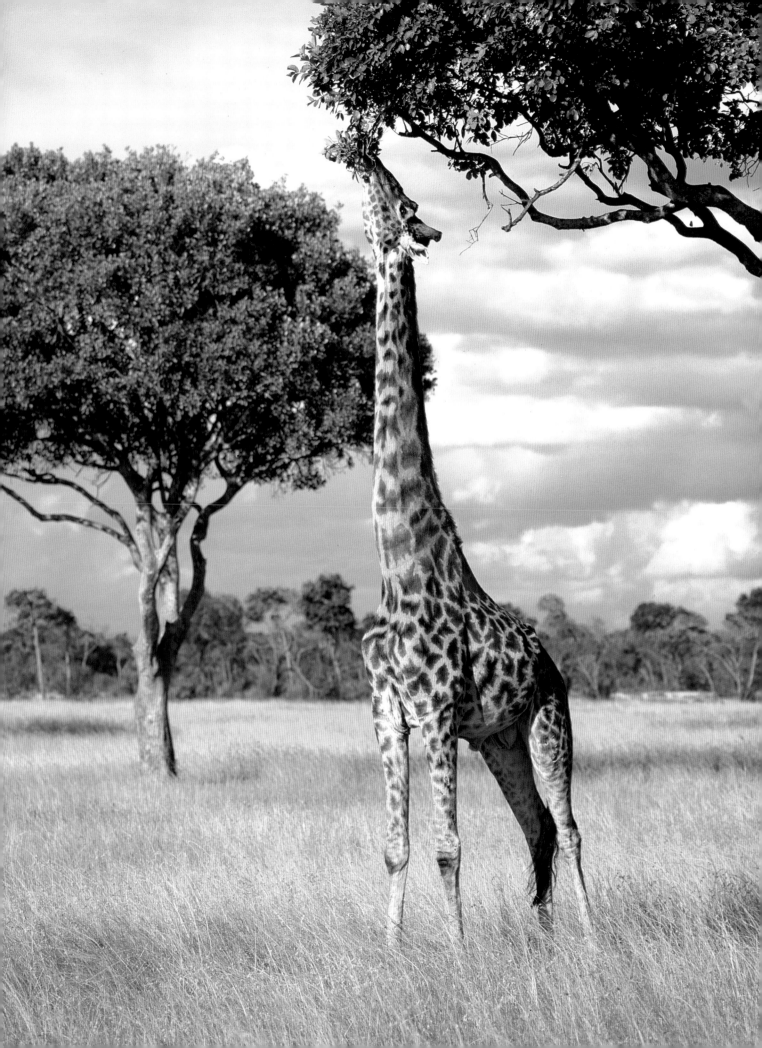

deer peeked around the corner. I was able to take only a single frame before he disappeared." Needless to say, he got the shot.

Taking advantage of fleeting opportunities and resourcefulness are two key traits of successful wildlife photographers. During a nighttime journey in Botswana with a driver and another photographer, Jim came upon a pair of mating leopards. Unfortunately for Jim, the flash he needed was several thousand miles away on his kitchen table. To make due, Jim asked his driver to use a spotlight just long enough for Jim to focus his camera. Then in darkness Jim opened his shutter while the other photographer fired his 35mm SLR with Vivitar flash to illuminate the subject. The incredible photograph that resulted can be seen on page 125.

Today Jim jokes about the flash he left at home, a mistake he will likely never repeat. Jim's candor about making mistakes contributes to his effectiveness as a photo instructor. Jim leads international photo tours and workshops, and has authored several essential books on photography. His book titles include *The Professional Photographer's Guide to Shooting and Selling Nature and Wildlife Photos, Digital Effects, Techniques of Natural Light Photography, Capturing Drama in Nature Photography,* and *The Guide to Exposure.* Jim is also a contributing editor to *Petersen's Photographic* magazine. His work appears around the world and has been used for packaging, advertising,

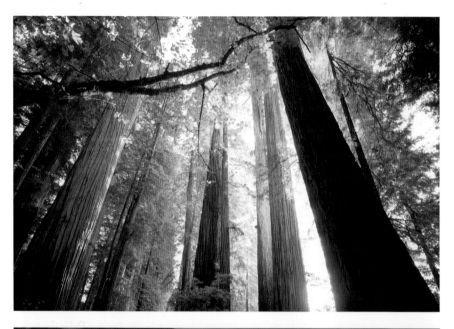

TOP RIGHT (REDWOODS):
A sunset glow in a forest of redwoods is unusual because the giant trees are often shrouded in fog or clustered so tightly that the low-angled light can't penetrate. To determine the correct exposure data, Jim Zuckerman used the Sekonic L-508 hand held meter on reflected mode and read the middle-toned portion of the gray tree on the left of the composition.

BOTTOM RIGHT (RHINOS):
It is rare to find so many rhinos together in Kenya. Zuckerman used a Mamiya RZ 67 II, 50mm lens, Fujichrome Provia 100F, and a beanbag to steady the camera during this $\frac{1}{125}$-second exposure at an aperture of f/11–16.

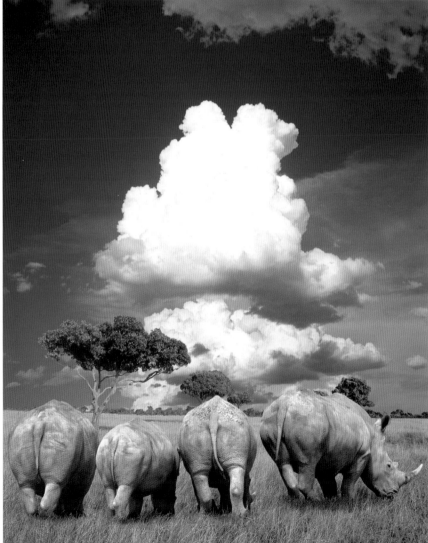

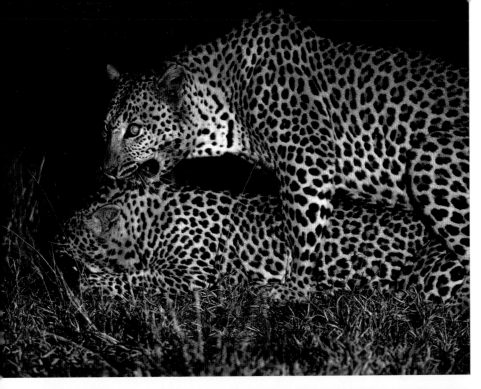

LEFT (LEOPARDS MATING):
Zuckerman's unusual shooting technique involved "sharing" a flash with a fellow photographer. He'd forgotten his flash, so he used a spotlight to momentarily focus, and then opened his shutter to the night, while his friend took a flash picture. In this way, his shutter was open when the other camera's flash lit the scene.

BELOW (BRISTLECONE PINE):
These are the oldest living things on earth. This tree, growing at 11,000 feet in the White Mountains of California, is almost 5000 years old. Mamiya RZ 67 II, 110mm lens, ⅛ second, f/22–f/32, Fujichrome Velvia, and a tripod.

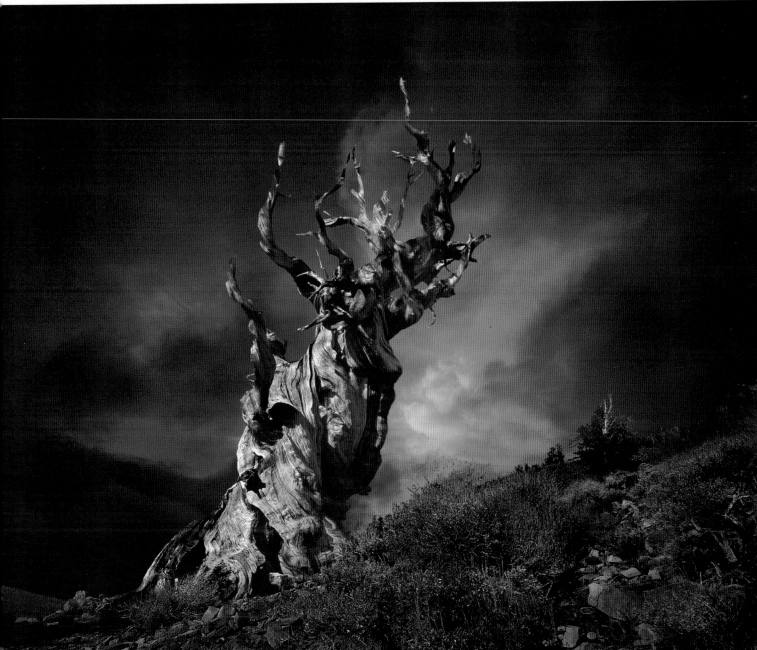

editorial layouts, corporate publications, calendars, posters, and greeting cards.

Jim Zuckerman derives most of his income, however, from the sales of his stock images. Jim is represented by Corbis Images, who actively promotes many of Jim's photographs. Jim says that stock can be very lucrative if you constantly provide new images for the agency to sell.

For more information on Jim Zuckerman's photographs, books, articles and workshops, check out his web site at www.jimzuckerman.com or e-mail him at photos@jimzuckerman.com.

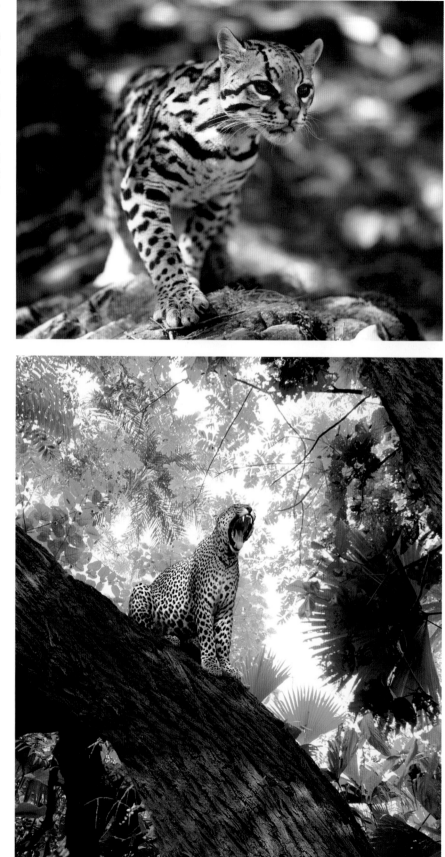

TOP RIGHT (OCELOT):
This ocelot crossed the road in front of Jim Zuckerman's car near the ruins of Tikal in Guatemala. Zuckerman stopped, and to his surprise, the jungle cat wasn't in a hurry to disappear; he allowed a relatively close approach. He used a tripod and spread the legs as low as possible to the ground to achieve this intimate perspective.
BOTTOM RIGHT (LEOPARD):
Zuckerman waited three hours for this leopard to do something more interesting than snooze. Finally, he sat up, yawned and then disappeared into the underbrush. He had enough time to shoot a few frames with his Mamiya RZ 67 II and 500mm lens. The exposure was 1/125 second at f/5.6 on Fujichrome Provia.

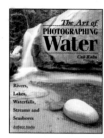